HOPE &
NEW ORLEANS

A HISTORY OF CRESCENT CITY STREET NAMES

SALLY ASHER

Charleston London

THE
History
PRESS

Published by The History Press
Charleston, SC 29403
www.historypress.net

Copyright © 2014 by Sally Asher
All rights reserved

Images courtesy of author unless otherwise noted.

First published 2014

Manufactured in the United States

ISBN 978.1.62619.053.5

Library of Congress CIP data applied for.

New Orleans. March 21, 1876

DEAR ROUNDABOUT—

Uncle Charles is so absurd—he will not pronounce the names of the streets correctly—to show you: For Melpomene. I say—Mel-po-mean. He says—Mel-pom-any.

 For Calliope. I say—Cal-e-ope. He says—Cali-i-o-p.
 For Coliseum. I say—Col-isee-eum. He says—Call-isee em.
 For Terpsichore. I say—Terp-se-core. He says—Terp-sick-hooray.
 For Penelope. I say—Pen-e-lope. He says—P-nell o-p.
 For Tchoupitoulas. I say—Shop-e-too-la. He says—Chop-i-too-lass.
 Who is right? Please answer.

Lucy

Permit us to say, dear Lucy, that your uncle Charley is a very well informed person whose advice you may safely take in the matter of pronouncing classical street names.

—New Orleans Times, *March 26, 1876*

CONTENTS

PREFACE

First off, my sincerest apologies if I did not include your favorite street. With more than two thousand streets in New Orleans, it was difficult to choose between them. Many streets deserve their own chapters, and some their own books, but I strove to strike a balance between well-known streets and those that might be less so, as well as give a glimpse into some of the stories and individuals for whom the streets are named.

My research, like some of the streets in this book, was sometimes complicated by misspellings and contradictory dates and data. I utilized the City's Master Street List; the "Alphabetical Index of Changes in Street Names, Old and New Period 1852 to Current Date, Dec. 1st 1938," compiled in 1938 by Gary B. Amos as a Works Progress Administration–sponsored project; city ordinances; and antique maps to discover and locate exact dates and names of streets. Unfortunately, these did not always match up with contemporary primary sources. I often found streets listed in advertisements or news articles years before they were "officially" streets, but I tried to be as consistent as possible and noted when there was a conflict between sources.

I am grateful for the New Orleans Architecture series compiled by the Friends of the Cabildo, which was indispensable. I am also appreciative of the invaluable scholarship of Richard Campanella, John Chase, Mary Louise Christovich, Charles Dufour, Leonard Huber, Bernard Lemann, Lawrence Powell, Betsy Swanson, S. Frederick Starr, Roulhac Toledano and Samuel Wilson.

One of my main resources was newspapers—many dating back almost two hundred years. The *Times-Picayune*, founded in 1837, underwent many changes,

seeing different names, owners and mergers, but for clarity's sake, I refer to it in my endnotes as simply the *Times-Picayune*. Often, city ordinances did not provide the "why" as to the naming of streets, but it could sometimes be found in newspapers—often with colorful commentary.

Second, you know the old saying "it takes a village"? Well, in my case, it took a city. Many people contributed to this book, and while I wish I could write a soliloquy for each one, please know that these few words represent boundless appreciation.

I would like to acknowledge and thank the following people for their generosity of spirit and depth and breadth of ability and assistance—be it historical or moral support.

Christen Thompson, my commissioning editor, for "discovering me" and for her unwavering support, patience, humor and good advice. Ryan Finn, my copyeditor, for all his hard work and assistance.

Zack Weaver, my boss, who treats me as an artist and as a professional. I am sincerely grateful.

Lee Miller, Sean Benjamin and Ann Case from Tulane's Louisiana Research Collection, who are always so helpful and patient with all of my requests—no matter how odd.

Barry Ahearn—even after I left your class, you have always been available for counsel and a good ear-bending.

Joel Dinerstein, who first encouraged my foray into nonfiction and who takes great joy in New Orleans culture.

Richard Campanella, who is one of the most erudite individuals on New Orleans history and is always charitable with his knowledge. Richard not only gave me the idea to divide my book into themes, but he also contributed a special map. You're the Bono Godfather!

Irene Wainwright from the New Orleans Public Library—I cannot imagine a researcher in New Orleans who is not indebted to and appreciative of you.

Matt Farah and Jennifer Navarre from the Historic New Orleans Collection's Williams Research Center, for being ever capable and helpful with maps and names.

David Johnson from the Louisiana Endowment for the Humanities, for his support of my research and for his infectious love of New Orleans.

Greg Lambousy from the Louisiana State Museum, who took a leap of faith with me and continues to back me on various projects.

Ruth Laney from *Country Roads*, who first interviewed me about my research.

Susan Larson, Peggy LaBorde and Chris Wiltz, for being such amazing mentors and inspirations.

Shane and Lisa Thomas, for your friendship and encouragement.

Sherri Montz, who is always willing to help and always does more than just show up.

Steve Himelfarb from the New Orleans Cake Café & Bakery, for supporting my career and for your fantastic culinary creations.

Veronica Russell, Andrew Ward and Trixie Minx, who have lent their amazing talents to many of my productions and continually keep me in awe. Y'all always bring it—in more ways than one.

The Big Easy Rollergirls and the Krewe of the Rollin' Elvi.

Mom, thank you for your alternative views, creativity, unparalleled generosity, concern for others and phonetically creative e-mails. Dad, thank you for your wisdom and your lessons and for being one of my favorite storytellers. Thank you both for always encouraging my love of reading; I love you both so much.

Bill (who fortunately for me and unfortunately for him became a graphic designer), for fielding my innumerable random requests.

Wendy, who is beautiful inside and out.

To all my fantastic nieces and nephews: Erin, Marsa, Spencer, Alex, William, Josephine, Saquoiah, Ryleigh, Dravis, Swayze, Matea, Juliana, Jacob, Whitney, Rachel and Justin. I love you.

David and Anita Cain, for your support and love through good times and bad.

Jay and Judy Chase, for your unconditional love over the years.

Scott Frilot, for being a fantastic buddy, a talented graphic artist, an expert at Photoshop and a bad-ass musician.

Kathryn "Trixie la Femme" Hobgood Ray, for being a catalyst for so many projects, for having a pure imagination and heart and for giving birth to one of the coolest individuals on the planet. You challenge me, inspire me and make me laugh on a daily basis.

Glenn May, you are my unsung hero and deserve a hundred songs sung about you. Thank you for lending your assistance, no matter how crazy the idea may be.

Thank you to all of my friends who asked, "What can I do for you?" instead of "What have you done for me lately?"

And especially thank you to John Haffner, to whom this book is dedicated. There is not a page in this book that does not have your presence. From proofing my words to going on photo shoots at the crack of dawn or in the middle of the night, looking at microfilm with me and squinting at two-hundred-year-old maps with a magnifying glass—you have been there for it all. This book would not be possible without your creativity, passion and benevolence. Thank you for giving me Hope.

And a special thanks to my team—Zelda Queen, Fannie Pie and Django Boy—for being mostly patient during this project, always offering me a belly (or two) to rub and constantly filling my heart with joy.

Thank you, New Orleans. I love you.

INTRODUCTION

New Orleanians have always taken pride in their street names, whether derived from the whim of a wealthy plantation owner to flatter or appease a daughter or lover, from the vanity of a surveyor anxious to leave evidence of his existence by designating a street with his own name or that of his favorite poet or statesman or from the fancies of an affluent playboy proclaiming his love of gambling and the arts. New Orleans's street names are cultural identifiers that often serve to memorialize or signify what people deem historically significant. But they are more than geographic markers or memorials for the chosen; they were a factor in the city's genesis.

New Orleans was founded in 1718 by Jean-Baptiste Le Moyne, Sieur de Bienville, and in 1721, Adrien de Pauger laid out the first streets in what is today the French Quarter, naming them after French royal houses and saints (the city, in fact, was named after the Duke of Orleans). Of course, being royal did not necessarily ensure "regal behavior," and even with tales of royals' deceit, adultery and foolishness, Pauger recognized Louis XIV's "bastards" with streets as well, while New Orleans looked the other way. Its location on the Mississippi was key to the French designating the city as its capital over Biloxi and Mobile, but it did not hurt that Pauger's map was an elegant grid of royal flattery.

Although the original streets of New Orleans were named after those in the uppermost echelons of society and piety, this was not reflected in the first people who walked the streets and certainly not in those who built them. Convicts did much of the early labor, and France and the Company of the Indies had to settle for many "undesirables" as the colony's first residents. The government

advertised "the Mississippi," a muggy, creature-infested swamp with air thick with mosquitoes, as a new Eden. When its public relations ruse was exposed, it emptied the jails and asylums and snatched people off the streets. French documents from 1719 record thirty cartloads of prostitutes being wheeled through the streets of Paris bound for the dreaded Mississippi. Then, in 1727, the Ursuline nuns arrived.

Like the original street names, honoring saints to bastards, New Orleans's early residents represented the extremes of the social and moral spectrum. And it was perhaps in these early years, when the adventurers, the streetwalkers, the pious, the fortune-seekers, the laborers and others all worked together to create New Orleans, that the foundation of its vivid, passionate, unique way of living was laid. From New Orleans's youth, there has always been a heavy dose of debauchery, but there has also been piety looking over it, trying to temper its wicked ways. This interplay is represented on the city's map. And in New Orleans, as its history has proved many times, you do not necessarily need to be benevolent or beloved to have a street named after you—you just need to make a splash.

Even in antebellum times, New Orleans's newspapers touted its streets' charm and distinctive celebration of history, its thoroughfares enfolding its denizens in the protection of saints, the beauty of nature, the wisdom of philosophers, the generosity of philanthropists and the bravery of military and civic leaders. Newspapers across the country published articles on the whimsy and romance of New Orleans street names and their links to yesteryear. In the 1870s, the *New York Evening Post* noted that New Orleans and Boston conformed less to the numerical pattern of naming streets than any other cities in America and that despite New Orleans's custom of "corruptions and perversions" of its street names, perhaps New York City should follow its lead—while numbers might be convenient, they were monotonous and lacked historical gravity. In fact, out of the more than two thousand streets in New Orleans, less than half of 1 percent are numbered (and that percentage would be even lower without the small succession of numbered streets in Lakeview), and even those streets are still referred to as "Yankee Streets."

In 1904, the *Times-Picayune* published a guide to New Orleans and declared that every once in a while, a petition is introduced to the city council to number the streets and label them with North, South, East and West (supplanting the unofficial cardinal directions of uptown, downtown, riverside and lakeside). It acknowledged that "such change in nomenclature would greatly facilitate the efforts of the business community, as well as afford a better guide to strangers who are here for commercial purposes. But these resolutions are invariably voted down in accordance with public sentiment. What would West Forty-fifth

or East Twenty-seventh Street mean to us in comparison with these old names that express the life, the growth, the thought of the city from its foundation to the present."[1]

The town of Carrollton initially had several numbered streets, but they were all wiped out in a mass street renaming in 1894, replaced with such bucolic names as Olive, Palmetto and Peach. There was also an effort that year by L. Soards, the publisher of the city directory, to avoid "common and ugly" names and eliminate the few numbered streets in the Lower Garden District since the city changed Fifth Street to Washington but kept Sixth through Ninth Streets. He also argued that First Street was not first in any sense of location and proposed that it be changed to Crown Street and after that King, Queen, Prince and so on.[2] Soards never got his wish, leaving New Orleans's few numbered streets nonsequential and confusing.

Even more perplexing than the city's sense of direction is its sense of dialect, which often gives new pronunciations to old words. Only in New Orleans do you hear (among others) Calliope (*cal*-lee-ope), Burgundy (bur-*gun*-dee) and Socrates (*so*-crates), and the locals would not have it any other way.

Notwithstanding understanding or pronouncing the streets, even settling on street names hasn't always been simple. When the city expanded beyond the carefully constructed grid of the Vieux Carré, and plantations were sliced into faubourgs and separate towns, the curves and quirks of the streets (following the bends of the river) sometimes became problems as much as the names themselves, fanning out in an organic, almost haphazard fashion. One of the privileges of subdividing one's plantation was naming the streets, and while many owners named them after loved ones, others named them after popular political and military leaders. At one point, there were more than half a dozen Napoleon and Washington Streets, and St. John the Baptist also showed up in numerous places throughout the city. In the 1860s, an ordinance was passed to limit streets to one name or, at the most, two—one above Canal Street and one below. In 1870, another ordinance was passed to try to alleviate the problem of different names given "to continuous parts of the same streets in the city of New Orleans, thereby occasioning frequent embarrassments to wayfarers in said city."

But New Orleans's unusual names, sometimes nonsensical directions and "interpretative" pronunciations were once not the only "unique" features of the streetscape. Numbering and labeling were often erratic, and immediately following the Civil War, there was a movement to rationalize them. But even into the early twentieth century, the ways street names were displayed were inconsistent. Locals fielded questions on a daily basis from visitors asking where house numbers were

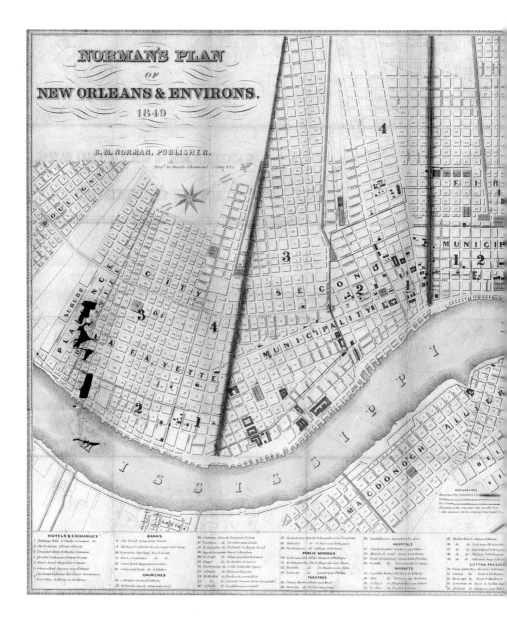

(mostly nonexistent) and where street signs were (mainly set in the sidewalk in white-and-blue tile). The general feeling was that if you lived in the city, you knew where you were, and visitors…well, they could figure it out for themselves or ask and experience some of the famous southern hospitality.

In 1852, 1894 and 1924, the city made sweeping name changes. Hundreds of street names were eliminated or altered under new ordinances. Most names

B.M. Norman's 1849 map of New Orleans. *From Norman's New Orleans and Environs: Containing a Brief Historical Sketch of the Territory and State of Louisiana and the City of New Orleans, From the Earliest Period to the Present Time.*

stuck, but some, for whatever reason, never made it from paper to pavement. Katherine Dent (named after the first New Orleans nurse to die in World War I and whose memory spawned multiple nursing organizations in her honor for decades thereafter), Madame Tranchepain ("Madame Loaf of Bread") and Jeanne d'Arc Streets disappeared before long. But it was not just women; Cardinal Mercier and Pere Roquette, although officially changed in 1924, also soon vanished from the record. During its history, New Orleans lost Good Children and Greatmen Streets but kept Madmen (which went "out of duration" in city records a few decades later). It kept Congress, Independence, Abundance, Painters, Arts and Music but deserted Poet, Virtue, Genius, Hunters, Circus and Love. New Orleans kept its Muses but lost such gods as Bacchus, Hercules and Apollo. It gave up Craps, Bagatelle, Swamp and Mysterious but retained Mystery, Peace and Duels. For a time, the Catholic city had Mahomet (French for "Muhammad") and Amen Streets coexisting next to each other, but both were eventually lost, as was Pope Street. New Orleans Street still remains, and some of the streets that cross it are representative of the city itself: Industry, Duels, Law, Agriculture, Treasure, Humanity, Benefit, Pleasure and, most poetically, Hope.

In New Orleans, tradition trumps grammar, ritual outweighs modernity and history prevails over efficiency. In the city that care forgot, built in the curve of

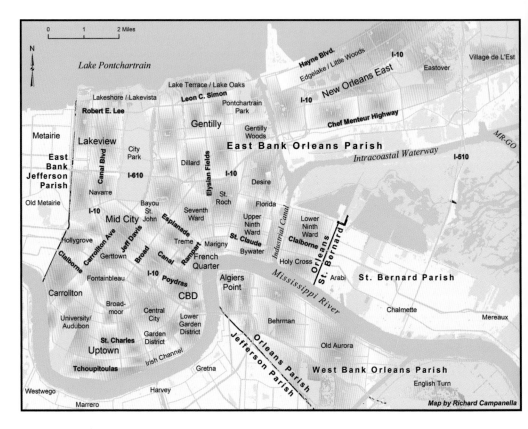

A present-day map of New Orleans by Richard Campanella that shows selected neighborhoods and streets.

the Mississippi River, it does not matter if the sun rises over the West Bank, a street is mispronounced or misspelled or one does not follow a logical pathway. All that matters is that it is distinctively New Orleans. And no place has its history written in its streets more than New Orleans.

CHAPTER 1
FROM FLAGS TO FLAG BOYS

The Explorers and the Founders

THEY WERE HERE FIRST

On April 9, 1682, René-Robert Cavelier, Sieur de La Salle, stuck the Lily Flag of Bourbon France into the ground and declared it Louisiana, after Louis XIV. For the next 120 years, the land was defended fiercely by its native inhabitants, used as a bargaining chip in foreign wars, threatened as punishment to Paris's undesirables, inspired mutiny and more, until it was sold in the real estate deal of the century and admitted to the Union. But before this territory was conquered and claimed for various kings thousands of miles away, other individuals lived in the subtropical climate, traveling under the feathered lattice of bald cypress branches, healing themselves with the lush foliage and sustaining themselves in the treacherous yet bountiful swamps. The ensuing battle over control of Louisiana would spill as much blood as the gluttonous mosquitoes extracted and create as much discord as the insects instilled disease.

When *La Nouvelle-Orléans* was founded in 1718, a cultural collision followed that decimated many customs and traditions, birthed others and ultimately led to a distinct heritage still evolving today. New Orleans has long honored those who were here first, arrived first, built first, governed first and died first under the banner of patriotism. From the time the land was divided by warring tribes until it left the gilded protection of the Crown to join the fold of the United States, Louisiana's rich foundational layers were laid down, one hero or villain, one accident or design, at a time.

CHEROKEE: The Cherokees were of Iroquoian lineage and controlled about forty thousand square miles of the Appalachian Mountains in parts of present-day Georgia, Tennessee and the Carolinas. Their name is possibly derived from a Choctaw word meaning "cave people," in reference to the numerous caves in their mountain country.[3] Clinton Street was renamed in 1894 to honor the tribe.[4]

CHICKASAW: The Chickasaws were closely related to the Choctaws, and even though they shared almost identical dialects, the Choctaws were noted for their agricultural pursuits, while the Chickasaws were noted for their warlike temperament. It could have been these differences that led the two tribes to constantly battle each other.[5] The Chickasaws' earliest known domain was in north Mississippi, but in 1864, New Orleans named a street after them.

CHIPPEWA: The Chippewas' (also called Objibwas) name means "to roast till puckered up," which referred to the puckered seam on their moccasins, not their occasional acts of cannibalism. The Chippewas were one of the largest tribes north of Mexico but were not well recorded in history due to their distance and isolation from the frontier during the colonial wars.[6] In 1852, New Orleans changed Pencanier and Soubie Streets to memorialize this tribe.

CHOCTAW: The Choctaws were probably the most well-known tribe in New Orleans. The origin of their name is unknown, but scholar Clare Leeper hypothesizes that it means either "flat," referring to their infants' flattened heads, or "separation," alluding to their split with the Chickasaws. The Choctaws battled frequently with other tribes, although their posture has been viewed as defensive. They moved into Louisiana shortly after New Orleans's founding. In 1925, Chartier Street was changed to honor the "terrors of early settlers in New Orleans" and, later, the "terror of political organizations," referring to the Choctaw Club, an elite social and political club formed in the late nineteenth century that, unlike its namesake tribe, operated on the offensive through violence, political favors and election fraud.[7]

COLAPISSA: The Colapissas (also known as the Acolapissas) were of the Choctaw lineage and lived along waterways in southern Louisiana. It's been suggested that their name means "those who look out for people," signifying spies or guardians.[8] When the town of Carrollton was developed, it named a street after the tribe. When New Orleans annexed part of Carrollton, it got part of Colapissa, too (and another remnant still exists as a sister street in Metairie).

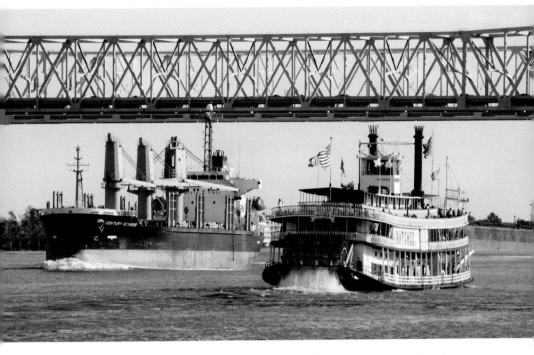

Modern and vintage live side by side in New Orleans, seen here as the steamboat *Natchez* and a cargo ship pass each other in the Big Muddy.

IROQUOIS: The Iroquois were a partly sedentary and partly nomadic tribe in New York State. They were called Irinakhoin, meaning "rattlesnake," by their Algonquin enemies, from whom the French learned the name and adapted it to "Iroquois." When New Orleans renamed several streets in Gentilly for Native American groups, the Iroquois were among the honorees.[9]

MOBILE: The Mauvilas were a Muskhogean tribe that located around present-day Mobile Bay when the French settled there in the early eighteenth century. Their name was modified and given to the new city and the bay. Although the name Mobile means "doubtful," it is certain that in 1894, New Orleans named a street after the tribe.[10]

NATCHEZ: The Natchez were predominantly sedentary and lived on the east side of the lower Mississippi (near the site of present-day Natchez, Mississippi). The tribe engaged in various wars with the French, one of which, in 1729, was ruinous to their tribe.[11]

SEMINOLE: The Seminoles were an indigenous Muskhogean tribe from Florida. The three Seminole Wars saw alliances of Seminoles, African Americans and other Native American groups fighting the United States Army in skirmishes from 1814 to 1858. In 1924, the city changed Jackson Place in Central City to SEMINOLE LANE.

TCHOUPITOULAS: The etymology of New Orleans's most unique street name, Tchoupitoulas (chop-ah-too-luhs), is shrouded in folklore and pieced together in analytical conjecture. Scholar Dr. William Read believed that it might be a fusion of various Choctaw words—*hatcha* (river), *pit* (at) and *itoula* (reside)—to mean "those who reside at the river."[12] Another theory is that Tchoupitoulas derives from the name of a local tribe that meant "mudfish people" or "fish hole road."[13] One legend is that an early Frenchman approached some Native Americans fishing on a small bayou and asked if there were any fish. They pointed to the bayou and responded, "Choupiques tous lá," which meant, "choupiques (mudfish) are all there." Hence, the Frenchman named the bayou and the Native American tribe Chapitoulas.[14]

The name, by various spellings, was attached to at least two different bayous in the colony's early days, as well as to land and roads. One of its earliest appearances was as a name for the Chauvin family's plantation just upriver from present-day Carrollton; the area was also called the Chapitoulas Coast.[15] In 1723, a "Bayou Chaptoulas" was mentioned in a document regarding two runaway Native American slaves charged with killing and eating cattle, and a Spanish map from 1798 depicts a "Bayu de Chapitulas" running through the backswamp and meeting "Bayu San Juan" (Bayou St. John).[16] This bayou and its parallel road eventually took the name Metairie (or "farm"). An 1849 map depicts a different "Bayou Tchoupitoulas", extending from Lake Pontchartrain down toward where Old Metairie is today.[17] And while some sources note that Metairie Road was once "Chemin des Chapitoulas," over time the road from New Orleans running alongside the Mississippi River came to be called the Tchoupitoulas Road.[18]

While the exact origins of the word *Tchoupitoulas* date back more than three hundred years, the spelling has continued to confound and confuse foreigners and locals alike to this day. On an 1845 map, it was spelled "Tchapitoulas."[19] An 1852 article from the *Daily Delta* reported that the original spelling was "Chapitulas," but "in the confusion of tongues, and the multiplicity of notaries public…it had added a 'T' to its head, so that it is now spelt in a way so peculiar, that the average man has to hesitate and think before he can write it."[20] New Orleans mayor Louis Philippe de Roffignac (1820–28) allegedly wanted to

change the name because no one could spell it. When someone asked him for a simpler suggestion, he replied, "P-E-R-L. Pearl." Uproarious laughter followed, and Tchoupitoulas remained.[21]

In 1921, the *Times-Picayune* reported that many local employers believed that youth entering the business world lacked basic skills in grammar, writing and arithmetic. The "house mother" at the department store Maison Blanche complained that incorrect deliveries, mistakes in stock and erroneous store charges were all due to young people's educational shortcomings. But they had to be lenient, she stated, for New Orleans had the most difficult list of street names of any city she knew. She also said that one of the requirements of a new hire was to do a daily spelling drill on Tchoupitoulas and other "twisters."[22]

A piece in the *New Yorker* in 1950 satirized the ease of pronouncing Wall Street and its association with capitalism. The article suggested that they should "borrow" Tchoupitoulas, envisioning that "[i]f the Kremlin's propaganda machine had to hang a lot of its stuff on Tchoupitoulas Street, mechanical costs would rise sharply, moreover the name would hardly be worth using, because so few people could say it."[23] In New Orleans, the pronunciation and spelling became a source of local pride and the shibboleth by which foreigners were detected.

The *Daily Delta* in 1852 touted the charms of Tchoupitoulas and its winsome difference from the typical names in northern cities:

> *New Orleans alone has a Tchoupitoulas. It is pretended that the name is difficult to spell, that it is not in any of the dictionaries or gazetteers, and that some people can't pronounce it. Then improve your spelling books and your pronouncing dictionaries. We like the name because it is hard to spell, and compels our nasal, whining people to crush their voices beneath their teeth as they crush a peanut, or smother it under a quid of tobacco, to open wide their mouths.*[24]

Tchoupitoulas was (and is) one of the longest streets in the city. Its five-and-a-half-mile path runs past the hotels, lofts and offices of the Central Business and Warehouse districts and then on through industrial areas; past stores, restaurants and bars; alongside the Port of New Orleans; and becomes increasingly residential before ending at Audubon Park. It is emblematic of New Orleans's defiant originality and its embrace of its foibles yet is still as mysterious as the great river it parallels.

TENSAS: The Tensas were a tribe from northeastern Louisiana who served with the Choctaws as mercenaries for the French during the Natchez wars.[25] Today, they are memorialized on the map with a short street near the Fair Grounds.

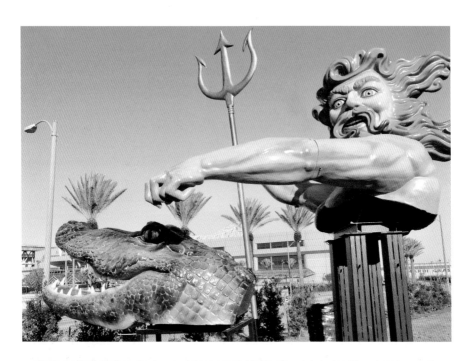

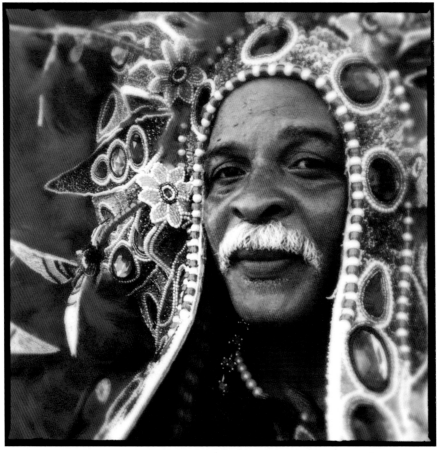

TUNICA: The Tunicas were from the Lower Mississippi Valley and lived on the Yazoo until 1706, when the entire tribe moved south, working as allies with the French against the Natchez. In 1941, two noncontinuous blocks in Gentilly were named after the tribe.

Beaten and banished from their own land, Louisiana Native American tribes tried to adjust from their old ways, living by the land and the season, to the new European civilization in their midst. In New Orleans in the early nineteenth century, the sentiment toward Native Americans appeared to be sympathetic. In 1837, the *Times-Picayune* called the Choctaws "poor homeless creatures" and "unfortunate" since they had been "egregiously denied" the purchase of their land.[26] This sentiment changed less than ten years later when it reported on a few dozen Choctaws who lived on Bayou Road and "wander about like ghosts of departed greatness" and, whenever citizens walked by, half-heartedly banged on drums and sang in a "guttural chorus, resembling a ventriloquist's imitation of a wood-sawyer at work." The paper noted that these performances were always under the pretense of raising funds for a wedding but pointed out that "celibacy is a state of existence unknown to the Choctaws" and that bigamy was recognized to the "fullest extent," with every "squaw" having played the bride multiple times.[27]

Less than ten years later, Choctaw members were frequently pitted against Louisiana Creoles in baseball games at the Fair Grounds for purses of $100.[28] But these games appeared to be more for spectacle than sport, as the Choctaws performed a war dance for the crowd in full costume beforehand. In the span of a few decades, attitudes about the Native Americans ran a course from empathetic to apathetic to patronizing. But another historically marginalized group soon claimed and reinvented aspects of Native American culture, converting it into their own distinctive aesthetic rich with folklore, tradition and pride—the Mardi Gras Indians.

The Mardi Gras Indians are secret tribes or "gangs" in the tradition of social clubs and mutual aid organizations. Their origin is believed to date back to the 1880s, when "Buffalo Bill" Cody's Wild West Show played in New Orleans, and Native Americans paraded through the streets in costume as promotion. At the time, African Americans were not allowed to participate in Mardi Gras. Inspired by the Native Americans' costumes and freedom of movement, black Indian gangs formed with names such as the Yellow Pocahontas, Creole Wild West and the

Opposite, top: Poseidon and an alligator welcome visitors at the entrance of Blaine Kern's Mardi Gras World on Tchoupitoulas Street.

Opposite, bottom: Big Chief David Montana of the Washitaw Nation Mardi Gras Indians is resplendent in his elaborate handmade headdress.

Wild Squat Toulas. In the beginning, the gangs had violent encounters with one another—members carried pistols, shotguns and decorated iron rods.[29] Over time, the fighting transformed into boasting battles, including over their elaborate, often hundred-pound, hand-sewn costumes that sometimes take a year to complete.

The streets, underpasses, grassy paths along the bayous and dusty trails at the Fair Grounds during Jazz Fest are the stages for the Mardi Gras Indians' theatrics. They refuse to be identified by any stereotypes, forging and melding their own form of expression through song, dance, costume and performance. While the Mardi Gras Indians present a spectacle for all to enjoy, their style is unambiguously their own.

THE FIRST FLAG: THE EXPLORERS

Explorers are known for "firsts." Some explorers seek to make history, while others seek only fortune or power, but regardless of their motivation, explorers' finds—deliberate or accidental, monumental or mundane—are often of more lasting significance than the glory they seek.

PONCE DE LEON: On April 2, 1513, on a quest for the mythical Fountain of Youth, Juan Ponce de León landed near St. Augustine, Florida, planted a flag and proclaimed ownership of the land for King Ferdinand of Spain. He returned to Florida in 1521 but was wounded during an attack by Indians and later died. In 1924, he was awarded a small piece of immortality in New Orleans when the city changed the street named after his greatest discovery (Florida) to the great discoverer.

PINEDA: Historians debate whether Alonso Álvarez de Pineda was the first European to see the mouth of the Mississippi River in 1519. Many believe that he was describing Mobile Bay and the Alabama River. Nevertheless, this Spanish explorer and cartographer born in 1494 is definitely credited with one first: his map is the first to show the coast of Texas. For a man who traveled great distances and was skilled in cartography, his street is hard to find on a map, being only one block long and tucked into a neighborhood in Gentilly.

CORTEZ: Hernán Cortéz (also spelled "Cortés") was a Spanish conquistador whose sixteenth-century expeditions caused the collapse of the Aztec empire and won large portions of Mexico for the Spanish Crown.[30] When he arrived in

Mexico in 1519, he was treated as a god fulfilling an Aztec prophecy. Apparently, life as a deity was more satisfying than being an explorer, for Cortéz broke his allegiance to Diego Velázquez, the Spanish governor of Cuba, and established his own government, even burning his fleet of ships to keep loyalists from reporting his coup.[31] When Velázquez learned of the deceit, he sent an army to capture Cortéz, who swayed his would-be captors into becoming defectors and arrested others. Cortéz's last years were not spent exploring or masquerading as an Aztec god but rather in quarrels with the Crown and other officials. In 1873, the city named a street after Cortéz.

DESOTO: Some historians believe that Pineda was the first to spot the Mississippi River in 1519, but others believe that credit goes to Hernando de Soto, a sixteenth-century Spanish explorer who is, regardless, considered the first to cross it, twenty-two years after Pineda did or did not see it. In 1539, De Soto headed north from Cuba, landing in present-day Tampa Bay. For years, he and his men cut across what is now the southeastern United States, covering more than four thousand miles, constantly battling Indian tribes and eventually crossing the Mighty Mississippi. But De Soto's luck didn't hold, and the following year, he died in present-day Louisiana from a fever. His comrades buried his body in the river—his greatest discovery becoming his grave. In 1894, New Orleans named a street in Faubourg St. John after him that parallels the old portage from the bayou to the big river.

LA SALLE: René-Robert Cavelier, Sieur de La Salle's earliest ambition was to join the priesthood. Born in 1643 in France, he was educated at a Jesuit college, but at the age of twenty-two, God's calling was drowned out by the call of the great unknown. Trading the priestly robes for animal pelts, he traveled to Canada in 1666 and established a successful fur-trading outpost.[32] King Louis XIV gave La Salle a royal patent to explore the "western parts of New France," trade skins and build forts under the condition that his company absorb all expenses.[33] This might have intimidated most men, but Canadian governor Louis de Buade, Count de Frontenac, described La Salle as a "man of intelligence and ability, more capable than anybody else I know here to accomplish every kind of enterprise and discovery."[34] Unfortunately, La Salle was also characterized as arrogant, unyielding and frequently abusive to his men. La Salle could make long journeys on foot during any season and survive on few provisions, but this lent to him being an unsympathetic leader who beat sick men in their beds, worked countless others to death and killed many for various infractions.[35]

Accompanying La Salle on his 1682 expedition down the Mississippi were Father Zenobius Membre, twenty armed Frenchmen, more than thirty Native

Americans and his chief lieutenant, Henri de Tonti (also spelled "Tonty"), an Italian-born solider and explorer whom La Salle regarded as an equal. Tonti served in the French navy and fought the Spanish during the Sicilian Wars, losing his right hand in a grenade explosion in 1668. He wore a prosthetic iron hook, thus acquiring the nickname "Iron Hand."

The expedition had many unscheduled (and sometimes disastrous) changes, but on April 9 of that year, La Salle and his group climbed from their canoes, found a dry piece of land and named it Louisiana after Louis XIV. That was the apex of La Salle's career, his remaining years a slow slide downward, starting with Louis XIV's declaring that his discovery of Louisiana was "quite useless."[36] This did not, however, prevent the king from naming La Salle governor of Louisiana and granting him powers to colonize the Mississippi.

La Salle's next expedition was marred by piracy, shipwrecks, illnesses, foul weather, Indian attacks, low supplies and gross miscalculations of geography. His group wandered through the forest for two years, his troop numbers rapidly depleting from desertion and death, all in an effort to find the mouth of the same river he had traversed only a few years earlier.

In March 1687, La Salle dispatched a small group to retrieve the meat of two slain bulls. His nephew Sieur de Moranger was one of them, and while La Salle's arrogance was backed by his abilities, Moranger's pomposity appeared to be founded only in his uncle's nepotism.[37] That night, the small group of men argued over the provisions; Moranger hoarded the majority. The campfire fight proved fatal. In the middle of the night, Étienne Liotot, a surgeon who had previously nursed La Salle back to health after an illness and Moranger after an Indian attack, used his healing hands to take an axe to Moranger's head and two others.

A few days later, La Salle and Father Anastase Douay went to their camp to see why they had not returned. Seeing vultures overhead, La Salle fired a shot into the air. One of the men approached La Salle, telling him Moranger was down by the river, when Pierre Duhaut stepped up and fired his gun into La Salle's head. Thus La Salle unwittingly achieved another first: the first Louisiana politician to be murdered. The men stripped their leader's body and dragged it into the bushes, leaving his body defenseless to the elements and to be enjoyed by wild beasts.[38] After hearing of La Salle's murder, Tonti searched for his body but never found it.

La Salle's colonial efforts may have fizzled, but he opened the door for French ambitions to be realized by other men, and New Orleans appreciated this. In 1882, the city formed the La Salle Bi-Centennial Committee to plan an elaborate commemoration, but the Mississippi River refused to cooperate. One editorial dolefully noted, "Perhaps La Salle would not have discovered the

Mississippi if he could have known that it would behave so badly in trying to break the levees and drown everybody out."[39] The celebration was canceled due to the river's overflow, and much like La Salle's expedition, grand hopes and glories were dashed by the temperamental and unpredictable nature of the river. In 1924, New Orleans named a street after La Salle.

Tonti's story did not end with La Salle; he would also prove to be a loyal companion to another man who was instrumental in the development of Louisiana: Iberville.

THE "VILLE" BROTHERS, THE FOUNDING OF NEW ORLEANS AND FRENCH RULE

IBERVILLE and BIENVILLE: Two Canadian brothers born in Montreal, New France, helped shape the fortunes of Louisiana and New Orleans: Pierre Le Moyne d'Iberville and his younger brother Jean-Baptiste Le Moyne, Sieur de Bienville.[40] Iberville gained success and fame at age thirty-six for his routine attacks against the Hudson Bay Company and his victories in King William's War. Louis de Phélypeaux, Comte de Pontchartrain, tasked Iberville to take up where La Salle's last voyage failed: find and establish a French presence near the mouth of the Mississippi and solidify Louisiana's claim. From 1699 to 1703, Iberville rediscovered the mouth of the Mississippi and established a temporary fort at present-day Ocean Springs, Mississippi; another below present-day New Orleans; and a third on the Mobile River. At Ocean Springs, he left Bienville second in command under the Sieur de Sauvole de la Villantray. Villantray died in 1701, the first known victim of yellow fever in the province, leaving Bienville at age twenty-one to take command.[41]

Iberville turned his attention away from Louisiana to focus on the English, defeating them on the islands of Nevis and St. Christopher, but died (it is believed to be of yellow fever) in Havana in 1706. Tonti served the brothers until his death in 1704 at Fort Saint Louis de la Mobile. In his life, Tonti assisted La Salle, who is credited with claiming Louisiana, and Iberville, who is deemed its founder.

After Iberville's death, Bienville continued building forts, charting waters, creating maps and mastering languages of various tribes. He cofounded Mobile in 1702 and founded New Orleans in 1718, declaring that "on the banks of the river is a place very favorable for the establishment of a post with one of the finest crescents on

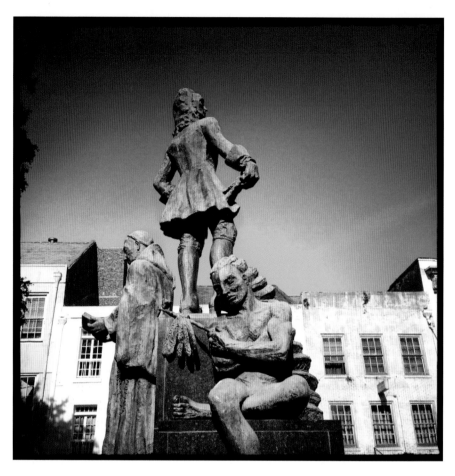

Jean Baptiste Le Moyne de Bienville, founder of New Orleans, looks out over the bustling French Quarter, where the city was born, with a priest and a Native American by his side.

the river."[42] Bienville watched over this crescent for more than forty years, battling Indians, nature, politicians and kings. He served as governor four separate times and achieved many firsts: he introduced the first cattle, hogs and chickens; grew and shipped the first cotton and tobacco; and operated the first lumber mills.[43]

Bienville was honored with one of New Orleans's original streets, laid out by Adrien de Pauger in 1721. BIENVILLE STREET runs from the river, through the French Quarter and ends in Mid-City. In 1873, New Orleans named TONTI STREET, running from Uptown down through the Lower Ninth Ward, after the loyal explorer. It wasn't until 1901 that the city created IBERVILLE STREET, honoring the "father of Louisiana." Previously it was called *Rue de la Douane* by the French, *Calle de la Duana* by the Spanish and Customhouse Street by the Americans.[44] One block over from Canal, it parallels his brother's street through the French Quarter and Mid-City.

In 1955, Bienville was also honored with a five-ton, twelve-foot bronze statue designed by local sculptor Angela Gregory. The statue features Bienville, Father Anastase Douay and a Native American and was originally placed in front of Union Passenger Terminal, but it was later moved to its present location between North Peters and Decatur. From Bienville's high vantage, he can keep an eye on the still-vibrant pulse of life on the banks of the crescent that he selected nearly three hundred years ago.

With Louisiana and New Orleans established, the colony and its new capital experienced a turbulent youth both creating and adjusting to their place in the landscape and the world. Louisiana was often a challenge for France, which gave it a succession of governors and proprietors, some of whom were later honored with streets in New Orleans.

PERRIER: Etienne de Périer was a French naval officer and former captain in the merchant fleet of the Company of the Indies who governed Louisiana from 1727 to 1733. He was noted for his charitable work, providing rations for orphan boys and money to the Ursuline nuns to care for and educate orphan girls. During his time as governor, the Natchez Massacre occurred, in which Natchez Indians attacked and killed more than two hundred colonists. This reinforced to the Company of the Indies that murder of colonists was generally not good for business. Bienville arrived to replace him, serving his fourth term. In 1890, the city named a street after Périer, which somehow picked up an extra *r* along the way.

CROZAT: Antoine Crozat, the Marquis de Chatel, was a wealthy merchant to whom King Louis XIV gave a fifteen-year charter for Louisiana in 1712, thus making him the first proprietor of the colony.[45] Louisiana had already cost the Crown a fortune, and while Louis XIV was not interested in investing in its improvement, he did not wish to lose it either. After five years, Crozat had invested 1.25 million livres, with a return of only 300,000. He petitioned the new king, Louis XV (the young successor to his grandfather), to be released from his contract, and his request was granted.[46] Today, the man who briefly owned Louisiana has a street in Tremé.

Although more French governors and officials would be honored with street names, an incident marked by violence and touted as patriotism would also come to evoke numerous street names.

THE REBELLION OF 1768

The Rebellion of 1768 arose over the transfer of Louisiana from French to Spanish possession. Some historians see the revolt as predating the American Revolution as the first stand in the Americas against European colonial rule, while others view it as a group of elite French Creoles determined to hang on to their way of life. The difference between the right of self-governance and the privilege of self-interest is often murky. What is clear is that the names of key characters in the revolt still stand on thoroughfares and historical markers in New Orleans. History has described some of these men as patriots, traitors, hypocrites, soldiers, killers, sycophants and martyrs, but heros or villains, New Orleans honors them.

In the eighteenth century, bad news traveled slowly. In November 1762, King Louis XV ceded Louisiana to King Charles III of Spain in the Treaty of Fontainebleau. Louisiana stretched from New Orleans to what is now southern Canada and from the Appalachians to the Rockies. The treaty was kept a secret, even during the signing of the Treaty of Paris in 1763, which ended the Seven Years' War. Louisiana was divided at the Mississippi River, with Britain receiving the eastern portion and France retaining the western section and New Orleans. Spain did not challenge Britain's rule because it knew it secretly ruled western Louisiana.

At the time of the Treaty of Fontainebleau, Louis Billouart, Chevalier de Kerlérec, was the governor of Louisiana. Kerlérec was a French army officer who had been appointed governor in 1752 but did not actually arrive in New Orleans until a year later. Louisiana was a disappointment to France both culturally and financially. New Orleans already had a reputation of possessing primitive principles and advanced degeneracy. Its trade was predominantly contraband, and it rarely produced enough raw materials to trade successfully. This was not wholly the fault of New Orleans or Kerlérec's governing style; his requests for additional troops, money and supplies were ignored by France. For two years he received no communication from France and, for four years, no supplies, yet he was still required to maintain order and turn a profit.[47] Additionally, common criminals were typically shipped back to France, but Kerlérec found it difficult to punish the elite Creole offenders who committed their infractions with panache and intrepidness. This inspired his famous comment, "If I sent back all the bad characters, what would be left of this colony's inhabitants?"[48] At the end of his governorship, Kerlérec had no idea that he, or the citizens, were under a different rule, and neither did the subsequent governor.

Jean-Jacques Blaise D'Abbadie, a French naval officer, was commissioned as the new governor of Louisiana in February 1763, but he did not arrive in New

Orleans until June of that year. In April 1764, the Treaty of Fontainebleau was made public in Paris. D'Abbadie issued a proclamation announcing that when the Spanish officials arrived, French rule would end. New Orleanians did not take the news well, especially the elite. They considered themselves equals to the Frenchmen who resided along the avenues of Paris.[49]

Nicholas Chauvin de Lafrénière, the attorney general of Louisiana and the power behind the Superior Council, was especially enraged that he had to pledge loyalty to a Spanish king. The council was created in 1712 by a French charter that gave it executive and judicial powers, and later it became the tribunal of last resort for all civil and criminal cases. Lafrénière was perhaps New Orleans's most distinguished citizen—in appearance and lineage. Tall and handsome, his confidence was perhaps rooted in the fact that he was from one of the first families of New Orleans. Lafrénière's father, whose name he shared, was one of the Chauvin brothers, who arrived on the Gulf Coast with Iberville and traveled with Bienville to found New Orleans.[50] Lafrénière, along with other members of the Creole elite—the commissary-general Nicolas Denis Foucault, Joseph Milhet (the wealthiest man in Louisiana), Jean-Baptiste Noyan (the son-in-law of Lafrénière), Joseph Villeré, Pierre Caresse and Pierre Marquis—incited the citizens to revolt. Lafrénière was a charismatic orator. Favored with a silver tongue and golden pen, he urged the colonists to petition Louis XV not to relinquish Louisiana, a petition that was ultimately ignored.

The strain of transferring a colony was apparently too much for D'Abbadie, who became bedridden shortly after the proclamation and died in February 1765. The highest-ranking military officer, Charles Philippe Aubry, was made governor-interim, making him the third French governor to serve under Spanish rule (knowingly or not) in just over two years. Aubry was a decorated solider who had won the Cross of St. Louis, but his response to this challenge has divided historians for centuries. Some view Aubry as a weak sycophant who was too eager to please foreigners and too apathetic to his French heritage. Others view him as a noble solider who followed orders and whose pragmatic bravery helped prevent widespread death. Aubry was in a complex situation and wrote to France about the "thorny proposition" of trying to keep the English, French and "savages" content and maintaining a degree of tranquility.[51] Three years and four months after the ink was dry on the Treaty of Fontainebleau, Spanish rule came to New Orleans, and Aubry was ready to assist.

The new Spanish governor, Antonio de Ulloa, arrived in Louisiana in March 1766 with only three civil officers and ninety Spanish troops. Ulloa was a brilliant explorer, cartographer, writer and astronomer; however, this did not mean that he was necessarily qualified to govern a colony. Ulloa seemed more

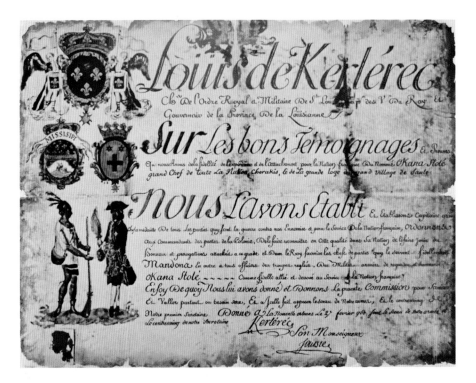

Louis Billouart, Chevalier de Kerlérec, was governor during the French and Indian War. This document is a military commission he granted to Cherokee chief Okana Stoté in 1761. *Photo by author, from the Latin American Collection at Tulane University.*

content to catalogue data than issue orders. Aubry described Ulloa as someone who was "too punctilious" and who raised "difficulties about trifles."[52] In the Creoles' minds, Ulloa had personal strikes against him—the first being that he was a Spaniard, and the second being that he was private, preferring books to balls. But ultimately, the most damaging issue for Ulloa was professional—he was understaffed and underfunded. New Orleans at the time had about 3,500 citizens, and Ulloa estimated that he needed 700 men and some artillery to properly secure the colony, all of which he was denied by the Spanish Crown.[53]

One of the Creoles' major grievances (which would later be used as an argument for the rebellion) was Ulloa's lack of ceremony in claiming Louisiana for Spain; the fleur de lis flag still flew in Place d'Armes. Ulloa used Aubry as a mouthpiece, stating that he would not take official possession of the colony until more troops arrived.[54] But perhaps the greatest grievance against Ulloa was over something the citizens believed was vital to their way of life: wine. And not just any wine, but Bordeaux wine.

A royal ordinance in March 1768 decreed that the territory could trade with nine ports on the Spanish peninsula, but only in Spanish ships.[55] Despite reassurances from Ulloa that, as Spanish subjects, this would not affect Louisianans' trade, a freeze on their shipping with France was confirmed in the rebels' minds when another commercial decree was issued in October that sanctioned nine Spanish ports for Louisiana shipping. According to Ulloa, New Orleanians took this as a horrifying signal that they would have to "say goodbye forever to the wine of Bordeaux, and accustom themselves to drink in its place the poisonous wine from Catalonia."[56] This fear was used as a touchstone for the rebellion, something the elite and commoners could rally behind. In a report Ulloa wrote to the Marqués de Grimaldi, he tried to describe the "ridiculous" nature of this uprising over wine:

> *The common folk of the city were very much impressed by what they* [the rebels] *told them about being deprived of the wine of Bordeaux by the fact that in its place they would have to subject themselves to drinking the wretched wine of Catalonia. In order to understand how this would bother them, one should remember that those people are so given to drinking that they drink to great excess, spending on this the major part of what they possess.*[57]

Enraged, paranoid and entitled, on October 28, 1768, under Lafrénière's leadership, the rebels seized the French forts in the name of the Republic of Louisiana. Shops closed, and houses barred their doors and shutters as the armed and inebriated rebels roamed the streets. Aubry secretly escorted Ulloa and his wife to the frigate *Volante* and left them with twenty bodyguards.

The next day, one thousand armed men gathered in the Place d'Armes; Lafrénière dazzled the crowd, condemning Ulloa as "the usurper of illegal authority" and banishing him.[58] The rebels wanted Aubry to take over the government with Nicolas Denis Foucault, but Aubry refused, reminding them that "the chiefs of a conspiracy have always met with a tragical end."[59]

On November 1, 1768, Ulloa fled Louisiana for Havana, but on the French ship *Cesar* since the *Volante* needed repair. He reported that Louisiana was put in a state "of insurrection at the voice of a single man"—Lafrénière.

After Ulloa's humiliating departure, the Superior Council adopted a formal declaration of independence and declared it the Republic of Louisiana, naming Lafrénière as its "protector." The rebellion, which was loud with accusations of despotism inflamed by drink and prerogative, now took on a humbled hush. Objections were replaced with questions: How and when would the Spanish react? Would France intercede? Unable to answer these questions, some looked to the Mississippi, if not for answers then for blame. The *Volante* remained at

New Orleans as "an offensive symbol for the insurgents of Spain's continued presence."[60] The rebels frequently tried to get rid of the ship, especially Lafrénière, who could not stand the sight of it anchored ominously in the river, a reminder of the "barbaric nation it symbolized," but Aubry swore to protect it to his last breath.[61] Six months after Ulloa was forced out, the *Volante* left New Orleans. The insurgents breathed a sigh of relief, unaware of the irony of the repaired Spanish vessel sailing out of the fractured city.

The roars of freedom faded to the stillness of reality. The colony found calamity in its liberty. Plans for a bank, voluntary taxes and trade (contraband or otherwise) came to naught. The council was broke, and the city existed in a panicked state of poverty. But those who thought that this uncertainty was the greatest punishment were not aware of what—and, more importantly, whom—Charles III commanded to extinguish the revolt and institute order in the colony: one of his favorite generals, Alexander O'Reilly.

O'Reilly was born in 1722 in Ireland and left his homeland, dominated by the Protestant English, at age ten. He joined the "Wild Geese," a group of mercenaries for Catholic rulers.[62] Known as Alejandro, O'Reilly swore allegiance to Spain and fought battles for his adopted country. While Ulloa seemed reluctant to formally rule, O'Reilly was not afflicted with the same reticence. O'Reilly sailed from Spain to Havana, gathered essential troops and supplies and traveled to New Orleans on July 4 with a fleet of twenty-three ships, the *Volante* as his flagship.

Before the general's arrival, per their request, Aubry arranged a meeting between Lafrénière, Pierre Marquis, Joseph Milhet and O'Reilly on the *Volante* at La Balize, the settlement at the mouth of the river. Stepping back aboard the "cursed" (and fully armed) vessel that the rebels had once expelled must have been humbling, but not enough for them to claim any responsibility. They blamed everything on the "severity" and "subversion" of Ulloa. O'Reilly's noncommittal response that he would regret harming anyone and would not judge before a proper investigation allegedly put the men at ease. Then the Irish-Spanish general, in an action befitting the Creole manner, invited the rebels to wine and dine with him.[63]

The Creoles could not accuse O'Reilly of lacking flair. His formal arrival on August 18, 1769, came with pomp, precision and intimidation. Many colonists were silenced in terror by the mere mention of O'Reilly's name, yet numerous citizens still wore white cockades on their hats as a symbol of the resistance. But what were ribbons to weapons?[64] A cannon fired as O'Reilly and his troops disembarked. The Spanish troops occupied three sides of the Place d'Armes, while the French militiamen closed the square. Aubry laid the keys to the city at O'Reilly's feet. Spanish flags were raised. Vessels fired more artillery. Troops shouted, "Long live the king!"[65] The French flag, which had flown undisturbed

for about three years and five months during and after Ulloa's reign, was removed within minutes of O'Reilly's stepping onto New Orleans's soil. There was no doubt to whom the colonists were expected to pledge their allegiance.

O'Reilly kept his promise and quickly investigated the rebellion, arresting twelve of the rebels three days later. A proclamation was posted around the city announcing pardons for the colonists who were "led astray by the intrigues of ambitious… people," and days later, everyone (including the clergy) was granted amnesty in return for pledging fidelity to the merciful King Charles III.[66]

On trial, the rebels argued that since the French flag had flown continuously in the plaza, the Spanish had not officially possessed the colony and thus they had been under French rule. This argument was ineffective. Five of the primary leaders—Lafrénière, Noyan, Caresse, Marquis and Milhet—were found guilty and sentenced to death by hanging. Villeré, who had died mysteriously in a scuffle aboard a Spanish ship, was posthumously sentenced to death. Other rebels were given various prison sentences from six years to life, but their sentences were soon commuted.

When execution day came, the hangman could not be found or would not comply. Another account holds that Lafrénière's wife pleaded to the "cannibal" O'Reilly that this ignoble execution style would bring shame on the family lineage. It is said that her pleas changed the execution method to one more befitting of gentlemen: death by firing squad.[67]

On October 26, 1769, almost one year to the day after Ulloa had been banished, Lafrénière, Noyan, Caresse, Marquis and Milhet were led into the barracks of the Lisbon regiment. Dressed handsomely in their uniforms, the men eschewed benches and stood. Lafrénière himself gave the order to fire. His last words as he fell to the ground and clutched his heart were "Je suis Français!"[68] The revolt was over. Spanish rule prevailed in Louisiana, where it would continue for almost forty years.

While historians do not agree on the motivations or moral character of the men involved in the rebellion, the majority agree that it was the first act of colonists making themselves independent of European rule.[69] Early historians paint Lafrénière and the other rebels as romanticized patriot-martyrs and Aubry, Ulloa and especially O'Reilly as either spineless autocrats or vicious barbarians. For years, O'Reilly was nicknamed "Bloody O'Reilly," despite the fact that he stopped an uprising with very little bloodshed and no damage to the city.

Today, historians have a more complex understanding of the Spanish governors and see the rebels as less patriotic and more opportunistic. In a letter Ulloa wrote to the Spanish Ministry, he stated that "Lafrénière spends more than he earns, the revolution for him was a pretext not to pay his debts."[70] Historian Charles Dufour agreed, writing that Lafrénière and the others were opposed to easily resigning the

freedom and economic advantages they had under the French regime.[71] It is likely that the unusual freedom the colonists experienced was just as intoxicating as the wine that they initially rallied around. Eventually, the rebels and their adversaries were brought together again, memorialized in the city's landscape.

Former governor Kerlérec was imprisoned in France when he returned in 1763 for violating the king's orders. He was exiled from Paris but was exonerated of all charges days before he died in 1770. Oddly, the streets named Peace and History in the Seventh Ward were renamed in 1852 to KERLEREC even though his brief history in New Orleans saw little peace.

Jean-Jacques Blaise D'Abbadie had D'ABADIE named after him in the Seventh Ward in 1853, with the city dropping one of the b's almost as quickly as his governorship passed.

Charles Philippe Aubry left for his native France on the ship *Pere de Famille*. In February 1770, the ship ran aground during a storm and broke in two, and Aubry was whisked into the sea, dying within sight of the French coast. Some New Orleanians called it justice. Yet despite his reputation for disloyalty to the French cause, in 1920 the city named AUBRY STREET after him, one block over from D'ABADIE, whose namesake's death left him in a position of simultaneous leadership and submission.

After fleeing Louisiana, Antonio de Ulloa commanded a Spanish squadron against English raiders during the American War of Independence. Afterward, he retired to southern Spain and died in 1795.[72] Even though the citizens of New Orleans drove him out of the city, ULLOA STREET in Mid-City was named in his honor in the 1850s. But he also has something else, a namesake more far reaching than any city street: "Ulloa's Halo," otherwise known as a "fog bow," similar to a rainbow but appearing in fog, which he helped explain.

There is no record of where Lafrénière and the other rebels are buried. It is rumored that their bodies were transported and buried in unmarked holy Catholic ground.[73] Out of all of the rebels, New Orleans honors Lafrénière the most. In 1911, LAFRENIERE STREET in Gentilly was named after him, and in 1956, the Spirit of '76 Chapter, Daughters of the American Revolution, dedicated a marker to the French "patriots and martyrs" on the façade of the Cabildo. In 1982, Jefferson Parish named a 155-acre park after him.

Alexander O'Reilly accomplished a great deal for his short time in Louisiana. He abolished the Superior Council and established the Cabildo, worked to improve relations with the Native American tribes and raised medical standards.[74] O'REILLY STREET in the Seventh Ward is named after him and located adjacent to his fellow governors D'Abadie and Aubry, as well as ONZAGA, named (and misspelled) after Don Luis de Unzaga y Amezaga, who traveled with O'Reilly

and served as governor from his departure until 1777. This "governor's strip" of streets has the governors lined up next to one another from northeast to southwest as follows: O'Reilly, Aubry, D'Abadie and Onzaga. Among those governors who (knowingly) ruled during the early Spanish period of Louisiana, only Ulloa Street stands apart, in a different neighborhood, banished once again.

In the end, most New Orleanians would say that the rebels had the best street named after them. Almost forty years after their execution, Bernard de Marigny subdivided his plantation, creating Faubourg Marigny, and commemorated the rebels just downriver from where they were executed with FRENCHMEN STREET. Today, the lower three blocks of Frenchmen are a vibrant stretch filled with bars, restaurants, coffee shops, tattoo parlors and live music. Many locals snub Bourbon Street as a garish tourist confection but feel that Frenchmen embodies the true spirit of music, culture and celebration in New Orleans. They revel in it just as the men of the Rebellion of 1768 cherished their own traditions and celebrations. Except today, they open their arms to all kinds of libations, not just to Bordeaux.

FROM PESOS TO FRANCS TO DOLLARS

As each new Spanish governor took office, he issued a *Bando de Buen Gobierno* (Proclamation of Good Government), just like provincial governors in Spain. It established the governor's principles and policies and typically included new laws due to population increase, the territory's development or modifications in Spain's colonial policy.[75] A total of eleven men served as governor during Spain's rule of Louisiana, and each of them brought his own rule and governing style that influenced the city. And while these men ranged from esteemed to tolerated to despised, all but one are honored with a thoroughfare (presented here chronologically).

GALVEZ: Bernardo de Gálvez succeeded Unzaga as governor and proved to be one of the most capable military governors in his tenure from 1777 to 1785. Gálvez successfully defeated the British in 1781, persuaded King Charles III to reduce duties on Louisiana exports to Spain and eliminate duties on Spanish imports to New Orleans and extended the boundaries of Louisiana. To further enhance his appeal, Gálvez married a local French Creole girl, Felicité St. Maxent. The Crown decorated him with the cross of Knight Pensioner and bestowed on Gálvez a special coat of arms showing a brig with the motto "Yo Solo" ("I Alone"). Historian John Walton Coughey argued that O'Reilly won

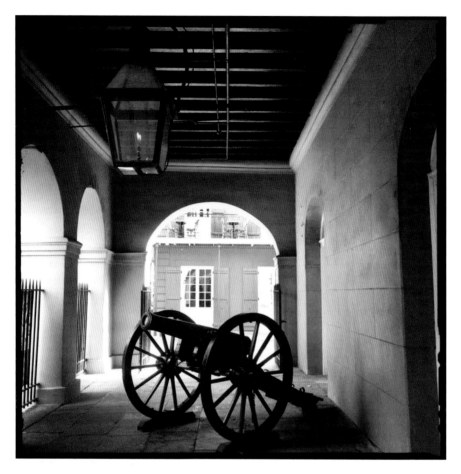

The Cabildo was built in 1795–99 during Spanish rule. Located next to St. Louis Cathedral, a "Napoleon" cannon sits near the archway leading to St. Peter Street.

over Louisianans by enforcing Spanish rule, while Gálvez "acquired domain over the hearts of Louisianans." In 1785, he succeeded his recently deceased father as the viceroy of New Spain but died the following year of a fever.[76] Eighty-eight years later, New Orleans gave Gálvez a street, which runs through the heart of the city from Uptown all the way to the Lower Ninth Ward.

MIRO: Esteban Rodriguez Miró was governor from 1782 to 1791. In 1782, when Gálvez was called to Haiti to plan a campaign against Jamaica, he appointed Miró acting governor. In 1785, Miró was named proprietary governor. Some argue that his main agenda was to reform the notoriously immoral citizens. Miró's proclamations

read more like moral condemnations, covering everything from dancing to dress: labor was prohibited on Sundays and on religious festival days, slaves were forbidden to dance before the end of Sunday services and gambling and dueling were prohibited. Women faced the greatest restrictions, as they were commanded not to call attention to their dress, and women of color were not allowed to wear plumes or jewelry and were required to cover their hair with *tignons* (handkerchiefs or turbans).[77] Miró didn't just police virtue, though. He also allowed the education and marriage of slaves and founded a leper hospital called "La Terre des Lepreaux" or Lepers' Land.[78]

Miró served the longest term of any Spanish governor, despite his many petitions to the Crown for more money (explaining that he had already used most of his wife's dowry to preserve his lavish lifestyle) and his desire to be replaced (for health reasons). Writer Gwen Bristow stated that the storming of the Bastille in 1789 caused much anxiety for Miró because "he knew that if people sang the 'marsellaise' long enough they became enthusiastic enough about liberty and equality to blow the brains out of their rulers, just by way of letting off steam." Miró, Bristow reported, was uneasy until the day Baron de Carondelet arrived.[79] In 1873, Miró got a street running from Uptown to the lower parish line.

CARONDELET: Francisco Luis Héctor, Baron de Carondelet, was the governor of the Spanish colonies of Louisiana and West Florida from 1791 to 1797, during the height of the French Revolution. Carondelet issued a proclamation forbidding the reading of any "public writings, printed matters or papers relating to the political affairs of France." Meetings or gatherings to discuss the revolution were prohibited, and those who violated these laws were to be imprisoned in Havana or fined 200 pesos. He invited citizens who found these laws too "rigorous" to leave the colony, but he had a militia of volunteers ready to maintain the peace. This did not stop the citizens (only a few decades removed from French rule) from marching through the streets singing French revolutionary songs or from mobs calling him a *cochon de lait* (suckling pig) and promising him a place on the guillotine.[80]

Carondelet's term was blighted by controversy and scrutinized for its striking highs and lows. Heralded for his diplomacy with the Native Americans and his success in preventing republican agitation, he is also seen by many historians as an aristocratic opportunist who wavered on his egalitarian stances when pressured by the elite.

Carondelet is best known for what he dug. He ordered a waterway, known as the Carondelet Canal, dug in the 1790s to bring shipping from Lake Pontchartrain directly to New Orleans's back door, circumventing the old portage along Bayou Road. The canal was dug from the head of Bayou St. John, through the cypress

swamp, to a terminus in the Tremé plantation, just across Rampart from today's French Quarter. By the early 1800s, the canal had "dwindled to a stagnant ditch, of little use for either drainage or navigation."[81] It was dredged and widened, but in the 1830s, a new canal, known as the New Canal Basin, was dug from the lake to the American Sector, in an effort to gain a commercial advantage over the old Creole side of the city. The Carondelet Canal became known as the Old Basin Canal. Its importance diminished, but it remained the main route for oystermen to bring their precious quarry to the city. Eventually, the canal became overrun with waterlilies, mosquitoes and rats. In 1925, it was filled in, and railroad track and a road, Lafitte Street, were laid in its path.[82] Today, the tracks are abandoned, and there are plans to make the area, now called the Lafitte Corridor, into a park with a bike trail.

In 1852, New Orleans memorialized the former governor with a thoroughfare by replacing the god of music—Apollo Street. A few decades later, Carondelet's street name was threatened with displacement. In 1922, businessman Max Singer campaigned to change Carondelet to Wall Street, arguing that the change would increase property values and give the street an "effective advertisement at home and abroad," evoking the namesake street in New York City. Singer believed that it would create the impression that the street was the "money center of New Orleans" and "build it up in conformity with its manifest destiny."[83] Citizens bristled at the idea, and the *New Orleans Item* ran a poll, with readers voting two to one in favor of keeping Carondelet.[84] The *New Orleans Item* noted that Carondelet was a "fine, mouth-filling word—sonorous in itself, mellowed by ancient local associations." In the end, Carondelet remained.

GAYOSO: Manuel Gayoso de Lemos only served as Louisiana governor from 1797 to 1799 but made good use of his time. Educated in England, Gayoso was seen as fairly progressive: he allowed Indians to trade with licensed traders, started the first garbage collection, organized volunteer firefighters and allowed for liberty of conscience (but formal worship was to remain Catholic).[85] He died in 1799 from a fever and was buried at St. Louis Cathedral.[86] In 1873, the city named a street after him, and in 1968, a white marble plaque was erected on the Chartres Street wall of the cathedral, with the following inscription: "In memory of Don Manuel Gayoso de Lemos. Spanish Governor of the Province of Louisiana, 1789 to 1799. Born Oporto, Portugal, May 30, 1747. Died in New Orleans, La., July 18, 1799. Buried in this Cathedral."[87] The wording of the plaque was chosen by a descendant of Gayoso, Mrs. C. Grenes Cole, who apparently wished to retroactively lengthen his governorship.

From Gayoso's death until December 20, 1803, Sebastián Calvo de la Puerta y O'Farrill, Marqués de Casa Calvo; Francisco Bouligny; Pierre Clément de Laussat;

and Manual Juan de Salcedo all served as governor, but only Salcedo was official, as the others served on an interim basis.[88] During Casa Calvo's term, the Treaty of San Ildefonso in October 1800 returned Louisiana to France. Like before, the treaty was not made public. Salcedo came into office in July 1801 showing little interest in Louisiana: he often relied on his son, Manuel María de Salcedo, as his mouthpiece; boycotted meeting with the Cabildo; and refused to permit a vaccine for the smallpox epidemic of 1802.[89] When the treaty was made public, the captain general of Cuba sent Casa Calvo back to oversee the transfer since he found Salcedo incompetent.

France did not take possession of Louisiana until late 1803, and Pierre Clément de Laussat, a French politician, was sent to receive the colony. Laussat had been named to the post in August 1802 and arrived in New Orleans in March 1803, only to discover a short while later that it had been sold to the United States. Thus, Laussat's time as governor was the shortest in Louisiana history, lasting only twenty days, from taking possession from Spain on November 30 until the transfer to the United States on December 20, 1803. Despite his brief reign, Laussat made one big change: he abolished the Cabildo, considering it insignificant and "generally composed of heterogeneous elements…of beings mostly disgraced and bespattered with mud."[90]

Although France's "repossession" was shorter than an average Carnival season, New Orleanians still celebrated. A grand dinner was held, with toasts made to the French Republic and Napoleon, Spain and King Charles IV and the United States and Thomas Jefferson. Each toast had a treble salute of twenty-one guns. Afterward, a ball was held with nearly one hundred ladies adding to its beauty and brilliance.[91] At the transfer, Laussat returned to the Cabildo, delivered the keys and handed the city over to the United States. New Orleans's era of European rule was over.

The first French dominion of Louisiana lasted about eighty years, the Spanish era lasted roughly half that and the second French period lasted under three weeks. Yet despite the lengthy French influence, New Orleans has named streets for almost all of the Spanish governors but only about half of its French officials. Out of all the Spanish governors, Boulingy was the only one not honored with a street in New Orleans. In 1852, the city created SALCEDO STREET, running from Broadmoor to Mid-City. Years earlier, Bernard de Marigny had named a street Casa Calvo (see Marigny), but in 1911, it was renamed as an extension of Royal Street. On the same day, Nelson Street in Algiers was renamed CASA CALVO. The city named a street after Laussat in 1894, but his time on the street sign mirrored his governorship, brief and sandwiched between two longer-tenured names: what for years was Port Street, running along Bayou St. John, became Laussat for thirty years before being changed to Moss Street, which it has remained ever since. Today, there is a LAUSSAT PLACE in the Florida-Desire area of New Orleans.

Of course, government officials are often obvious choices for street names, regardless of their performance or politics, but the following men—a politician, priest and businessman—are all linked together by a haphazard event that shaped New Orleans's landscape.

NOT SO GOOD FRIDAY FIRE

Don Vincente Victor José Nunez was the colony's military treasurer during Miró's tenure and was responsible for the Good Friday Fire in 1788. Devoutly religious, he erected an altar in his Chartres Street office. After lighting fifty to sixty candles to observe Christ's crucifixion, he went to lunch.[92] One of the candles lit a nearby lace curtain on fire, and aided by a strong south wind, the fire quickly spread to other buildings, which were built with beautiful but highly flammable cypress wood. Church bells were supposed to ring during a fire, but the priests refused out of religious observance. The church burned to the ground. The conflagration overtook the city, and by nightfall, 856 buildings, housing four-fifths of the population (including the military barracks, arsenal, jail, stores and government warehouses), were in ashes. Ironically, one of the priests most criticized for failing to ring the bells, Père Antoine, was also one of the most praised as he organized a bucket brigade that saved Ursuline Convent and the Royal Hospital. In the aftermath, Governor Miró distributed tents and rice rations to the citizens, froze the price of provisions and dispatched ships to Philadelphia and other ports for supplies.[93]

Don Andrés Almonaster y Rojas, a wealthy businessman, donated money for St. Louis Church to be rebuilt as a cathedral, which was completed in December 1794.[94] For his efforts, Almonaster was awarded a special seat of honor in the cathedral and a long-desired decoration as a Knight of the Royal and Distinguished Order of Charles III. When he died four years later, his remains were placed under the church's floor. A marble slab that is still discernible today was laid to honor his generosity. His daughter, Micaela Almonaster, later married Célestin Delfau de Pontalba in the cathedral, the ceremony conducted by Père Antoine.[95] Micaela would later inherit the title Baroness de Pontalba and build what are now known as the Pontalba Buildings, the red brick townhouses located on either side of Jackson Square (see Pontalba, Chapter 2). In case the buildings are not reminder enough, the railings of their balconies bear the initials "A" and "P" to recognize the Almonaster and Pontalba families.[96]

Café du Monde, a New Orleans classic established in 1862, serves coffee and beignets every day of the year except for Christmas and the occasional hurricane day. Right across Decatur Street is the Lower Pontalba Building.

Although the men were linked by the Good Friday Fire in the Vieux Carré, their streets are spread out across the city. ALMONASTER AVENUE and BOULEVARD are named after the businessman-philanthropist. The avenue is in the Florida area and continues across the Almonaster Avenue Bridge to the boulevard, its continuation in New Orleans East. In 1924, the alley on the downriver side of the cathedral was named PERE ANTOINE ALLEY. And in 1894, the city named NUNEZ STREET after the man who started the fire, but wisely, this street is located in Algiers, safely across the river from the French Quarter.

From the claiming of Louisiana in 1682 to its purchase by the United States in 1803, its people—natives and newcomers, colonists and Creoles, royals and scoundrels—created the essence of what many have called a cultural gumbo. Like a gumbo's holy trinity of celery, bell peppers and onions, New Orleans's mix of Native American, European and African American cultures combined to create a rich, zesty city and set the tone for the dynamic history to come.

HEADS OF CROWNS TO CROWNS OF THORNS

Bastards, Saints and Sovereigns

New Orleans loves all of its children equally. The good ones, the bad ones and the ones who exist in that divine, complex place in between. Whether their actions leave them destined for sainthood or purgatory, if they bequeath to the city a flash of infamy or a dose of charity, if history renders them as poor and pious or wealthy and iniquitous, New Orleans envelops them in its fold. It claims the deviants, the orphans and even the bastards as long they demonstrate either the proper pedigree or an "improper" amount of flair. In New Orleans, the martyrs and the marauders coincide peacefully next to one another in the streets, creating a symbiotic relationship between the saint and the sinner.

ALEXANDER: Charles Zimpel, the nineteenth city surveyor, was a grand Napoleonist. Zimpel named multiple streets after the French leader, sites of his victories and even some of his field marshals. Perhaps New Orleans could be viewed as the ultimate Napoleon complex—a small, provincial city struggling to overcome both its natural and man-made challenges and inadequacies. Maybe its libertine reputation was not due to a moral deficit but simply overcompensation. Regardless, possibly wanting to depict New Orleans as a mighty and moral city, Zimpel also named several streets after kings: ALEXANDER, after Alexander the Great, the King of Macedon; DAVID, after the Old Testament king David; and SOLOMON, after the Old Testament king Solomon. Whatever Zimpel's intentions, he gave New Orleans many kingly streets, as John Chase has noted.

ANNUNCIATION: Jacques Livaudais was married to Celeste de Marigny (sister of Bernard de Marigny) and owned two large plantations upriver from Faubourg St. Mary. In the early 1800s, he divided the lower of the two into Faubourg de L'Annunciation. Barthelemey Lafon laid out the street grid, in conjunction with those of three neighboring plantations and included a *Place de Annunciation* (Annunciation Square) and *Rue de L'Annunciation*. He also named *Rue Jacques* and *Rue Celeste* after Livaudais and his wife, which later became SAINT JAMES and CELESTE, respectively.[97] Livaudais' upper plantation later was subdivided, and LIVAUDAIS STREET was named after him.

BARONNE: *Baronne* is French for baroness, and the street is named after María de la Concepción Castaños y Aragorri, the wife of Spanish governor François-Luis Hector, Baron de Carondelet. Her street was named in 1852, and like her husband, she replaced a street named after a favorite god—Bacchus, the god of wine. (The Uptown portion of the street, in what was then Jefferson Parish, was named Coffee Street after General John Coffee, who served with Andrew Jackson in the Battle of New Orleans. It was renamed Baronne in 1854 after New Orleans annexed the area.) In 1922, a move arose to rename part of lower Baronne Street to Perrin Street to honor Emilien Perrin, a businessman who had died a few weeks before. The *Times-Picayune* noted that the "soul of the Baroness would not begrudge the surrender, especially as the long residential stretch would continue to bear her title."[98] In the end, royalty prevailed over real estate, and her street name went undisturbed.

BOURBON: Bourbon Street conjures up images of amber-colored whiskey, clear vodka, "huge-ass beers" and sugary drinks with names that evoke both natural and unnatural disasters (hurricanes, hand grenades and horny gators), all served in deceptively innocent plastic cups. Neon signs line the street where twenty-four hours a day their steady glow promises food, flesh and music. Bourbon Street has become world renowned as a place where inhibitions are as easily discarded as the flyers that hawkers shove in hands promising erotic indulgences of taste, sight and sound.

Despite its legendary hedonism, Bourbon has royal origins. The House of Bourbon was a branch of the Capetian Dynasty and one of the most powerful sovereign houses of Europe.[99] The house descended from Louis I, the Duke of Bourbon, and grandson of the King Louis IX of France. Like most families, the Bourbons had their share of virtuous and sordid characters, as well as scandal. There was even a "bastard" bloodline that was rumored to have the "Bourbon nose" (larger and more protruding), known as an indicator of the infamous "Bourbon temperament"—a polite phrase for their epic sexual appetite.[100]

In its youth, Bourbon Street was a paragon of decorum. Its premier bastion of sophistication was the French Opera House, located on Toulouse with its main entrance on Bourbon. It was built in 1859 and was an immediate landmark of the city's cultural vitality, but in 1917, a "ghastly artistic misfortune" occurred when the opulent structure was destroyed by fire. It could be said that the burning of the French Opera House was an omen of the cultural combustion to come.

During the Prohibition era, agents targeted Bourbon Street. Newspapers told frequent stories of raids where Prohibition agents seized "wine and women," busted in on youthful patrons enjoying a "merry tinkling" of glasses, "cut their way to the bar" with axes and saw one proprietor dive out of a second-story window to avoid capture when his speakeasy was raided.[101] But Prohibition could not truly subdue Bourbon, and after it ended, the street thrived. Its status as a hot place for drinking and revelry was only fueled by the city's growing tourism. For a time, culture and vice coexisted, but one quickly eclipsed the other.

In 1954, Billy Graham called Bourbon the "middle of hell."[102] Nightclubs such as the Hotsy Totsy Club, Jazz Limited Club, Guys and Dolls, Flamingo Club and Silver Frolics lined the streets of Bourbon. Strippers like Delilah, Tempest Storm, Tiger Lily, Fatima, Reddi Flame, Panther Girl and Blaze Starr removed their sequins, tulle and satin, exposing themselves to hordes of fans on a nightly basis. Cleanup campaigns and regular police raids occurred during the 1950s and 1960s that dampened tourism and left some locals terrified to even walk down Bourbon for fear of being swept up in a moral blitzkrieg.[103] Many of the clubs adopted stricter clothing regulations after the raids and attempted to bring their dancers' oscillations to ossification.

One of the most popular dancers on Bourbon was Miss Lilly Christine, aka "The Cat Girl," who John J. Grosch, the chief inspector under the district attorney, said had "the most filthiest, most lewd and indecent performance I have ever witnessed in my life. The purpose of her dance was purely and simply to debauch the morals of the audience."[104] Christine worked at the 500 Club, located at the corner of Bourbon and St. Louis and owned by Leon Prima, the brother of bandleader Louis Prima. Known for her sensuous looks and exquisite muscle control, one columnist was awed by Christine's "rotating innards. This estimable girl is equipped with revolving viscera, like a four-speed rotisserie!"[105] Some strippers were arrested multiple times for lewd conduct, but most charges were eventually thrown out due to the "vague" obscenity laws. Bourbon prevailed, and "natural sex orgies and unnatural sex acts" still took place in the clubs.[106]

The burlesque dancers of the 1950s and 1960s seemed almost quaint by comparison to the prostitutes of the 1970s. Bourbon became known as a "Wham-Bam Babylonian" of the flesh market. The *Times-Picayune* reported that the Old

Early morning is the one quiet time on Bourbon Street, when the revelers head home, the garbage trucks roll through and the neon lights are slowly outshined by the morning sun.

Absinthe House at 240 Bourbon and Lucky Pierre's at 735 were two of the most notorious places for prostitution, where a few twenty-dollar bills could buy you a cab, a room and some "company."[107] The visibility and availability of sex was so great that feminist activist Andrea Dworkin and one hundred others from the National Organization of Women marched down Bourbon in 1985 chanting, "Hey, Hey, Ho, Ho; Pornography Has Got to Go" and placing "por-NO" signs on strip clubs.[108] Still, Bourbon prevailed: strips clubs flourished, and music and alcohol continued to flow from the backrooms to the streets. Entering the twenty-first century, some critics argued that Bourbon had become overrun with mass commercialism, citing the profusion of souvenir and daiquiri stores. Regardless,

the street today draws in the multitudes to enjoy the freedom to walk with drinks in hand and window shop for sins, all on display and all for a price.

Culture still has a place on Bourbon though. It is home to one of the most distinguished and celebrated restaurants in the city—Galatoire's, which opened in 1905 at 209 Bourbon and is where locals still stand in line on a first-come, first-serve basis for the legendary service and creative cuisine. It was a favorite haunt of Tennessee Williams, who mentioned the restaurant in his play *A Streetcar Named Desire*. Exemplifying today's Bourbon, it is just a few doors down from the strip club Larry Flynt's Hustler Club.

For all its notoriety, Bourbon Street only extends thirteen blocks, bookended by Canal Street and Kerlerec (just past Esplanade Avenue). The blocks closest to Canal are primarily commercial, while those closest to Esplanade are mainly residential. To most locals, Bourbon is like that slightly tacky, quite frequently inebriated uncle who never ceases to embarrass everyone. Love him or hate him, he's still part of the family.

BURGUNDY: Louis, Duke of Bourgogne (Burgundy), also known as Le Petit Dauphin, was the eldest son of Louis, Le Grand Dauphin, the grandson of King Louis XIV, and second in line to the throne. Bourgogne did not cut the most dashing figure: short, with a hump and receding chin, he also possessed a jaundiced temperament and slightly sanctimonious religious convictions. When he was fifteen, he married his second cousin, Marie-Adelaide of Savoy, who years later contracted measles and died. Bourgogne, who remained by her side, died six days after his wife at age twenty-nine.[109] New Orleanians pronounce BURGUNDY STREET as "bur-*gun*-dee." In 1852, it was extended, replacing Craps Street. The three churches located on Craps that petitioned the city council were pleased with the change, as I am sure the pious Bourgogne would have been as well.[110]

CHARTRES: While King Louis XIV's "bastard" sons are honored with street names, so are the husbands to whom he married off his bastard daughters. Françoise-Marie de Bourbon was the youngest daughter of Louis XIV and his mistress Françoise-Athénaïs, Marquise de Montespan. Françoise-Marie was known as a fairly attractive, willful and spoiled young lady who grew to love her nightcaps. In 1692, she married her first cousin (the king's nephew), Philippe d'Orléans, who was styled the Duke of Chartres at the time. He nicknamed her "Madame Lucifer" (granted, he was not much better). The two would later gain other titles when Philippe inherited the dukedom of Orléans after his father died in 1701, making her the Duchess of Orléans and the second-highest-ranking lady in the kingdom. Never particularly fond of each other, the couple nevertheless had eight children.[111]

In 1715, Philippe became regent of France and a few years later was honored with not only *Nouvelle Orléans*, *Rue d'Orleans* and *Rue St. Philippe* but also *Rue de Chartres*. The streets named for his and Françoise-Marie's titles—ORLEANS and CHARTRES—are perpendicular to each other in the French Quarter but never cross, with St. Louis Cathedral standing between them.

According to some sources, part of today's Chartres, the stretch between Jackson Square and Esplanade, was once named Condé Street, for Louis de Bourbon, Prince of Condé (known as the "Great Conde"), who married Claire-Clémence de Maillé, the niece of Cardinal Richelieu.[112]

CONTI: King Louis XIV's illegitimate daughter, Marie-Anne de Bourbon, received the same honor in New Orleans as her half-sister (see Chartres). Marie-Anne's mother was Louise de la Vallière, who became the king's mistress in 1661. Louis married the pretty and spirited Marie-Anne off at the age of thirteen to the fifteen-year-old Louis Armand I, Prince of Conti. The marriage was a scandal, not because of their ages but because it was the first time a union had occurred between a legitimate royal and one of the king's "bastards." The relationship was a disaster, and on her wedding night, the young bride complained that her husband "lacked force" and that she preferred his brother instead.[113] The couple had no children, and the marriage ended when the prince died of smallpox, leaving Marie-Anne a widow at the age of eighteen. She devoted herself to the pleasures of court life and being continually forgiven by her father for her "adorable if naughty ways."[114] CONTI STREET was named for Marie-Anne's husband and the Conti family in general, and it runs parallel to the two "father" streets in the French Quarter: Bienville, the "father" of New Orleans, and St. Louis, of which her own father was a namesake.[115] Her bloodline makes up the essence of this chapter: the crown, the church and the scandals that occur when the two are merged.

DAUPHINE: Louis of France was the eldest son and legitimate heir of King Louis XIV of France and Marie-Thérèse of Spain. While his mother was in labor in 1661, Spanish actors and musicians performed beneath her window, which did not distract from the pain of childbirth, as she yelled out, "I don't want to give birth. I want to die."[116] But the queen and her child survived, and he became the Dauphin, or heir apparent. Although affable and popular, Dauphin was also considered lazy and frequently relied on his father to pay his gambling debts. He married twice, once to his second cousin, who died ten years later, and once to his lover. After his son Louis was born, he became known as Le Grand Dauphin (while young Louis was called Le Petit Dauphin). He died

suddenly at the age of fifty from smallpox, predeceasing his father, who lost the only legitimate heir among his six children who lived past childhood. In 1852, New Orleans named a street after him. Many historians argue about how Dauphin became Dauphine, but historian Jas. S. Zacharie argued that since *rue* is feminine, the name became Dauphine for the sake of euphony. If it were actually the feminine Dauphine after the king's wife, as some suspect, then it would have been translated to Dauphiness.[117]

DAVID: See Alexander.

DUMAINE STREET: Louis-Auguste de Bourbon was the illegitimate son of King Louis XIV and his mistress Madame de Montespan. Born in 1670, he was rumored to be the king's favorite. Beautiful and precocious, he also had one leg shorter than the other. When he was three years old, the king legitimized him by giving him the title *Duc du Maine*. When it came time for him to marry, many royal families were appalled at the idea of marrying their daughter to a "crippled bastard." Du Maine married Louise Benedicte, Mademoiselle de Charolais. Their marriage was unhappy; although intelligent, du Maine was considered a weakling, especially compared with his wife's domineering ways and expensive tastes. The king tried to intervene but deemed it useless and opted "to keep silent and let him wallow in his blindness and foolishness."[118]

As the king's bastard son, du Maine was always on the fringe of respectability and acceptance. Although he was one of the original French Quarter streets, New Orleans "bastardized" him a second time, linking the preposition with the noun, forming Dumaine.[119]

FELICITY: See Nuns.

HENRIETTE DELILLE: Henriette Delille was born in New Orleans in 1813 to Marie Josef Dias, a free woman of color, and Jean Baptiste Delille-Sarpy, a white man of French descent. By law, Delille's parents could not marry, and she was considered a "quadroon," meaning she was believed to be one-fourth African American. Her siblings identified as white, but Delille refused. When she was ten years old, Delille attended a school in the French Quarter for free African Americans, which left an indelible impression on her, leading her to work to educate impoverished blacks and slaves. In 1842, she cofounded the Sisters of the Holy Family Order, an African American congregation that exists to this day. In 2010, after members of the order submitted sixteen years of research totaling nearly three thousand pages of historical data to the Vatican,

In 2008, St. Louis Cathedral dedicated a prayer room to Henriette Delille; local artist Ruth Goliwas designed the altar and stained-glass window honoring the sister.

Pope Benedict XVI declared Delille "venerable," two steps removed from being formally recognized as a saint.[120] Delille is the first native-born African American whose pathway to sainthood has been officially established by the Catholic Church. In 2011, a section of St. Claude Street was renamed to honor Delille. It is a particularly appropriate placement for the street honoring Delille—one she scarcely could have imagined 174 years earlier when she established her school on that very street.

JOLIET: See Marquette.

LOYOLA: Ignatius of Loyola was the founder of the Society of Jesus (the Jesuits). Born in 1491, Ignatius was a Spanish knight who as a young man promenaded around in his military uniform and challenged men to duels over any trifle. During the Battle of Pamplona in 1521, he was seriously wounded, and during his recovery, he underwent a profound spiritual conversion. Ignatius abandoned his military career for the priesthood. Unfortunately, he was thirty-three years old and didn't know the prerequisite Latin. Undaunted, he studied relentlessly and was frequently thrown in jail for teaching the gospel without being ordained. After eleven years, he received his degree and dedicated his life to the teachings of God. Ignatius died in 1556, was beatified by Pope Paul V in 1609, was canonized by Pope Gregory XV in 1622 and was declared patron of all spiritual retreats by Pope Pius XI in 1922. The Jesuits were banished from New Orleans in 1763 and had their vast estate confiscated and sold at auction, only returning years later.[121] LOYOLA AVENUE is named in Ignatius's honor; it runs from the Central Business District (CBD) through the area of their old plantation and uptown to Loyola University, which is also named after him.[122]

MARIGNY: Perhaps no other man in the history of New Orleans embodied the city's duality of propriety and impropriety so effortlessly and so elegantly as Bernard Xavier Philippe de Marigny de Mandeville. Throughout his life— whether his was purchasing intricate silver goblets, opening his purse to someone less fortunate (be it prince or peasant) or paying a gambling debt—he always maintained his wit and humor.

Born in 1785 in New Orleans into one of the wealthiest and most aristocratic families in Louisiana, he was also privileged to possess a handsome face, an ease of speech and manners and an airy elegance, representing both the virtue and imprudence of the wealthy Creoles of his era.[123] In New Orleans's expanding footprint, it was not uncommon for wealthy men to leave their mark on the map by naming streets after themselves, wives, esteemed friends and even admired men of past and present. Although Marigny followed this custom with a few streets, his predominant focus was memorializing his virtues and vices. In his faubourg, he embedded his passions in life—gambling, politics, fighting, women and the arts—into the very framework of the city. No single individual contributed more to New Orleans's street names than Marigny, and nobody was more difficult to decide where to place in this book, as he represents so much about the city and its history.[124]

Marigny's father, Pierre Philippe de Marigny de Mandeville (whom the city of Mandeville is named after), died when Marigny was fifteen, leaving the young man with an inheritance estimated at $4 million, including the plantation that became Faubourg Marigny.[125] He was sent to England to establish manners (and curb his

Peace Street was one of Bernard de Marigny's original streets. Later, it was changed to Kerlerec, but a short street was named Peace Court to preserve the name.

wildness), but while his genteel, gentlemanly demeanor was innate, he acquired a gambling habit—particularly, a love of craps. Marigny is noted as the man who brought to America the dice game that would contribute to his financial ruin.[126]

The answer to Marigny's gambling problem was simple. Whenever he needed money, he sliced off a portion of his plantation and sold it. And while it meant loss of property, it also meant naming the streets. When Marigny lost roughly $100,000 playing bagatelle, a variation of billiards, he cut a corner off his lot, sold it and named a street Bagatelle as a memorial for his mishap. It would later take the name of its neighbor across Esplanade, Bourbon Street, in 1850.[127] After a disastrous night with the dice, he lost so much money that he believed it needed a monument and so named a street Craps, which was later changed to Burgundy.[128] But games of chance weren't all Marigny memorialized. He also named a street Love, which was allegedly where he housed his mistresses (later changed to North Rampart). One street over was Good Children, where he reputedly kept the children from these

various love affairs (later changed to St. Claude). He also named Great Men, which was gradually adapted to Greatmen Street before becoming the part of Dauphine Street below Esplanade Avenue; Casa Calvo, after the Spanish governor of Louisiana (now the part of Royal Street below Esplanade); Victory, which is believed to be after Andrew Jackson's victory at the Battle of New Orleans in 1815 (now part of Decatur below Esplanade); Union, after the Federal Union (later changed to Touro); Moreau, to honor General Jean Victor Marie Moreau (sections were changed to Chartres); Antoine, after his son Antoine James (later changed to Allen Street); Enghein, to honor the Duke of Enghein (later changed to Lafayette and now Almonaster); Peace (later changed to History and then Kerlerec); Magistrate (changed to Dorgenois); Virtue (changed to Rocheblave); Force (changed to Tonti); Liberals (changed to Miro); Genius (changed to Galvez); and Poets, to honor the lyrical wordsmiths (later changed to St. Roch).[129]

Despite all the changes, many of Marigny's streets still stand today: SPAIN, commemorating Spain's rule of Louisiana; SAINT BERNARD, after a family name (and his own); MANDEVILLE, after another of his family names; ST. FERDINAND, named for the eponymous city fort and paying tribute to King Ferdinand VII of Spain; ANNETTE, a diminutive of Ann, named after his two wives; and ELYSIAN FIELDS, originally called *Avenue Champs Elysees*, as well as TREASURE, ABUNDANCE, AGRICULTURE, INDUSTRY, DUELS, HOPE, LAW and, for his love of the humanities, MUSIC, ARTS and PAINTERS.[130]

Marigny loved New Orleans as passionately as he lived. He was the aide-de-camp to Pierre Clément de Laussat, a member of the Constitutional Conventions of 1812 and 1845; chairman of the Committee of Defense when the British army invaded Louisiana in 1814; and a veteran of the War of 1812. He also served as a member of the state government for twenty-six years. Marigny started his life with every imaginable luxury but ended it working as the recorder of conveyances and living in a modest house.[131] He fought more than fifteen duels as a young man, and at age sixty-seven, he survived being attacked and beaten with an iron bar by George Stocks.[132] At the end of his life, the citizens of New Orleans agreed that above all, Marigny was a gentleman who shrugged "his shoulders at ails," not troubled by however events affected him or those who came after him.[133]

Marigny lived under the flags of France, Spain, Louisiana and the United States, witnessed the War of 1812 and the Civil War and watched (as well as participated in) the transformation of private plantations to public faubourgs. Marigny left an indelible mark on New Orleans's culture, government and map. Shortly after his death, some of his remaining items were auctioned off, including a half dozen old mahogany chairs. The chairs, which were once used

to entertain royalty, were bought by a barber.[134] Perhaps Marigny had held on to them in the hopes that his fortunes would change and that he would one day entertain in the same manner as he had in his youth. In the end, he was buried in a simple tomb in a corner of St. Louis Cemetery No. 1, but his legacy endures on street corners all around New Orleans.

MARQUETTE: Jacques Marquette was a French Jesuit missionary and explorer who traveled down the Mississippi River with French Canadian fur trader Louis Joliet, reporting the first accurate data on its course. Joliet was an experienced mapmaker more concerned with finding the river, while Marquette concentrated on spreading the word of God to whomever they encountered. Regardless of their differences, they accomplished much and are credited with being the first Europeans to map the northern reaches of the Mississippi River. Marquette University in Milwaukee, Wisconsin, is named in his honor, as is MARQUETTE PLACE near Loyola University. JOLIET STREET in Carrollton and Hollygrove is named after his partner.

MAUREPAS: See Pontchartrain.

NOTRE DAME: Notre-Dame de Bon Secours, or Our Lady of Prompt Succor, is a title bestowed on the Virgin Mary by the Ursuline nuns and also refers to a particular statue of Mary. In 1803, a group of nuns fled New Orleans for Cuba in fear of the anti-clerical sentiment brought on by the French Revolution. Only six nuns remained.[135] Mother St. Michel Gensoul, who was in France, asked to transfer to New Orleans. Bishop Fournier stated that Pope Pius VII, who was a prisoner of Napoleon at the time, was the only one who could grant permission. Gensoul prayed for the impossible before a Virgin Mary statue, promising to honor her in New Orleans if her request was approved. In roughly five weeks, her prayers were answered, hence the "prompt" part. Gensoul and the statue arrived in New Orleans in 1810 to reside in Ursuline Convent, where the statue remains to this day. She is the patroness of the state of Louisiana and New Orleans, and a street in the Warehouse District is named in her honor.

NUNS: RELIGIOUS and NUNS STREETS, in the industrial section of today's Lower Garden District, were laid out by surveyor Barthelemy Lafon in the early 1800s when he drew plans to turn several former plantations into faubourgs as the city grew upriver. It appears that Religious came first, as there was room in the plan for a new street, parallel to the river, angling off Tchoupitoulas and running several blocks through Faubourg de la Course and Faubourg de L'Annunciation

Religious and Nuns, a fitting junction in the area of the former Ursuline plantation.

to the upriver boundary of the city at Felicity. Perhaps Lafon gave it the name because it terminated at the doorstep of the Ursuline nuns' plantation, on the other side of FELICITY (named after Sister Ste. Felicitee Alzac, the assistant to the Mother Superior; a negligent mapmaker forgot to add "Saint" as a prefix). Lafon also created St. John Baptist Street, one block over from Religious, which was

eventually changed to SAINT THOMAS after the former owner of the property, Thomas Saulet (alternatively spelled as Soulet or Solet).

A few years later, the nuns subdivided their plantation into Faubourg des Religieuses, and Lafon laid out this faubourg, creating SAINT MARY (after Sister Ste. Marie Olivier De Vezin, the Mother Superior who signed the act of sale for the lots) and SAINT ANDREW (named after Sister Ste. André Madier) above Felicity and extending Religious one block into the new neighborhood. There was room for a short new street running away from the river into the neighborhood, and Nuns was named, extending for two blocks from Levee Street to Religious.[136] Oddly enough, because of its location near the Mississippi River, the street became known in the nineteenth century less for its religious namesakes and more for wharf rats, murders, illegal bars and labor brawls. Today, the area encompassing both streets is largely industrial, with a few new housing and commercial developments.

ORLEANS: The street and avenue of Orleans (as well as the city of New Orleans) was named after Philippe II, duc d'Orléans, a member of the royal family of France, regent of the kingdom from 1715 to 1723 and someone described by the French philosopher Voltaire as a "man of few scruples but incapable of crime."[137] Paris at the time was a hotbed of couture corruption, boasting "more mistresses than wives," but Philippe managed to eclipse even the most degenerate deviants.[138] His various affairs, rumors of murder and incestuous relations with his daughter were too much for even the tolerant elite. He was honored with one of the original streets laid out by Adrien de Pauger, but certainly this was due to his royal lineage and stature, not his character or accomplishments.

PLACE JEAN PAUL DEUX: For three days in September 1987, Pope John Paul II visited New Orleans. The pope met with Catholic schoolteachers in the Superdome, delivered an outdoor Mass before 130,000 at the University of New Orleans and visited St. Louis Cathedral. The one-block pedestrian mall in front of the cathedral was christened shortly thereafter PLACE JEAN PAUL DEUX to memorialize his visit.[139]

PONTALBA: Micaela Almonaster was three years old when her seventy-year-old father, New Orleans magnate Andrés Almonaster y Rojas, died in 1798. Twelve years later, her mother, Louise de la Ronder, arranged her marriage to her cousin Célestin de Pontalba, who resided in the Chateau Mont-l'Eveque in France. Célestin's father, Xavier de Pontalba, was anxious to get his hands on his daughter-in-law's fortune. For the next twenty-three years, Xavier mounted repeated campaigns of emotional manipulation (including ordering the entire Mont l'Eveque household to view her as

invisible) and lawsuits to gain control over her riches. Micaela managed to elude or adapt to every restriction and legal maneuver Xavier initiated. Eventually, he tried to murder Micaela, shooting her multiple times and leaving her with two bullets in her chest and several missing fingers. Distraught over yet another failure to control or destroy Micaela, Xavier committed suicide.

After Micaela recovered, she obtained a legal separation from her husband, retaining much of her fortune. She returned to New Orleans, where she was surprised to find the French Quarter of her birth hardly better than a slum. She resolved to improve it, using her money, business sense and enterprise to commission the building of the fine apartments on the Place d'Armes (now Jackson Square), which took her name, as well as to beautify the square itself.[140] Her stipulations were that the river view should never be cut off from Jackson Square and that the "abominable American ice cream" should never be sold there.[141] A short street near City Park honors her.

PONTCHARTRAIN: Louis de Phelypeaux, Comte de Pontchartrain, was the navy minister in the court of Louis XIV. His son, Jerome de Phelypeaux, Comte de Maurepas, joined him in government at age eighteen and later succeeded him as minister of the navy. Pierre Le Moyne d'Iberville, on his expedition in 1699 to colonize Louisiana, named the large (six-hundred-square-mile) lake he discovered after Pontchartrain (who had submitted Iberville's name to King Louis XIV for the expedition to establish a French presence near the mouth of the Mississippi) and the smaller (ninety-two-square-mile) adjoining lake after Maurepas. Obviously, Pontchartrain got the larger honor. Iberville might have later regretted his decision to honor the count when Pontchartrain sanctioned him for questionable dealings on an expedition in the Caribbean.[142] Still, both Phelypeaux men have streets named for them, and similar to the lakes, PONTCHARTRAIN is a lengthy boulevard and expressway, while MAUREPAS is a short residential street in Mid-City (in the former Faubourg Pontchartrain, also named for the elder Phelypeaux).[143]

RELIGIOUS: See Nuns.

ROYAL: Of all the streets in the French Quarter, the name of ROYAL STREET is most befitting. The street was originally called *Royalle-Bourbon* to honor the royal family and dynasty, but Governor Bienville ordered it changed to *Rue Royale*, which it remains to this day.[144] Although Royal parallels Bourbon, the two streets could not be more different. While Bourbon is known for its bars with three-for-one drink specials, strip clubs and T-shirt shops, Royal is known for its art galleries, posh hotels and antique stores. Rock music, jazz and the sounds of

Pontchartrain Boulevard only a few weeks after Hurricane Katrina, littered with debris from Lakeview and West End.

off-key karaoke enthusiasts blare out from clubs on Bourbon, while Royal hosts street musicians such as Dixieland jazz bands, bluegrass pickers or the odd solo songstress armed with a banjo and sleeping hound dog that occasionally adds his baritone backup vocals. A section of Royal closes to vehicular traffic daily from 11:00 a.m. until late afternoon, transforming it into a pedestrian mall to allow people to leisurely cross the street back and forth to peer in the windows of their favorite stores. Bourbon, meanwhile, takes the opposite approach, closing to cars nightly at 7:00 p.m. to allow people to match their gait with Bourbon's

neon pulse. Bourbon and Royal are the quintessential alter egos of New Orleans, prompting Walt Disney to once remark of the two streets, "Where else can you find iniquity and antiquity so close together?"[145]

SAINT ANDREW: See Nuns.

SAINT ANN: Originally spelled "Saint Anne," this street is believed to be named after one of the most popular baptismal names of the aristocratic Orleans family.[146] St. Anne was the Blessed Virgin Mary's mother and is the patron saint of widows, pregnant women, barren women and nursemaids.[147]

While St. Anne might be the patron saint of suffering women, at the intersection of Bourbon and St. Ann she serves as the patron saint of gays and lesbians, drag queens and transgendered people. This corner is known as the "Velvet Line," meaning it is the soft edge of the gay area in the French Quarter. The Bourbon Pub & Parade, the largest gay club in the city, and Oz, another gay nightclub, face each other at the corner, offering dancing, strip-offs, show tune sing-alongs and even risqué versions of "Bingo." The intersection also hosts the Bourbon Street Awards, a popular drag and costume contest on Mardi Gras Day that has been described as a "lively pageant of sequins, peacock feathers and spandex."[148] Southern Decadence, one of the city's largest festivals (also known as "Gay Mardi Gras"), is held every Labor Day weekend, with Bourbon and St. Ann serving as the epicenter, where some dress in sequined gowns while others might prefer only one strategically placed sequin.

A nontraditional Carnival society that follows the traditional spelling of St. Ann Street is the St. Anne Society, a walking krewe that parades from the Bywater to Canal Street every year on Mardi Gras Day. The general ethos of the St. Anne Society is DIY, with costumes stitched, glued and stapled by hand rather than store-bought. The krewe is accompanied by the Storyville Stompers brass band, and the costumed revelers wear shimmery fairy wings or electrifying body paint or sometimes may just be wrapped in police-line tape or draped in unpaid parking tickets, marching down the street. The parade loses and gains members at each block, with some revelers electing to stop at their favorite bar or sit on the stoop of a good friend, while others doing the same thing join in. While the original St. Anne might have been associated with the downtrodden, in New Orleans, she frequently represents the high steppin'.

SAINT ANTHONY: According to historian John Chase, this street was named by City Surveyor Charles Zimpel, who named it after one of his favorite saints.[149] While there are many Anthonys in the sainthood, perhaps it is named after

The corner of Bourbon and St. Ann—the Velvet Line—is all dressed up in anticipation of Southern Decadence, its biggest party of the year.

Anthony Correa, Anthony Fernández and Anthony Suárez of the Blessed Ignatius de Azevedo. They were three of the forty Jesuits who were put to death on a Hugeuenot ship near the Canary Islands in the sixteenth century.[150] St. Anthony Street runs from the Marigny to Gentilly, pauses at Dillard University, becomes St. Anthony Avenue and then runs to the University of New Orleans.

SAINT BERNARD: See Marigny.

SAINT CHARLES: One of the city's most historic and picturesque streets is named after King Charles III of Spain, who reigned for the majority of Louisiana's

time under Spanish rule. While the street is arguably most widely thought of for its stretch in the Garden District, St. Charles starts at Canal on the edge of the French Quarter, runs through the Central Business District, curves around Lee Circle and then journeys past the live oaks and resplendent mansions of Uptown until it ends at Carrollton Avenue. Originally, only the stretch from Canal to the circle, then called Tivoli Circle, was named St. Charles. Above the circle, it was called Nayades (after the Greek water nymphs called naiads) until it was renamed in the 1850s.

One of the street's hallmarks is the streetcar that runs its entire length and is the oldest continuously operating streetcar in the country. With mahogany seats and brass rails, the streetcars fill with commuters and tourists alike, who can raise the double-hung windows and catch a breeze while enjoying the transition

A rare snowfall in New Orleans in December 2008, blanketing the city and bringing a dash of winter wonder for a few hours.

from modern skyscrapers and Neoclassical structures in the Central Business District to the houses, churches, synagogues and university buildings in Uptown, dating from the antebellum period to the turn of the twentieth century. Greek Revival, Colonial, Victorian and Italianate mansions, as well as Mediterranean-style villas, are all on display, nestled between such landmarks as Tulane and Loyola Universities, Academy of the Sacred Heart and Audubon Park.

Despite its genteel reputation, St. Charles is one of the main Mardi Gras parade routes. Carnival season starts and ends on St. Charles. Beginning with the Phunny Phorty Phellows, who costume and ride the streetcar on Twelfth Night to signal Carnival's arrival, right through to the truck parade that follows Rex and Zulu to signal the end of Mardi Gras Day, for weeks the Avenue is lined with parade ladders, revelers of all ages and missed beads dangling just out of reach from the oaks above.

Maintaining the character of St. Charles and the Garden District has always been vital to residents, who have formed various neighborhood associations. Regardless, St. Charles has also been the focal point of controversies. One of the most recent became known as the "Gothic vs. Gauche" or "Chicken King vs. Vampire Queen." On the Friday before Mardi Gras in 1997, fiction writer Anne Rice, known for her *Vampire Chronicles*, took out a full-page newspaper ad to lambast Al Copeland's new "California Cuisine" restaurant, Straya, at 2001 St. Charles Avenue. Rice was known for her dark, Gothic portrayals of the city, while Copeland, founder of the Popeye's fried chicken restaurant chain, was famous for his splashy style, wearing ostrich-skin cowboy boots and diamond earrings, driving a Lamborghini and racing his speedboats on Lake Pontchartrain. Rice apologized to visitors and locals for Copeland's new peach-colored, neon-lit restaurant that was festooned with metal palm trees and large golden panthers wearing faux diamond-studded collars. Rice wrote that the restaurant was "nothing short of an abomination," a "ludicrous and egregious structure," a "monstrosity" that "in no way represents the ambience, the romance, or the charm that we seek to offer and strive to maintain in our city."[151]

Copeland fired back with a two-page "Dear Anne" ad touting the classic design of Straya and stating, "In the meantime, I'm putting a little extra garlic in the food at Straya, keeping a crucifix under my pillow and carrying a wooden stake for good luck." He also added, "P.S. See you in court." One of Rice's main bones of contention was that in her 1995 novel *Memnoch the Devil*, one of her most popular characters, Lestat the vampire, catches his reflection in the showroom window of an abandoned Mercedes-Benz car dealership—coincidentally the very building that Copeland renovated into Straya.[152]

Copeland filed a defamation suit against Rice, and when he learned that she had plans for a restaurant nearby called Café Lestat, he amended his lawsuit to include a charge of unfair trade practice. Both claims were thrown out, and Copeland took it in stride by running an October "Find Lestat" promotion and urging his employees to dress up like vampires.[153]

End to end, ST. CHARLES AVENUE is a true New Orleanian. It is stately and historic; loves its splendor, architecture and food; and is enterprising yet always ready to *laissez les bon temps roulez.*

SAINT CLAUDE: See Tremé (Chapter 3).

SAINT DENIS: St. Denis is the patron saint of France, but this street could also be named after Louis Juchereau de St. Denis, a French Canadian explorer and soldier from Québec. In 1699, St. Denis traveled with Sieur d'Iberville (his uncle-in-law) for his second expedition to Louisiana. St. Denis led his own expedition in 1714 from Natchitoches (which he founded that year near an Indian village) to the Spanish town of San Juan Bautista (modern-day Guererro) on the Rio Grande. Routinely jailed for smuggling, he served as commander of Post St. Jean Baptiste in the Natchitoches District until he died in 1744. Natchitoches has a street named after him, as does New Orleans.

SAINT FERDINAND: Nicholas Daunois was a plantation owner who subdivided his land into a faubourg in the 1810s. Three streets were named for the forts Spanish governor Baron de Carondelet built around New Orleans, but only St. Ferdinand survived, which also honors King Ferdinand VII of Spain.[154]

SAINT JAMES: See Annunciation.

SAINT JOSEPH: Dona Maria Josefa Deslondes and her husband, Don Beltran (or Bertrand) Gravier, subdivided their plantation, just upriver from the city, after the Good Friday Fire of 1788 destroyed most of the French Quarter. Was it

compassion or capitalism? The faubourg was originally called Ville Gravier, but after his wife's death, Gravier renamed it Faubourg Ste. Marie (St. Mary).[155] St. Joseph was one of its original streets. St. Joseph is a popular saint in New Orleans; the city celebrates St. Joseph's Day, on which Catholics throughout the city build altars adorned with food, candles and flowers. The Italian American Marching Club hosts an annual St. Joseph's parade, where marchers wearing black tuxedos dance through the French Quarter handing out silk flowers and fava beans. Many Mardi Gras Indians also honor St. Joseph with their tradition known as Super Sunday. On the Sunday after St. Joseph's Day, more than fifty Mardi Gras Indian tribes gather in their elaborate, handmade costumes in a friendly competition of dance, pageantry and showmanship. Regardless of the saint's popularity, however, John Chase maintains that the street is not named after the spouse of the Blessed Virgin Mary but rather after the spouse of Bertrand Gravier.[156] Also, GRAVIER STREET is named after Betrand, and DESLONDE is named after his wife's family.

SAINT LOUIS: St. Louis Street is named after King Louis IX, known as the "Saint King," who ruled France from 1226 to 1270. Under Louis's reign, France prospered, and he built many religious and educational institutions.[157] Pope Boniface VIII canonized Louis in 1297. It has been claimed that all of the Bourbon kings who followed Henry IV were christened Louis, but any semblance of saintly behavior ended with Louis IX. Extramarital affairs, mistresses, cross-dressing and incest did not sit well with the church.[158]

Originally, St. Louis was nestled between Bienville and Conti, but after the city redesignated certain street names in the early to mid-1700s, the Saint King found his home where he is today, between streets inspired by two of his namesake Louis XIV's illegitimate children, Conti and Toulouse.[159] To be surrounded by sinners appears to be St. Louis' fate in New Orleans. St. Louis Cathedral in Jackson Square is also named in his honor. The oldest continuously operating cathedral in the country, it is also one of the few Roman Catholic churches that is located on a large public square. While worshipers seek prayer and penance inside, tarot readers, street artists, musicians, mimes and tourists seek pleasure and profit outside. The entrance of the cathedral that faces the square is a favorite spot for religious groups to rally during Mardi Gras. Somber and sometimes irate groups of individuals stand with large signs condemning everything from homosexuals to adulterers, fornicators and drunkards (or all four) in front of partygoers often wearing only body paint and little more than patches of cloth who mockingly dance to their chants and protests. It makes for a poignant symbol of piety and humanity—the singular spire of St. Louis standing high above, with the façade of the cathedral spreading out and down to the rowdy jumble of zealots and heathens below.

SAINT MARY: See Nuns.

SAINT PATRICK: St. Patrick, the patron saint of Ireland, is revered in New Orleans or at least greatly appreciated as an inspiration for various celebrations. In the early nineteenth century, a large number of Irish immigrated to New Orleans. In 1841, the parishioners of St. Patrick's Church purchased land for a cemetery near the intersection of Canal and City Park Avenue in Mid-City, creating St. Patrick's Cemetery I, II and III, and later, a nearby street was named St. Patrick.[160] The spirit of St. Patrick lives on with an assortment of parades all over the city. As in most places, the saint who drove the snakes out of Ireland now serves as a symbol to wear green and enjoy a tipple or two, something New Orleans heartily endorses.

SAINT PETER: St. Peter was one of the favorite saint baptismal names of the royal Orleans family. It was originally called *Rue St. Pierre*, using the French version of Peter. As with many streets, over time the name was changed to the English version. Even though Henry IV was the first Bourbon king of France, it was rumored that his predecessor was a Peter, whose brother Jacques preserved the bloodline.[161] There are various St. Peters, but it is likely that the street is named after Peter the Venerable, also known as Peter of Montboissier, who was born into a French noble family and was an advocate of education.[162]

SAINT PHILIP: St. Philip was originally called *Rue de Clermont* (after Robert, Count of Clermont, who was the sixth son of Louis IX and the head of the Bourbon line). By 1750, it was called *Rue St. Philippe*, after the first name of the Duke of Orleans, who was regent of France when New Orleans was founded and after whom the city is named. Additionally, St. Philippe was a patron saint of the royal House of Orléans, although to be a saint in New Orleans (as well as a street) means to suffer its misspellings and mispronunciations. ST. PHILIP STREET is no exception, and it lost its original spelling over time. Like most streets in the French Quarter, at first it only ran six or seven blocks from the river to the "back of town," but as the city grew, so did St. Philip. Today, it extends through Tremé and ends at Bayou St. John.

SAINT ROCH: St. Roch is the patron saint of plague victims and one of the Catholic Church's "Fourteen Holy Helpers." He was born in the thirteenth century in Montpellier, France, with a red cross on his chest.[163] In 1868 in New Orleans, there was a yellow fever epidemic, and Father Peter Leonard Thevis urged his congregation to pray to St. Roch, vowing to build a chapel if they were spared.

None of the members of his congregation died, and in 1884, they built the church, including a cemetery, modeled after the Campo Santo dei Tedeschi near St. Peter's Basilica in Rome.[164] In 1894, Poets Street was renamed to honor the saint.

SAINT THOMAS: See Nuns.

SAINT VINCENT: St. Vincent de Paul was the founder of the Lazarist Fathers and Sisters of Charity. The French saint is the patron saint of all charitable groups. New Orleans was charitable to St. Vincent, giving him two streets, although each is only one block long. One is in Gentilly, and the other is near the New Orleans Fair Grounds.

SISTER: There is no sibling rivalry in this five-block street located in the Lower Ninth Ward alongside the Industrial Canal. SISTER STREET was named in honor of the Ursuline nuns, who once had a convent and landholdings located in the area.[165]

SOLOMON: See Alexander.

TOULOUSE: Louis-Alexandre de Bourbon, Comte de Toulouse, was an illegitimate son of Louis XIV and Madame de Montespan and the younger brother of du Maine (see Dumaine). Although King Louis had declared in his will that du Maine and Toulouse could succeed him if legitimate members of the House of Bourbon died out, their cousin, the unscrupulous regent Philippe II, duc d'Orléans, had the Parliament of Paris nullify that portion of the king's will. Toulouse and du Maine are both blessed to have original street names in the French Quarter and are fortunate to be buffered by "saint streets" so they are not too close to their conniving cousin Orléans.

URSULINES: At the request of Governor Bienville, twelve Ursuline nuns voyaged from France to New Orleans in February 1727 to take charge of a hospital and educate female citizens to be worthy wives and mothers. Their holy providence, however, did not guarantee smooth sailing. Persistent pirates followed them, they lacked general provisions and endured ferocious storms, one in particular during which forty-nine sheep and five hundred chickens allegedly died of seasickness.[166] When their ship ran aground on a sandbar, the captain ordered the nuns to throw their trunks over the side to lighten the load yet, at the last minute, decided against it. Time and time again, he ordered them to toss their belongings only to change his mind. Instead, the crew lost to the sea sixty barrels of brandy.[167] Perhaps this explained the sailors' unsympathetic feelings toward the nuns. With water scarce,

A view from under the bell of the manicured gardens of the old Ursuline Convent.

the crew negotiated a savvy trade—the nuns' wine for their water, a bottle-for-bottle exchange. Apparently, the crew's pity was as absent as their lost provisions.

The nuns arrived in New Orleans in August 1727. The city was comfortable by comparison to their journey but was not abundant with the riches or physical splendor that they were expecting. One eyewitness described the "village" of New Orleans as being no better than a vast sink or sewer, and "within a stone's throw of the church...reptiles croaked, and malefactors and wild beasts lurked, protected by impenetrable jungle. The air was on fire with mosquitoes, every one provided with a sting like a fine, red-hot nail."[168] Yet their reception was welcoming, and the colonists were far more hospitable than the mosquitoes or the snakes.

The nuns quickly set out to educate women—all women—tutoring them in English, geography, arithmetic, sewing, knitting and, of course, the Catechism. They believed that education and Christianity should not be segregated, and to the vexation of white plantation owners, they taught African slaves.[169]

Being nuns, however, they were unable to serve the primal needs of the male colonists. The next year, another group of women from France landed in New Orleans for a different purpose—marriage. The *filles a la cassette* ("casket girls") earned their nickname for the small "casquette" box that they filled with their belongings from France. The girls were harbored and educated in the convent, the nuns monitoring their courtships and arranging their expeditious marriages. Still, these unsullied girls could not meet the demand of the male colonists. While the casket girls were handpicked from upstanding families, other women were picked off the Paris streets and shipped like carnal cargo to the new French colony: prostitutes, drug addicts and "frail" women of ill repute. A common joke in New Orleans is that all of the prostitutes must have been infertile since all of the first families of New Orleans trace their lineage back to the poor yet virtuous casket girls and none to the Parisian streetwalkers.[170]

During the War of 1812, when the British fleet landed at Chalmette in 1815, General Andrew Jackson asked for the nuns' prayers for victory. On January 7, 1815, Mother Superior Ste. Marie Olivier de Vezin and the sisters, mothers, daughters and wives of soldiers kept vigil before the statue of Our Lady of Prompt Succor. The Mother Superior vowed that if their prayers were answered, a novena and solemn High Mass would honor Our Lady of Prompt Succor forevermore. The next day, Jackson led his troops to victory, and Mother Ste. Marie registered the vow. To this day, High Mass is observed by the order in honor of the wartime conquest.

The Ursuline nuns moved into their first convent in 1734 and then to another building in 1752 at the corner of Chartres and Arsenal Streets. This building is still standing, the oldest building in the Mississippi Valley and the only remaining structure from the French colonial period in the French Quarter. (Sources say that Lafitte's Blacksmith Shop Bar was built sometime between 1722 and 1772, and Madame John's Legacy, though French Colonial in style, was built in 1788, during the Spanish period.) Its side street, Arsenal, was changed to Ursulines in the late 1700s, and as the city grew toward the lake, the street was also extended. URSULINES AVENUE runs from the French Market at North Peters and through the French Quarter, Tremé and Faubourg St. John before ending just before Bayou St. John.

Today, the Old Ursuline Convent houses the Archdiocese of New Orleans's archives and is a popular tourist attraction. The nuns' primary goal of educating women and safeguarding their spirituality remains strong. This was substantiated again in 1948 when thousands of circular advertisements for a strip club were accidently dropped into the courtyard of the Ursuline Academy as fifth-grade girls played. Shooing them away, the nuns gathered the offensive material, containing a picture of a "derober," and burned it. The children then gathered and, under the guidance of the Sodality of the Blessed Virgin Mary, wrote to the proprietor of the club and demanded an apology. They, of course, received it.[171]

CHAPTER 3
EXQUISITE NEPOTISM

Plantation Belles and the Landowners Who Loved Them

The lore of the southern belle is steeped in nuanced myths of leisure, privilege and delicacy. During antebellum times, when a majority of these streets were named, women lived within a complex system of restrictive legal and cultural norms that were almost as confining and binding as the corsets they wore. Still, some of the women in this chapter defied convention, and many fought for legal control of their property and named streets of their own after loved ones. Men, meanwhile, named streets after their wives, mothers, daughters and sisters and often took names for their own by right or by simply being a pioneering landowner. Sibling rivalries, bitter marriages and feuding families still play out in the nomenclature, where some members would be horrified to find themselves crossing or being so closely situated to an archenemy. New Orleans's families' histories are inextricably intertwined on our modern streets.

ADELE: See Josephine.

ALINE: See Delachaise.

ALLARD: Louis Allard's life was a romantic tragedy that New Orleans embraced and perhaps exaggerated. When Allard's parents died, their plantation, which bordered Bayou St. John and Bayou Chapitoulas (Bayou Metairie), was divided equally between Allard and his siblings, Andre Latour and Louise (who married Jean François Robert).[172] In 1825, Andre, already in debt to Allard, went to France, signing power of attorney over to him. In 1829, Allard sold Andre's portion to his

Countless lives were lost and reputations defended under the branches of this stately tree, the one remaining of City Park's two famous Dueling Oaks.

brother-in-law and, months later, purchased some of the land back, leaving the land equally divided between himself and Robert. In March of that year, they mortgaged the land for $27,500.[173] Allard was more of a poet, philosopher and politician than a planter.[174] In 1845, his property went to auction. His 654 acres, nineteen slaves, 140 head of cattle and ten horses and mules were purchased by entrepreneur John McDonogh for $40,500. He continued to let Allard live on the property. This lent another facet of Allard's myth—the privileged, genteel Creole who lost his property due to his "leaning toward literature," ending up but a visitor on his land, living his remaining days beneath his beloved oaks.[175] Allard died in 1847, and three years later, McDonogh followed, bequeathing the land to the City of New Orleans, which turned it into City Park.

Even before McDonogh's gift, the large oaks in City Park were already legendary. Trees that had stood for hundreds of years (some are estimated to be between eight hundred and one thousand years old) and seen all nature could throw at them also saw many men succumb to their darker natures. Three of the most famous oaks were the Suicide Oak and the Dueling Oaks. The Suicide Oak was a favorite place for the grieving to hang themselves using the branches, a rope and a horse.[176] The Dueling Oaks witnessed countless duels. Their canopy of intertwined branches and Spanish moss was as stout as the Creole Code of Honor, making for the perfect place to restore honor—or at least a pretty last sight. It is estimated that between the years of 1834 and 1844, duels were fought almost daily under these oaks, with men sometimes lining up to wait their turn.[177]

Decades after Allard's death, it was rumored that he was buried beneath the Dueling Oaks, an apt if ironic thought considering his battles to keep his land. For years, an aged tomb under the oaks was linked with Allard. In 1902, the *Daily Item* reported that the tomb was crumbling, with children clambering over it and shouting with glee as bricks fell "to the green sward."[178] A few years later, the tomb was exhumed, but all that was left of Allard (or whomever) and his casket was a "single handle and a lock."[179] Some believe that Allard's remains were moved to Greenwood Cemetery, shipped to France in 1861 and laid to rest with his ancestors; others believe that he is buried at St. Louis Cemetery No. 2. The tomb, whether Allard's in reality or only symbolically, remained for more than a century until 2011, when City Park officials abruptly removed it. In a letter to the *Times-Picayune*, Russell B. Guerin wrote that it was irrelevant whether Allard was buried there or not—that did not negate the structure's history, and its unceremonious removal removed "the mystery that was there for all lovers of the park to experience."[180] Allard's legacy lives on in a beloved park for the whole city to enjoy, among branches of living history and shoots of vibrant renewal, as well as ALLARD BOULEVARD, just across City Park Avenue.

AMELIA: See Peniston.

ANNETTE: See Marigny (Chapter 2).

ANTONINE: See Delachaise.

ARABELLA: See Hurst.

BARTHOLOMEW: Bartholomew Street in the Upper Ninth Ward is named after Louis Barthelemy Macarty, who owned a plantation in the area. He and his

partners subdivided the property in the 1830s.[181] The Macarty family also owned the large plantation that became Carrollton, but aside from property, the family also left a dark, infamous bit of New Orleans's history.

Delphine Macarty, daughter of Louis Barthelemy Macarty, niece of Governor Miró and cousin of Joseph Celestin Delfou, Baron de Pontalba (Baroness Pontalba's husband), was at the pinnacle of the Creole elite.[182] She was considered one of the most beautiful society women, with the perfect mixture of manners, charm and wealth. She married Don Ramon de Lopez y Angulo but was soon widowed and left with a daughter, Marie Borgia Delphine Lopez y Angulo (nicknamed Borquita). Delphine married twice more, her final time to Dr. Leonard Louis Lalaurie.

It was during Delphine's marriage to Lalaurie that one of New Orleans's most notorious events occurred, a night that for almost two centuries has lived on in hearsay, anxious whispers and supernatural encounters. The couple purchased a mansion at 1140 Royal Street in 1831 and hosted elaborate parties that simultaneously cemented and glorified their status.[183] Their genteel façade smoldered to dust, however, on April 10, 1834, when a fire broke out during a party.[184] Allegedly, an elderly slave woman set a fire in the kitchen either as revenge or as a crude suicide attempt. As the flames grew, Delphine calmly instructed the crowd on removing pricey items from the home. When they asked Delphine about her slaves, she dismissed them: "Nevermind the servants, save my valuables, this way gentlemen, this way."[185] The crowd murmured that the Lalauries kept their slaves chained up behind locked doors and demanded entry. Delphine, with aristocratic aplomb, refused to hand over the keys. Finally, people broke down the attic door to find seven slaves wounded and chained.[186]

The next day, the *New Orleans Bee* reported that the slaves were "horribly mutilated" and suspended by their necks, with their limbs "stretched and torn from one extremity to the other. Language is powerless and inadequate to give a proper conception of the horror which a scene like this must have inspired. We shall not attempt it, but leave it rather to the reader's imagination to picture what it was."[187] And the readers did use their imaginations! Rumors of the slaves suffering crude sex-change operations, having their skin peeled away, with maggots eating away at their rotting flesh or their bones broken and reset to resemble "crab-like creatures" have circulated in New Orleans for decades.

The slaves were taken to the local jail, where more than four thousand citizens viewed their battered bodies, satisfying their curiosity, getting confirmation of the Lalauries' abuse for themselves or both. The embers of outrage were inflamed to seek justice. Newspapers across the country covered the story with headlines like "Atrocious Cruelty," "Revolting Details" and "Shocking Barbarity." Overnight

The Lalaurie Mansion at the corner of Royal Street and Governor Nicholls is one of the grandest and most elegant homes in the French Quarter. It is also said to be one of the most haunted in the country.

Delphine went from being exalted to being demonized. One newspaper commented that "of all the hideous transformations to which our moral is liable, the conversion of one of the softer sex into a monster of cruelty is the most detestable and incomprehensible."[188]

The following day, with a mob outside her home, Delphine stepped out, elegantly dressed as if she were going for her daily ride, and took off at full speed in her carriage. The shocked crowd screamed out to shoot the horse, shoot her, anything to stop the carriage, but she escaped to a waiting schooner on Bayou St. John and thence to Covington, Mobile and eventually Paris, as rumors go. Enraged, the mob tore apart her house, throwing pianos, armoires and buffets into the streets. Bonfires arose out of the detritus.[189] But before the Lalauries escaped, they had the presence of mind to handle their affairs. An 1846 court opinion mentioned that in 1834, "about to depart for France, where she has resided ever since," Lalaurie gave power of attorney to her son-in-law, Placide Forstall, who was married to Borquita (see Forstall).[190]

Since that night, the house has been transformed many times, to a girls' school, a furniture store, a barbershop, a tenement house, a music school and a private residence, each time marred with stories of paranormal behavior: ghostly apparitions, unearthly noises, furniture covered with foul-smelling slime, flickering lights and more. Actor Nicolas Cage bought it in 2006 but lost it in foreclosure in 2009. Recently, the house underwent another renovation, and the caretaker stated that she, too, experiences mysterious occurrences: footsteps, body imprints on pillows and the landline calling her cellphone when no one is home.[191]

Dr. Lalaurie seems to have disappeared into history, and scholars disagree on Delphine's final whereabouts. Some say that her final days were spent in luxury in Paris. Others claim that she quietly made her way back to New Orleans and is buried at St. Louis Cemetery No. 1. Some believe that the stories of Delphine are false, mere propaganda to destroy the couple's propriety out of jealousy. No one knows for sure, but in New Orleans, sometimes whispers that are shared behind dainty gloved hands and on lips over scotch glasses, over time, become truth.

Fats Domino's house on the Lower Ninth Ward's Caffin Avenue, named after the prominent Caffin family.

Bellecastle: See Robert.

Benjamin: See Hurst.

Caffin: This avenue in the Lower Ninth Ward was likely named for Charles Caffin, who owned a plantation in the area (and also briefly owned the infamous Lalaurie Mansion in the French Quarter) that was subdivided into lots in 1862.[192]

Clouet: Louis Brognier de Clouet may have been French, but that did not stop him from plotting to restore Spanish rule in Louisiana. Born in New Orleans in 1766 to French immigrants, he engaged in real estate speculation with plantations near New Orleans after some early military assignments and explorations. His gambles paid off.[193] De Clouet continued his military career, eventually buying a plantation in the present-day Upper Ninth Ward. He subdivided the plantation for residential development, creating Bourg Clouet

in 1809. He named the streets CLOUET (after himself), Piété (which in less than a decade started showing up on maps as PIETY) and LOUISA (possibly after his daughter Luisa). He named two cross streets *Rue Alexandre* (which could have been after his father or his brother) and *Rue Clara* (most likely after his wife, Clara de la Pena), but they were later changed to ST. CLAUDE and DAUPHINE, respectively. In 1813, De Clouet left his streets behind and traveled to Madrid, where he wrote a paper recommending an invasion of Louisiana to restore Spanish rule, became governor of the province of Jagua in Cuba and retired back in Madrid, where he was named count of La Fernandina–Jagua and a member of Parliament.[194] Although it is unclear whom Piety Street was named after, perhaps it suits De Clouet himself, a Frenchman so devoted and pious to the Spanish cause.

COHN: See Millaudon.

DELACHAISE: Philippe Auguste Delachaise originally purchased sections of the Wiltz plantation just uptown from today's Louisiana Avenue in piecemeal fashion from 1820 to 1823. Years later, Delachaise added the neighboring LeBreton plantation.[195] He married Marie Antoine Foucher, and they had two sons, Auguste and Louis Philippe (called Philippe), as well as a daughter named Elizabeth Lucienne, who went by Aline. When Delachaise died in 1838, he left the property to his wife and children, as well as more than five hundred books (a notable collection since books were rare). After Madame Foucher died in 1855, the siblings subdivided the property into lots known as Faubourg Delachaise. They named the streets radiating back from the river DELACHAISE (after their family name), ALINE (after the sister) and FOUCHER and ANTONINE (after their mother).[196]

In 1922, Miss Philomel Erickson, who owned the old house at 3603 Carondelet, caused a stir in the neighborhood. Spectators called the home the "house of lanterns" for all the lanterns placed in the windows. The house had a history. When Erickson's father, Richard, bought it decades earlier, it was part of the Delachaise plantation, in a stretch of cultivated swampland that extended upward from Canal Street. During that time, it was difficult to find one's way through the swamp during dusky nights, so Erickson installed a "blood-red" glass pane in the transom above the front door as a beacon to show wanderers the "right path." Erickson's mother was afraid of electricity, so even though it was common, the family still used oil lamps and lanterns. After their parents died, Erickson and her sister, Martina, continued the custom. When Martina died, Erickson kept the lantern tradition alive. The red pane broke in 1917, but Erickson saved the pieces as a remembrance and

continued placing lanterns in her windows, briefly transporting Carondelet residents back in time, until her death in the 1940s.[197]

DELERY: The four Chauvin brothers (as they were known) and one nephew became landowners in New Orleans one year after its founding. Three of the brothers stayed and were instrumental in New Orleans history: Nicholas Chauvin de Lafrénière, Louis Chauvin de Beaulieu and Joseph Chauvin de Léry (who came to Louisiana with the second expedition of Iberville).[198] De Léry married Hypolite Mercier and had three children but was killed during the Natchez Massacre in 1729 (his son and namesake suffered a similar fate in 1736).[199] DELERY STREET in the Lower Ninth Ward is named after him but honors the whole family.

DESIRE: Tennessee Williams's 1947 Pulitzer Prize–winning play *A Streetcar Named Desire* was a manic sexual and psychological tragedy. While some wish to connect Williams's seminal play to Desire Street, the actual origin of the name comes from a true southern belle. It is unknown whether she shared the same exaggerated, helpless tendencies and delusions of grandeur as the fictitious Miss Blanche Du Bois, but Desiree Gautier de Montreuil was a daughter of Robert Gautier de Montreuil, owner of the eighteenth-century plantation located where the street now runs. He had two other daughters, Estelle and Elmire, but only Elmire and Desiree were fortunate enough to have streets named after them when the plantation was subdivided into a faubourg. Elmire was later changed to Gallier, and Desiree Street was corrupted over time into Desire. Despite having a street in her name, Desiree moved away from New Orleans when she married François de La Barre, who, like his wife, had a street named after him, Labarre Road in Metairie.[200]

The Desire streetcar ran down Bourbon, through the Faubourg Marigny to Desire and then back to Canal, but it ceased running in 1948. Public transportation still continues with a tribute to the street, although a "bus named Desire" does not have the same lyrical ring to it as the namesake of Williams's play.

DESLONDE: See St. Joseph (Chapter 2).

DREUX: The Dreux brothers held court in New Orleans. Pierre Dreux was present at the founding of New Orleans in 1718 and is believed to be one of the eight witnesses when Bienville landed. His brother, Mathurin, arrived the following year from France. The brothers acquired large amounts of land along Bayou Sauvage (a stream connected with Bayou St. John) and operated timber, brick-making and cattle businesses from their land, quickly prospering. They called their place Gentilly after the area of Chantilly in France and became known as the Sieurs de Gentilly.[201]

The Desire streetcar, made famous by Tennessee Williams, ran from the French Quarter to Desire Street in the Ninth Ward from 1920 to 1948. *New Orleans Public Library.*

The Dreux brothers' plantation was the fashionable place to visit, and they lived in a stately independence, "maintaining an attitude of aristocratic supremacy over what was virtually their seigneuire Gentilly."[202] Through the 1880s, Gentilly was the "countryside" for New Orleanians to view through Smoky Mary's train windows as it took them to Milneburg on the shores of Lake Pontchartrain. It saw its first suburban development in the 1920s and a boom after World War II. DREUX STREET remembers the brothers, and GENTILLY BOULEVARD carries the name they lent to their plantation, the adjoining bayou and the whole neighborhood.[203]

DUFOSSAT: There is an old joke in New Orleans. "Q: Why can't the lawns be watered at the Latter Library? A: Because you can't 'turn on Dufossat' there." The Latter Library sits on St. Charles Avenue between Soniat and Dufossat Streets, and Dufossat runs one way toward the avenue, so a car cannot turn there to get to the library.[204] Another quirk of the areas is that three streets near the library are named for the same person, Martin Valmont Soniat Dufossat, who earned this honor by

simply marrying François Robert Avart's daughter. When Avart subdivided his plantation in 1841, he called it Faubourg Avart and named VALMONT, SONIAT and DUFOSSAT STREETS after his son-in-law, as well as BELLECASTLE after a branch of Soniat's family in the Midi-Pyrénées region of France.[205] Although exceptionally generous to Duffosat, Avart named one street in his own honor, ROBERT. His daughter, however, did not warrant a street, instead being reminded of the men in her life on every corner of her family's faubourg.

EGANIA: Juan Y. de Egaña was a wealthy merchant and sugar planter who owned plantations in Thibodaux, Grand Isle and downriver from New Orleans in Plaquemines Parish.[206] He died in 1860, sparking years of litigation over his estate, which was of "great interest" due to the "marked peculiarities and the amounts of property involved," which was more than $2.5 million.[207] Manuel J. de Lizardi, another wealthy landowner, was one of the interested parties. From 1848 to 1853, he had been a partner *in commendam* (limited partner) to Egaña, investing in his business. Egaña's will named two executors, one each for his affairs in Spain and in Louisiana. Lizardi, however, intervened and declared himself liquidator of Egaña's business affairs, awarding himself hundreds of thousands of dollars from the estate. Egaña's Louisiana executor and his creditors did not take kindly to this and filed suit. Judge Whitaker ruled that Lizardi's partnership with Egaña had long since ended, so Lizardi had no claim and had to pay everything back. Lizardi fought back, claiming that he was Egaña's legitimate partner and the rightful liquidator, but he was denied.[208]

Some of Egaña's creditors, perhaps not satisfied with their proceeds from the succession of the estate, then sued Lizardi personally, arguing that if he was Egaña's partner, as he said, he should pay them for Egaña's debts. Lizardi then did an about-face from his previous position, saying that the court ruled that he was *not* Egaña's partner. Ultimately, the Supreme Court ruled that Lizardi was Egaña's partner, but he was a limited partner, not personally liable beyond the capital he contributed to the partnership. Sorry, creditors.[209]

Whatever kind of partnership Egaña and Lizardi had in life, afterward they became partners on the map of New Orleans. Lizardi died in 1869, and within ten years, the city honored the men with parallel streets running side by side from the levee to the backswamp in what today is the Lower Ninth Ward. And in a unique deviation from the norm for an altered New Orleans street name, Egaña's spelling was changed to actually preserve (nearly) the original pronunciation: EGANIA.

ELEANORE: See Hurst.

One of the two Doullut Steamboat Houses, built in 1905 on Egania Street in Holy Cross, affords an expansive view of the Mississippi River from its crow's-nest.

FORSTALL: Historian Grace King said of the Forstall family that they "lie like a stratum of rich ore under the soil of New Orleans society. Scratch the surface under any prominent name, and you tap a Forstall. The vein is pure and true, and it has yielded in the past a good profit to the city."[210] Edmond Jean Forstall, who was in the state legislature for twenty years and an agent of the London banking house Baring Brothers, owned a plantation in the Lower Ninth Ward, where FORSTALL STREET is today.[211]

FOUCHER: See Delachaise.

GENTILLY: See Dreux.

GRAVIER: See St. Joseph (Chapter 2).

GREEN: John Green is another man who had a faubourg and street named after him. In 1836, he and his partners subdivided the Lebreton/Foucher plantation, between Carrollton and the Foucher property that would become Audubon Park, into Greenville.[212] Green Street was named after him, and while it was not necessarily named for foliage or trees, the streets running parallel to it, Birch and Hickory, were. The three fit well together. Green also created the Bloomingdale neighborhood, slightly downriver from Audubon Park, and named its lone long-ways street STATE STREET.[213]

HARMONY: Although HARMONY and PLEASANT STREETS are not named after plantation belles, their names represent some of the traits that were so esteemed in ladies of that era and social standing. Laid out as part of Faubourg Delassize in 1836, their original street names were Augustine and Eulalie, which do appear to have been specific belles. Their names were changed, however, when the area was annexed by the city of Lafayette in 1844.[214]

HURST: In 1831, Cornelius Hurst, Pierre Joseph Tricou and Julie Robert Avart purchased equal shares of Jean Baptiste François LeBreton's ten-arpent plantation, which extended from the river to Nayades (St. Charles) and from an unnamed street (soon to be called Joseph) to approximately present-day Henry Clay Avenue. The following year, Hurst bought Tricou's tract and thus owned the downriver two-thirds of the original LeBreton plantation. This area became Hurstville.[215]

Hurst subdivided his property and named streets: HURST after himself, ELEANORE after his wife (he also had a daughter named Eleanor), ARABELLA after one of his daughters, JOSEPH (after his son Cornelius Joseph, who died in 1830 at the age of two) and BENJAMIN (after a friend).[216] Hurst also named NASHVILLE AVENUE after the prospective New Orleans–Nashville railroad that he envisioned running through his property and increasing its value. Hurst's optimism about luring the railroad explains Nashville's relatively spacious width.

The Panic of 1837, sparked by declining cotton prices and the bursting of the real estate bubble, started a major recession and brought New Orleans's burgeoning prosperity to a standstill. It took roughly eight years for the city (and the nation) to recover, but by that time, the railroad and Hurst were bankrupt.[217] Even before the panic, Hurst tried to hide his assets from creditors by "selling" property to his brother, John Hurst, who was also his employee and lacked the financial resources to purchase such properties. The creditors sued Hurst in 1845, with the courts ruling in their favor.[218] His wife, Eleanore, had died the previous

year of a "painful and protracted illness," and Hurst died six years later of cholera at fifty-four, with only a short mention in the *Times-Picayune*. Although the railroad never came, and he died broke and broken, Hurst's streets survive today as lovely residential lanes in Uptown.[219]

Another of Hurst's grand creations survives too. In the early 1830s, he built a stately mansion facing Tchoupitoulas, bounded by Joseph, Arabella and Annunciation. The Colonial-style home was known as the Hurst Mansion and was considered the apogee of antebellum architecture. With its cypress shutters, Palladian windows, giant columns, red chimneys, cedar rafters and stanchions, the house harkened to a time when "New Orleans was young and steamboats were a novelty."[220]

Louis and Louisa Schwarz eventually purchased Hurst Mansion. Louis died in 1893, and Louisa passed away in 1913 at the age of ninety-two; newspapers subsequently marveled at the house's "remarkable state of preservation."[221] One month after she died, the American Institute of Architects, in town for a convention, toured the Hurst home.[222] To replicate the feeling of the "model of antebellum architecture," the architects and their wives were treated to special "entertainment" that added a "further touch of realism" from the era in which the house was built. "Mammies" in chignons distributed pralines while "plantation negroes" sang "old-time songs."[223] But after Mrs. Schwarz's death, the "pride of old Orleans colonial mansions during slavery days" quickly fell into decay.[224]

In 1921, Ike Stauffer acquired the property for the sole purpose of moving the home. He hired an elderly couple to live there and slowly restore the garden until its relocation. The garden was a "dreary waste," and the home was not much better; the cypress shingles were warped, the broad steps leading to the grand doorway were rotten in places and the mortar that held the bricks together was eaten away. The mansion's dungeon, where "unruly slaves were once imprisoned," now had rusted iron bars and three new residents—stray dogs who refused to leave, "content to bask in the warm summer's sun or loaf in the shadows of the dungeon."[225] Eventually, Ike Stauffer moved the grand old mansion, once the jewel of Hurst's prosperity and the centerpiece of Hurstville, and rebuilt it brick by brick at 3 Garden Lane, opposite the New Orleans Country Club and a stone's throw from Metairie Cemetery, where Hurst and many of his relatives are buried.

HUSO: Charles Huso was one of the first homeowners in the town of Carrollton in the 1830s. His home stood at the corner of Levee (now Leake Avenue or River Road) and Short Streets but was destroyed during the Civil War. HUSO STREET is named after him.[226]

JOSEPH: See Hurst.

JOSEPHINE: Margarite Wiltz's life was dramatically affected by Spanish rule of Louisiana. Wiltz was married to wealthy merchant Joseph Milhet, who was executed in 1769 under the order of General Alexander O'Reilly for his role in the Rebellion of 1768.[227] Wiltz was left with a daughter, Catherine. Eight years after Milhet's death, Margarite married Don Jacinto Panis, a Spanish captain and sergeant major, apparently unaware (or unbothered) that he officiated the execution of her husband.[228] Catherine, who like her mother had valid reasons for hating Spanish military men, ended up marrying one herself: Pierre Georges Rousseau.[229]

During Wiltz's marriage to Panis, he purchased land above New Orleans, which later made up a large part of the city of Lafayette.[230] After Panis died, leaving Wiltz a widow again (and sole heir to his property), she subdivided the plantation, which was commonly called Rousseau's Plantation because Rousseau operated a brickyard on the property at what is now Tchoupitoulas and Seventh.[231] Wiltz advertised in 1807 that her lots were "an agreeable and salubrious asylum" and one of the "finest cypress-woods," but it was not officially subdivided until 1813 at the river end and 1818 at the swamp end.[232] There was a *Cours Panis* to honor Wiltz (who was known as Widow Panis), but it was later changed to Jackson Avenue. ROUSSEAU is named after Wiltz's son-in-law, and it is believed that JOSEPHINE and PHILIP STREETS are named after two of her children.[233] SORAPARU was named after Jean Baptiste Soraparu, a close friend of the family who assisted in financial matters.[234]

JULIA: Julia Street's etymology is unclear. Most historians believe that it is named in honor of philanthropist and slave owner Julien Poydras's cook, Julie Fortier, a free woman of color, although this is not proven.[235] It is also possible that it was a nickname for Julien, as on early maps Julia Street is spelled "Julie."[236] In 1852, almost thirty years after Poydras's death, Florida Landing Street was changed to Julia. Located where the Central Business District meets the Warehouse District, Julia is the anchor street for the New Orleans Arts District. In the mid- to late 1970s, the street underwent a major revitalization, with its old industrial warehouses becoming art galleries, restaurants and museums. Today, on the first Saturday night of each month, galleries in the district host an art walk, with Julia as the focal point for a street party combining art, music, food and drink. Regardless of where the name came from, Julia is now one of the cultural heartbeats of the city.

LEONTINE: Debt followed Samuel Ricker wherever he went. He married wealthy belle Eliza Beale in the early 1830s and almost immediately engrossed

his wife and mother-in-law in his debts. When Eliza died in 1836, Ricker boarded their daughters, Leontine and Octavia, year round at Ursuline Convent and proceeded to lose three of his wife's properties in nine years. Through dishonesty and fate, he then managed to gain control of part of the old Beale plantation, uptown in Jefferson City, lost by his mother-in-law. In 1849, the estate was subdivided into Rickerville.[237]

Ricker could not escape his bad practices, though, as in 1851 his sister-in-law, Céleste Beale, sued him for not only cheating her with a lowball price for her share of the property but also failing to make payments. Ricker's daughters sued him for mishandling their mother's estate, but they had to get in line with the other creditors, including Jefferson City for back taxes, mortgagors and even a carpenter who was not paid. One creditor, John Pearson of Boston, with whom Ricker had done business, intervened in the daughters' suit and in June 1856 won a Supreme Court ruling that tore down Ricker's false kingdom. Rickerville was seized and sold, and Samuel Ricker disappeared, shamed and broke. Although his daughters did not win their case, they do live on in their family's old estate and their father's old neighborhood as LEONTINE and OCTAVIA STREETS. This appears to be the only thing they ever got from him.[238]

LIVAUDAIS: See St. James (Chapter 2).

LIZARDI: See Egania.

LOUISA: See Clouet.

MILLAUDON: Laurent Millaudon was born in France in 1768, immigrating to New Orleans in 1802. From meager beginnings, Millaudon saved his money, worked as a merchant, invested in real estate and, by 1860, owned the largest sugar plantation in the state.[239] Millaudon, along with Samuel Kohn, developed and sold lots in East Bouligny and Carrollton.[240] Like his partner, Kohn emigrated from Europe in the early 1800s with little money but became a tavern owner and a wealthy real estate investor.[241] As early financiers of Carrollton, both men got streets in the area, although as often happens with New Orleans streets, Kohn became altered, to COHN. There was a Solomon Cohn who owned a ropewalk in Carrollton, after whom some sources say the street was named; however, the historical record is unclear, and it seems likely that it would have been named after the developer.[242] Samuel Kohn eventually returned to his village in Bohemia, where the whole town "was thrown into a paroxysm of the most intense excitement," and then he retired in Paris.[243] Millaudon died

in 1868, and the *Times-Picayune* reported that he was of "slender physique and apparently weak constitution, but he lived to bury three generations of men" and acquired property worth roughly $2 million.[244]

Octavia: See Leontine.

Peniston: Dr. Thomas Peniston is remembered in this Uptown street, as is his wife, Amélie (Amelia) Duplantier, who was a ward of Madame Louis Avart (Claudia Augustine Eugénie Delachaise). Avart was widowed in 1812 with no children of her own. In 1840, Amélie married Peniston but died five years later. In 1849, Avart subdivided her plantation, naming Amelia in honor of her adopted daughter, Peniston Street after her son-in-law and the whole faubourg of St. Joseph after their son Joseph.[245] Avart already had her family name in Delachaise Street.

Philip: See Josephine.

Pleasant: See Harmony.

Poeyfarre: Jean Baptiste Poeyfarré married Elizabeth Louise Forstall despite their nearly forty-year age difference. When Poeyfarré died in 1824 at the age of ninety-two with no heirs, his widow continued to live on their property on the old Delord/Duplantier plantation, which was being subdivided around her. In 1831, a new street was cut through, right alongside her house, and named after her late husband.[246]

Robert: See Josephine.

Rousseau: See Josephine.

Short: Samuel Short was credited with building the first house in the town of Carrollton in 1834. A second house Short built was deemed historical because it was the first place occupied by the mayor and council after Carrollton's incorporation into a town.[247] Short is honored with a street in, where else, Carrollton.

Soniat: See Josephine.

Soraparu: See Josephine.

TOLEDANO: Joseph Wiltz subdivided his property into forty-two lots in 1807 and called it Quartier Plaisance, after a community in San Domingo. A canal separated it from Faubourg Delassize, and Christoval Toledano brought some land from Wiltz.[248] Toledano was a veteran of the War of 1812 who died in 1869, but he lives on with a street in his name running through his old Uptown property.

TREME: Two streets and one faubourg in New Orleans are named after the same man: hatter, convicted murderer and real estate investor Claude Tremé. Tremé came to New Orleans in 1783 from France. A hatter by trade, at four o'clock in the morning on December 21, 1787, he shot and fatally wounded a slave named Alejo, who belonged to Francisco Bernoudy. Tremé and his housekeeper insisted that Alejo was in their yard, while the dying slave claimed that he was walking down the street when Tremé shot him. The court found Tremé guilty, sentencing him to five years in prison. After serving his time, he petitioned Governor Carondelet in 1793 to resume his millinery business. Five days after Tremé was granted the right to continue his vocation, he petitioned to marry Julie Moreau, the granddaughter of Madame Julie Prevost Moreau. Since Tremé had no proof of his birth or heritage, he had witnesses testify that he was suitable to marry the prominent Moreau's granddaughter. The couple married, and after Moreau's death, Tremé became tremendously wealthy. In a few short years, the hatter went from a cramped jail cell to one of the largest plantations in New Orleans.[249]

It appeared, however, that Tremé was not interested in managing a large plantation. In 1798, he created *Rue St. Claude* (named after his patron saint), which ran roughly perpendicular to Bayou Road, and soon subdivided his plantation, selling many plots to free people of color (including women) and to islanders fleeing the Haitian Revolution.[250] City surveyor Jacques Tanesse created Faubourg Tremé in 1812, which stretched from Rampart to the backswamp and from the Carondelet Canal (now the Lafitte Corridor) to present-day St. Bernard Avenue, and named the first street beyond St. Claude TREME STREET.[251] Today, it is a short street, squeezed out of the grid, but Rue St. Claude eventually became ST. CLAUDE AVENUE and now stretches down through the Ninth Ward to the parish line.

Faubourg Tremé has had just as interesting an evolution as did the man for whom it was named. It transformed from a cypress swamp bisected by a Native American portage to the site of the city's first brickyard to a plantation to the first U.S. residential neighborhood for free blacks. Its earliest residents were Spanish, French, Creole, *gens de couleur libres* (African Americans who had

Armstrong Park in Tremé is just steps from the French Quarter, filled with sculptures, ponds and historic Congo Square, plus a sculpture of Louis Armstrong by artist Elizabeth Catlett, dedicated by Lucille Armstrong in 1980.

never been slaves) and Haitians. Tremé is one of the most culturally diverse and creatively fertile neighborhoods in the city, home to artisans, craftsmen, musicians and various benevolent societies and social aid and pleasure clubs; it is included in the National Register of Historic Places.[252]

VALMONT: See Robert.

SILVER TONGUES, SILVER TIPS AND SILVER KEYS

Politicians, Pirates and Prodigies

I n New Orleans, politicians, pirates and prodigies are often indistinguishable and occasionally interchangeable. They specialize in sly exercises of dominion—be it dazzling an audience with an unexpected blast of music or imaginative double-dealings in the corridors of power and backrooms of bars. Whatever else their talents, though, the best of them share an ability to capture the hearts and minds of the city.

AUDUBON: John James Audubon first came to New Orleans in early 1821 hoping to find work as a portrait painter to finance the study of his real passion: birds. *The Birds of America*, his book of 435 life-size, hand-colored prints made from copper plates, was published in serial from 1827 to 1838 and made Audubon famous. When he died in 1851, newspapers across the country ran tributes to him.[253] Many included the story of how he once lost more than one thousand of his drawings to fire, but after a brief period of mourning, he picked up his "gun, note-book, and pencils, and went forth to the woods as gayly as if nothing had happened," replacing all of them in three years.[254] Audubon's tenacity was much like his famous namesake park in New Orleans. Formerly the Boré sugar plantation and then owned by the Foucher family, the city purchased it in 1871, calling it "Upper City Park." After hosting the World's Industrial and Cotton Centennial Exposition in 1884, it was renamed Audubon Park to honor the naturalist, but the once "unkempt stretch of tangled grass and massive oaks" faced challenges for decades, surviving "storms and strife, a perennial lack of money, lawsuits, and political changes."[255] Its zoo was once even called an

Uptown's Audubon Park, named for the great naturalist, abounds with natural and sculptural beauty, including this sunflower overlooking Gumbel Memorial Fountain.

"animal ghetto."[256] Through the late 1970s and early 1980s, the park established itself as a beloved oasis. AUDUBON BOULEVARD, PLACE, STREET and COURT are also named to commemorate this talented naturalist and artist.

BUDDY BOLDEN: The "King of the Cornet," Buddy Bolden is believed to be the first bandleader to play jazz. Born in 1877, in Bolden's heyday (circa 1895–1906), it was said that the power of his cornet was so strong that when he played in Algiers, his horn's melodious vibrations could be heard in New Orleans.[257] Bolden is also credited with producing a more novel variant of ragtime by adding blues. His band was in constant demand in the black community for parades,

dance halls and church functions, and there was never a shortage of female fans anxious to uncover any of his other talents. Despite his musical talents, he was also thought to be an alcoholic and schizophrenic. Eventually, Bolden was committed to the state mental hospital in Jackson, Louisiana, where he died in anonymity. He never recorded, but his music was kept alive by legends that passed from street corners to bar stools to other musicians' setlists, as well as in conflicting, fragmented interviews from old-timers who could still hear the blast of Bolden's cornet. He is buried in an unmarked grave at Holt Cemetery.

In 2002, a one-block street named after Bolden provoked conflicting reactions. Supplanting the final block of Toulouse, it has no residences and lies between City Park Avenue and Holt Cemetery. The *Times-Picayune* wrote that it was sad enough that Bolden died in obscurity without giving him an "obscure memorial."[258] But Bari Landry, chairwoman of Friends of Holt Cemetery, wrote that her group tried "to recognize this great musician."[259] It is bittersweet that a man whose musical influence was expansive is honored by a street that goes nowhere.

BURTHE: Although Dominique François Burthe was not a politician, he admired them. Burtheville was named for him (as was BURTHE STREET) after he subdivided his Uptown plantation in 1854 and named streets after three nineteenth-century U.S. statesmen: CALHOUN after John Calhoun, the seventh vice president and senator from South Carolina; HENRY CLAY after the "Great Compromiser," the congressman and senator from Kentucky who eventually received a statue honoring him in New Orleans; and WEBSTER after Daniel Webster, the congressman and senator from Massachusetts.[260]

Webster died in October 1852, and as New Orleans planned a day of mourning, it realized that it had forgotten to honor Clay, who had died in June of that year, and neglected to honor Calhoun two years earlier as well. The city fathers quickly organized a joint ceremony to commemorate all three and give citizens the opportunity to share "in the profound emotions of reverence for the illustrious dead and regret for the bereavement of the nation in their loss," as well as give the chance to express "public manifestations of these feelings."[261]

On December 9, 1852, more than five thousand processioners took part in the two-and-a-half-hour march that started in Lafayette Square, wound around the city and ended back at the square. The funeral car was sixteen feet high and eleven feet long, drawn by six gray horses and draped in black velvet with gold and silver trim and the names of the three men in large silver letters on each side. Three bronze (and empty) urns with the men's names inscribed in silver sat on top. When the procession returned to Lafayette Square, the empty urns were placed on an altar, and Reverend Walker delivered a benediction. The newspaper noted that it "will be an epoch in the history of New Orleans."[262] An epoch is

debatable, but Burthe's three streets running from the levee to St. Charles adjacent to Audubon Park still stand the test of time.

CALHOUN: See Burthe.

CLAIBORNE: In 1804, William Charles Cole Claiborne became the first governor of Orleans Territory. Appointed by Thomas Jefferson, Claiborne's primary job was to assimilate the former French and Spanish colony into the United States. There was no love lost between the Creoles and Americans, and Claiborne wrote to Jefferson saying that he found the citizens generally "uninformed, indolent, luxurious—in a word, illy [sic] fit to be useful citizens of a Republic."[263] Claiborne also wrote that under the Spanish government, education was discouraged, and "[w]ealth alone gave respect and influence, and hence it has happened that ignorance and wealth so generally pervade this part of Louisiana." He added that the youth had no accomplishments except "dancing with elegance and ease," although he admitted that the females were "the most handsome women in America."[264]

Claiborne's tenure in Louisiana was, in part, plagued by conflict and affliction. In 1807, he and longtime rival Daniel Clark dueled outside Baton Rouge—Claiborne assuming Clark a conniver and Clark considering Claiborne an idiot.[265] Claiborne sustained a bullet to his thigh, and the men called it even. After Louisiana earned statehood, Claiborne was grandfathered in as its first governor, only to succumb to a liver ailment before he could officially take office. As governor, Claiborne was handed a hodgepodge European colony and helped transform it into one of the eighteen states in the Union.[266] Befitting his leadership, CLAIBORNE AVENUE is a major thoroughfare—a backbone of New Orleans tying together a kaleidoscope of people and places from one end of the city to the other.

DERBIGNY: Pierre Derbigny was born to a noble family in France but fled during the French Revolution and made his way to Louisiana, where he would later deliver the first Fourth of July oration the state ever heard.[267] In 1820, he was in a group that was granted the first license to operate a steam ferry in New Orleans. He won the governorship in 1828, but less than ten months later, he was thrown from a carriage, later dying from his injuries.[268]

FLANDERS: Benjamin Franklin Flanders was Louisiana's governor for seven months in 1867–68 and then mayor of New Orleans from 1870 to 1873. During his tenure, Flanders received a letter that shaped Mardi Gras history. On January 31, 1872, the *New Orleans Republican* newspaper printed the following:

"To the Hon. B.F. Flanders, mayor: His Majesty, the 'King of Carnival,' believing that both the peace and prosperity of the city could be better secured by organizing the wandering maskers on Mardi Gras into a procession on Canal St., respectfully requests your permission to carry out his views, and the co-operation of the police in enforcing his 'self-assumed' authority. An early answer is requested. 'REX.'"[269]

The mayor agreed. The first Rex parade was organized by local businessmen to make the Grand Duke Alexis of Russia's visit memorable, which coincided with Mardi Gras of 1872. Rex became one of the city's most influential and iconic Mardi Gras krewes.

Flanders, who opened the city's coffers for the duke's visit, was criticized seven months later for being stingy toward local entertainment. It was proposed that New Orleans employ thirty-three skilled musicians for $15,000 to play in public squares. The *Times-Picayune*, knowing that Flanders would oppose it, suggested that the council and the "music-loving" public should respond that the expenditure be allowed under "funeral expenses," since the mayor's administration had "made no progress whatever" except to lay groundwork for the city's own funeral. "Music is a recognized concomitant of public obsequies, and by withholding this usual provision for celebrating mortuary solemnities in such cases the authorities have added insult to previous injury."[270]

Despite his refusal to support (and pay for) public music during his time as mayor, his administration was lauded for acquiring the land for modern-day Audubon Park for $800,000.[271] Flanders died in 1896 and was honored with a street in Algiers.

FRERET: William Freret was a native New Orleanian who owned a two-block cotton press in the American Sector with his brother James. He served as mayor of the city from 1840 to 1842 and again from 1843 to 1844. Freret was considered a very "hands-on" mayor and made surprise visits to public institutions for inspections.[272] Freret is best known for 1841's Ordinance No. 159, establishing and organizing public schools, considered the birth certificate for public education in the city.[273]

Despite Freret's general benevolence, he was met with scorn after supposedly attempting to thwart *charivari* in June 1843. Charivari, common during this time, was a cacophonous "serenade" (often with pots, pans and cowbells) directed at individuals or couples disapproved of by the community: a widow remarrying too quickly, a couple with a vast age (or class) difference, an unwed couple and so on. Allegedly, Freret interfered and "spoiled the sport," and months later, the *Times-Picayune* ran reports on the "death blows" to charivari, claiming that it was

a cherished custom and that if they were not careful, the next thing they knew, philanthropists would add orangutans to Parliament or, worse, teach women to be blacksmiths.[274]

Freret died in 1864, and the city soon honored him with a street.[275] Today, it is home to Freret Market, a food, art and flea market occurring on the first Saturday of every month (except July and August) and featuring musical acts of all sorts. Even those resembling charivari are welcome.

GENOIS: Charles Genois was a New Orleans native who served as mayor from 1838 to 1840. His administration was rather uneventful, except for Andrew Jackson's visit in 1840. Jackson's presidency had recently concluded, and he was in the city to commemorate the twenty-fifth anniversary of the Battle of New Orleans. He landed at Carrollton Wharf on January 8, 1840, to immense crowds, followed by an elaborate celebration that filled citizens with pride and pickpockets with profits.[276] Genois died in 1866, and seven years later, the uncelebrated mayor was honored with a street running through Gert Town and Mid-City.

GIROD: In 1812, Louisiana became a state, and Nicholas Girod became New Orleans's first elected mayor. From a prominent French shipping and mercantile family, it was said that Girod's devotion to his homeland bordered on fanatical. His inauguration ceremony was conducted in French because he did not speak English. Many proposed that since Girod was now mayor of an American city, he should learn English, but he countered that since he was mayor, more citizens should learn to speak French.[277]

Thankfully, Girod's devotion to France did not dissuade him from making improvements to the streets of New Orleans. He paved sidewalks with brick gravel and dug the first drainage canal. Another of Girod's acts was forcing the night watchmen hired to protect the city's inhabitants to actually do their jobs. People nicknamed the watchmen "watchinangoes" for their habit of sleeping on public porches and corridors, leaving the city to fend for itself. But the deed Girod is most famous for is the one he failed to complete: the attempted rescue of Napoleon Bonaparte from exile on St. Helena (see Napoleon).

Girod's death in 1840 caused great anxiety. With no heirs and no apparent will, New Orleanians were appalled that Girod left no bequests to charitable institutions or close friends. This was customary for wealthy gentlemen, and his lack of benevolence was viewed as a disgrace to the city. Months later, Girod's reputation was redeemed when some of his belongings were sold, and *bons* (promises) to individuals totaling over $710,000 were discovered in an old desk.[278] Girod bequeathed $100,000 to build an asylum for French orphans,

$30,000 to the Second Municipality and $100,000 to Charity Hospital, as well as some to other institutions and to friends.[279] The people of New Orleans were thrown into a "most joyous excitement" and were relieved that Girod's legacy would not be marred by extreme "odium."[280]

GOVERNOR NICHOLLS: Francis Redding Tillou Nicholls was born in Donaldsonville, Louisiana, in 1834, graduated from West Point and Tulane University and maintained a private law practice in Napoleonville when the Civil War broke out.[281] During the Battle of Winchester in Virginia, he "left his arm on the battlefield" from a cannonball. At the Battle of Chancellorsville, he lost his left foot after it was shot out from underneath him. With one arm and one leg, Nicholls returned to Louisiana and ran for governor in 1876. Citizens were encouraged to vote for "what is left of General Nicholls."[282] He won, becoming the first Louisiana governor after Reconstruction.

Nicholls was known as an honorable man and eloquent public speaker who disdained politics. He served two terms as governor, from 1877 to 1880 and from 1888 to 1892. He resumed his law practice after his first term but returned to the governor's office, primarily to battle the Louisiana Lottery Company (LLC), a corrupt private corporation that at the time was the only legal lottery in the United States. The company had no government officials auditing its books, so it was difficult to ascertain its finances, but some scholars estimate that the LLC cleared as much as 43 percent from its ticket sales. As a private company, an added bonus was that unsold tickets went into the cylinder, meaning that the company, on occasion, won its own prize money.[283]

The LLC was granted a twenty-five-year charter (and tax exemption) by the state legislature in 1868. In turn, it annually gave the state $40,000. When the charter was up for renewal, the company offered the state $1 million, but this did not mollify its critics, nor Nicholls. The LLC then offered Louisiana a million-dollar annual fee.[284] The legislature approved the charter, but Nicholls vetoed it, delivering his famous speech. Holding up his one arm, he declared, "At no time and under no circumstances will I permit one of my hands to aid in degrading what the other has lost in seeking to uphold the honor of my native state. Were I to affix my signature to the bill I would indeed be ashamed to let my left hand know what my right hand had done."[285] Nicholls's veto was overturned, but the LLC's triumph was short-lived. The U.S. Congress soon ruled that lotteries could not sell their tickets through the mail. The LLC moved to Honduras in 1894 and survived only a few more years.

In 1892, Nicholls became chief justice of the Louisiana Supreme Court, a position he held until 1911. He died on January 4, 1912, and Governor J.Y.

Sanders called him a "mighty warrior, pure jurist and unblemished political chieftain."[286] Despite this reverence, many property holders complained about changing Hospital, the nearly two-hundred-year-old street, to GOVERNOR NICHOLLS in 1909.[287] Nicholls State University in Thibodaux, Louisiana; a New Orleans vocational school for girls; a high school; and a wharf are also named in tribute.[288]

HAMPSON: John Hampson was a man of many talents. He was the engineer and superintendent of the New Orleans and Carrollton Railroad and was Carrollton's first (and later fourth) mayor after the city's incorporation in March 1845.[289] Hampson also patented venetian blinds in 1841, claiming that they had been used in railroad cars in New Orleans for more than seven years and gave "universal satisfaction."[290] New Orleans annexed Carrollton in 1874, and twenty years later, the city renamed that area's Washington Avenue to honor the first mayor of the short-lived town.

HENRY CLAY: See Burthe.

JACKSON: General Andrew Jackson was the seventh president of the United States, but to the majority of New Orleanians, he was first and foremost the hero of the Battle of New Orleans in 1815. Against all odds, Jackson defeated the British, who were determined to capture New Orleans. In gratitude, New Orleans renamed Place d'Armes to Jackson Sqaure. Jackson's death thirty years later brought widespread mourning to the city—members of the New Orleans Bar Association wore crape on their left arms for thirty days, stores closed, ships dropped their flags to half-mast and guns were fired at intervals of fifteen minutes from the public squares of the three municipalities.

One man, however, was not so enamored of the war hero. Bishop Blane refused to allow eulogies of Jackson in St. Louis Cathedral because he considered him a heretic—a Protestant. The irony that Jackson essentially saved the cathedral from the British and that the square on which it sat bore his name was lost on the righteous bishop. Blane stated he would have prayed for Jackson when he was alive, but it was a conflict to pray for non-Catholic deceased souls without a "dereliction of his clerical duty."[291]

Less than ten years later, New Orleans honored "Old Hickory" again with a statue by sculptor Clark Mills. The statue was unveiled in Jackson Square on February 9, 1856, with more than sixty thousand people in attendance, many of whom had traveled hundreds of miles for the tribute. The orator, L.J. Sigur, called Jackson "a real man of blood and of flesh, of bone and of sinew—a hero

St. Louis Cathedral is reflected crisply off the granite pedestal of the cannon in Washington Artillery Park.

of Homer, not the hazy and fanciful creation of a dreamy bard."[292] The statue shows Jackson on his horse, reared as he lifts his hat parallel to the cathedral, almost as if he is passing by but not daring to venture in. New Orleans also gave him a street, running from the river through the Garden District to Central City.

JEFFERSON: Former president Thomas Jefferson died on July 4, 1826, but New Orleans did not know until almost three weeks later, when the steamboat *Rob Roy* arrived from Louisville with the news. The *Louisiana Gazette* acknowledged that it often disagreed with the revered deceased, but in his honor, it would not utter "an offensive word."[293] John Adams, the second president of the United States, died

on the same day as Jefferson, and although New Orleans honored both of them on August 16, 1826, with a stately ceremony, Jefferson was clearly the star. The newspapers assured the public that even though Adams and Jefferson were once rivals, "no party feuds" would "disturb the harmony." The day of the ceremony, a procession formed in front of St. Louis Cathedral and marched through the city, returning for speeches on the "venerated patriarchs of the Revolution," among numerous other honors, including more than four hours of church bell tolls and the assembly of more than 180 Masons in full regalia. A street in Uptown honors Jefferson, and although he is at home in New Orleans, MONTICELLO STREET also honors him and his Virginia home.

JEFFERSON DAVIS: Jefferson Davis, the former president of the Confederate States of America, died in New Orleans on December 6, 1889. National newspapers claimed that Davis was given the grandest funeral ever seen in the South. Four days after Davis's death, the *Times-Picayune* ran out of column space to report all the resolutions and proceedings of meetings honoring Davis. He laid in state at city hall, and an estimated 100,000 southerners from several states viewed his body.[294] He was interred at Metairie Cemetery, where federal officers guarded his "sacred dust" twenty-four hours a day, protecting him from grave robbers, vandals and souvenir seekers. In 1893, Davis's widow moved him to Hollywood Cemetery in Richmond, Virginia.

Less than a week after Davis's death, a prominent clergyman suggested changing Canal Street to Jefferson Davis Avenue, since its name only perpetuated an "obsolete fact" that possessed "no historic interest or value." Eventually, in 1910, part of Hagan Avenue was renamed JEFFERSON DAVIS PARKWAY. A statue of Davis was placed at the intersection of Canal and Jefferson Davis the following year to honor the "leader of the Lost Cause."[295] More than five hundred schoolgirls formed a living Confederate flag, and other young girls presented floral tributes. The twenty-five-foot-high statue depicts Davis addressing "his people in behalf of states' rights."[296] Today, a passerby could be forgiven for thinking he is simply directing traffic.

JOHN CHURCHILL CHASE: John Churchill Chase was a beloved local cartoonist, writer and historian who directed his tart sense of humor at politicians and public officials with an "ever sharp, but never poisonous" wit. Controversial governor Huey P. Long once told him that the satrical pictures he drew of him were not flattering and that he would send Chase some photographs of himself to help him. Despite never receiving the photographs, Chase's depiction of Long was an instrumental contribution to his legacy.

On September 10, 1935, Long was assassinated at the state capitol. State police threatened to shoot all photographers and destroy their cameras. Chase went to

Baton Rouge, furiously sketching from eyewitness accounts. They were the only illustrations of the scene and were carried nationwide by the Associated Press.

Chase is well known for his 1949 book about the history of New Orleans's streets, *Frenchmen, Desire, Good Children…And Other Streets of New Orleans!* Passionate about the city's preservation, he and other historians protested the changing of the two-hundred-year-old Front Street to Convention Center Boulevard in 1983. Chase called it "historical heresy" and argued, "It's a shame to erase that much history. A street name belongs to those people who put it there. It should be endowed with reverence." Despite his stance on respecting street names, New Orleans in 1990 renamed a part of Calliope in the Central Business District to JOHN CHURCHILL CHASE STREET.[297]

KENNON: Robert Kennon entered the Louisiana governor's race in 1951 because the state constitution prevented Governor Earl Long from succeeding himself. Kennon beat Carlos Spaht, Long's chosen successor, and served as governor from 1952 to 1956. During his term, Kennon made voting machines available throughout the state, improved civil service and set up citizen boards aimed to remove state institutions from political control.[298] Long, known for his unique philosophical wit, once said of Kennon that he "had such an open mind, if he leaned over, his brains would fall out."[299] Kennon died in 1988 at the age of eighty-five and was honored with KENNON AVENUE in Gentilly near Bayou St. John.

LAFITTE: Hero or villain? Pirate or privateer? Patriot or profiteer? Jean Lafitte, leader of the notorious Baratarians, exists in legend just as much as in history, but a few things are certain. Lafitte was one of the earliest and most successful seafaring "fencers" in the Gulf, selling his stolen goods cheaper than local merchants, and was a magnet to women, who perhaps believed that his attractiveness absolved him of the nefarious deeds of which he was frequently accused. Governor Claiborne, however, was immune to Lafitte's charms and repeatedly tried to pass legislation to send an expedition to destroy Lafitte's headquarters in Grand Terre. When that failed, he offered a $500 reward for his capture, but Lafitte issued an even larger reward for the capture and delivery of the governor. If Lafitte's actions were deplorable to New Orleanians, he was redeemed during the Battle of New Orleans in 1815 when he rebuffed a British request for aid and instead offered his services to Andrew Jackson (in exchange for pardons for himself; his brother, Pierre; and some of his men).

Following the success of the battle, Lafitte soon returned to his pirating ways. Rumors of his death range from an honorable one in battle and burial at sea to the dishonorable possibility that he was killed by his own men. People still search

On the corner of Bourbon and St. Philip, Lafitte's Blacksmith Shop Bar was built sometime between 1722 and 1772 and is believed to be the oldest structure used as a bar in the United States.

for the buried treasure of Lafitte in Galveston and along other coastal areas of Louisiana. In New Orleans, you don't have to search for certain treasure—it can be found at Lafitte's Blacksmith Shop Bar on Bourbon Street (built during the colonial era and said to be the oldest building operating as a bar in the country). An 1891 ordinance by Mayor Joseph Shakspeare changed Union Street to LAFITTE "after the memorable buccaneer."[300]

LEPAGE: New Orleans existed in name only when Antoine-Simon Lepage du Pratz arrived at Dauphin Island in 1718. Bienville and his engineers, Pierre le Blond de La Tour and Adrien de Pauger, had returned from the site of the

new city only three days earlier. Undaunted by descriptions of a low, swampy place, du Pratz went to Louisiana and spent sixteen years (eight of them living with the Natchez tribe) before returning to France to publish the first edition of his acclaimed *Histoire de la Louisiane* in 1758, which described sixty different Louisiana birds and featured engravings of flowers, trees, fish and customs of the Natchez.[301] One of du Pratz's most important lessons came from a Natchez slave girl he acquired. Upon seeing a large alligator approach his campsite, he ran to get his gun; when he returned, he witnessed the girl calmly picking up a stick and beating the alligator "so lustily on its nose that it retreated." Through sign language, the girl communicated that a gun was not necessary to kill such a beast when a stick worked perfectly well.[302] Lepage Street in Faubourg St. John honors du Pratz, one of Louisiana's earliest historians and naturalists.

Lopez: In his time, Don Ramon de Lopez y Angulo was known for being the royal intendant under the Spanish governor Don Manuel Juan de Salcedo. In history, he is more famous for being the first husband of the controversial Delphine Lalaurie, whom the majority of historians portray as an antebellum socialite and sociopath (see Bartholomew, Chapter 3). In 1804, Lopez was recalled to Spain to "take his place at court." En route to Madrid, Lopez died suddenly in Havana a few days before his daughter was born, but he lives on in New Orleans with a street running from Broadmoor through Mid-City to the Fairgrounds area.[303]

Louis Prima: New Orleanian jazz trumpeter, singer and bandleader Louis Prima was born in 1910. Prima dutifully practiced his violin until jazz caught his ear, and he started his career with two-dollars-per-night neighborhood gigs. Prima moved to the neon glow of Bourbon and then the first-rate clubs of New York City, the flashy nightspots of Las Vegas and, finally, back to New Orleans thirty-four years later. It's arguable that Prima loved women as much as he loved jazz, marrying five times. When Prima died in 1976, he was buried in his family crypt in Metairie Cemetery. His tomb celebrates his love for jazz and for women, with the angel Gabriel playing the trumpet and the epitaph quoting one of his big hits: "When the ends comes, I know, they'll say, 'Just a gigolo' as life goes on without me." His street, actually a trio of short residential streets in New Orleans East, has gone on without him since 1979.

Maestri: In 1930, then governor Huey P. Long announced at a citywide rally at the Municipal Auditorium that he would die for Conservation Commissioner Robert S. Maestri. Long claimed, "I have many friends, but under the shining heaven I haven't got a friend I would offer up my life quicker for than Robert Maestri."[304]

The angel on Louis Prima's grave appears to be swaying with the music of the bandleader's groove.

Maestri was born in New Orleans in 1889 to Italian immigrants. With little formal schooling, he displayed astute business skills at an early age, particularly in real estate, and became one of the wealthiest and most prolific property owners in the city.[305] After Long died in 1935, three of his stalwarts decided that Maestri should be the next mayor. Since no one dared to challenge Long's machine, Maestri ran unopposed in 1936, serving until 1946. Many historians state that Maestri began his mayoralty with genuine interest in the city (even loaning it money at zero interest), but most agree that he ended it focused strongly on his own interests and those of his friends. Prostitution and gambling burgeoned, and vote-buying was common.[306]

No one could deny that Maestri was a colorful character. He chomped on cigars, and his coarse language and phrases won him praise and ridicule. His most

famous utterance came when President Franklin Roosevelt visited New Orleans and went to Antoine's Restaurant. As Roosevelt was eating oysters, Maestri blurted out, "How ya like dem ersters?" One of the senior waiters recalled that no one dared laugh. "If you were the mayor at that time, you didn't get corrected about your English."[307] During his term, Maestri halted a movement to rename a section of Orleans Avenue after him, but in 1983, the city renamed two streets bordering Lafayette Square to NORTH and SOUTH MAESTRI STREETS.[308]

MADISON: This one-block street in the French Quarter was named after Virginian and fourth U.S. president James Madison. Before his presidency, Madison was the secretary of state under Thomas Jefferson and helped supervise the Louisiana Purchase, for which the city of New Orleans honored both men in 1826 with two streets bearing their respective names, each running from Decatur to Chartres, through the blocks on either side of Jackson Square.[309]

Years later, Jefferson was renamed for former governor James Wilkinson. While these two contemporaries cradle one of the most historic and famous sites in the city, they could not be more different. Madison is viewed as the Constitution's staunchest defender, while Wilkinson was opposed to it. Madison is considered a patriot, while Wilkinson is considered an American traitor and spy for Spain. Madison, while president, court-martialed Wilkinson for treason. Their parallel street placements are fitting—never crossing each other but forever connected. At exactly 380 feet, MADISON STREET is tied with Wilkinson Street as the third-shortest drivable street in the French Quarter.[310]

MONTICELLO: See Jefferson.

MOUTON: Alexandre Mouton was Louisiana's governor from 1843 to 1846. The state's finances were so poor that Mouton sold state-owned properties, steamboats, equipment and slaves to balance the budget. In January 1861, Mouton was chosen as president of the Secession Convention in Baton Rouge, and for two months after it seceded, Louisiana was a republic, until it the joined the Confederate States of America in March.[311] Despite Mouton's support of slavery, the *Times-Picayune* reported that at his funeral in 1885, in the "most impressive event" the reporter had witnessed in years, two elderly African American servants acted as pallbearers alongside "such distinguished personages as Judge Martells, attorney Laurent Dupré and others."[312] Mouton is honored with a street in Lakeview.

O'KEEFE: Native New Orleanian Arthur Joseph O'Keefe succeeded Mayor Martin Behrman, who died in 1926, a little more than a year into his fifth term. O'Keefe

served until 1929, when he took a leave of absence because of an illness. During O'Keefe's administration, construction started on the Municipal Auditorium in Tremé, with O'Keefe driving the first piling. The building opened in 1930 and for years was home to Mardi Gras balls, Russian ballets, high school graduations and even pro wrestling, until it sustained extensive damage following Hurricane Katrina. Today, it is shut down, with no definite plans for its future. O'Keefe died in 1943, and in 1961, Dryades in the CBD was renamed O'KEEFE AVENUE in his memory.

PATTON: Isaac W. Patton served as mayor of New Orleans from 1878 to 1880. During his tenure, he reduced the city's debt by 50 percent and improved sanitary conditions, which helped lower the death rate. Patton died in 1890 at the age of sixty-two and was buried according to Masonic rituals.[313] That same year, New Orleans honored him with a street in Uptown.

PAUL MORPHY: In the early nineteenth century, chess masters rarely hailed from the United States and certainly not from New Orleans, but the trend stopped in 1837 with Paul Morphy's birth.[314] Morphy learned chess by watching his father and uncle play, and when he was thirteen, he defeated visiting Hungarian master Janos J. Lowenthal.[315] Morphy obtained his law degree from Tulane University at twenty, a full year before he could legally practice law in Louisiana. Instead, Morphy accepted an invitation to play in the first American Chess Congress in New York City. He won and was declared the U.S. chess champion.

The following year, Morphy traveled to Europe, checkmating his way across the continent. In Paris, he frequented the Café de la Régence, where he once played eight opponents simultaneously while blindfolded, calling out his moves. The matches lasted more than ten hours, and Morphy won six and drew two. Known as a quick and aggressive chess player, his shy demeanor and petite appearance often shocked people. When he returned to New Orleans in 1860, Morphy announced that he would never play for money again.

The Civil War further delayed his law career (which never took off), and Morphy fell into a routine of idleness: daily Mass, strolls and reading the newspaper in the St. Louis Hotel lobby.[316] In the early 1870s, reports surfaced that he suffered from mental instability, but in 1879, the *Times-Picayune* noted that Morphy was "a quiet little gentleman, engaged in minding his own business, which fact is perhaps sufficient reason for meddling correspondents to call him crazy."[317] But Morphy did, according to some accounts, develop a near psychosis about chess and shunned anyone associated with it.[318] On July 10, 1884, he slipped into a cool bath and suffered a stroke, dying at the age of forty-seven.

After almost seventy years, the iconic restaurant Brennan's on Royal Street closed in 2013, leaving this wistful remnant of its heyday. Previously, it was the home of Paul Morphy, who now has a street in Gentilly.

Interest in him continued, however, and more than forty years after his death, his house at 417 Royal appeared on maps as a "must see." In 1920, wealthy industrialist W.R. Irby purchased and donated it to Tulane University.[319] Tulane leased it to a number of tenants and then, in 1946, to Owen Edward Brennan, who turned it into the world-renowned restaurant Brennan's, which operated until 2013.

In 1924, the city named a street after Morphy near the New Orleans Fair Grounds. To this day, people play games with both strategy and luck there, doubtlessly without the success that came so easily to Morphy.

PIERCE: Franklin Pierce was the fourteenth president of the United States (1853–57) and was the only president to be denied renomination by the Democratic Party. Many scholars attribute this to his failure in handling the growing seccessional debate over slavery. Pierce (considered an alcoholic) lived quietly after his presidency, but months before his death in 1869, the *New York Herald* published an interview with him in which he said he was not satisfied with Congress's handling of Reconstruction, couldn't understand the "anti-filibustering activity" of the Grant administration regarding Cuba and had no faith in the women's rights movements.[320] New Orleans honored him with a street in Mid-City four years later.

PIRATES ALLEY: Situated in the French Quarter between St. Louis Cathedral and the Cabildo, the narrow, block-long Pirates Alley is suffused with mystery and myth. Originally called Orleans Alley, locals referred to it as Pirates Alley decades before the name was officially changed in 1953.[321] The alley's greatest legend (with no historical foundation) is that General Andrew Jackson left meetings at the Cabildo to sneak into the alleyway and meet with pirate Jean Lafitte to plan the city's defense against the British. A famous (and historically confirmed) resident of Pirates Alley was the Nobel Prize laureate William Faulkner, who wrote his first novel, *Soldier's Pay*, there.

During the Great Depression, the artist community in the French Quarter established periodic open-air art shows under the patronage of the Royal Street Association and the New Orleans Art League, which eventually became an institution.[322]

The cobblestone block continues to attract the artistic and lovers of the quaint, almost colonial feel. The alleyway is a popular stop for history and ghost tours, as well as for weddings, with many couples wishing to be married with St. Louis Cathedral at their back instead of inside its walls.

In 1990, Joe DeSalvo and Rosemary James purchased Faulkner's old home and turned the first floor into Faulkner House Books. Rumors of ghosts wandering the alley have always been whispered over sounds of quiet jazz music and sips of absinthe, but apparently they exist within the buildings too. James claims that Faulkner's spirit is a "terrible lecher" and that every time they have a pretty female employee, she has felt an "inappropriate caress."[323]

Pirates Alley is a symbolic and literal divide between the ultimate emblems of authority, the church and government, and is quintessential New Orleans—a picturesque and seductive subversion against anything orthodox.

PRIEUR: Denis Prieur became mayor of New Orleans in 1828 and served the city for ten years, elected nearly unanimously each term. During his mayoralty, he

A spire of St. Louis Cathedral looms above as dawn creeps into Pirates Alley.

approved the taxing of gambling houses, prohibited the exhibition of slaves for sale in the more frequented parts of the city and battled deadly cholera outbreaks. But Prieur is better known for what occurred after he left office.

On March 28, 1843, Prieur fought a duel with Louisiana senator George A. Waggaman. The former senator and former mayor fought over a "family affair of long standing" that could not be "settled" any other way.[324] Prieur shot Waggaman through "the front part of the legs of his pantaloons, between the knee and the ankle," forcing Waggaman to have his leg amputated. One northern newspaper commented, "It is not the least of the ridiculous notions that make humanity to be laughed at, the wounds of the honor are only to

be healed by wounds in the body."[325] Unfortunately, Waggaman died from his wounds a few days later. Prieur died in 1857, and less than twenty years later, the city named a street after the dueling mayor.

RENDON: Francisco Rendon was the royal intendant under Governor Francisco Louis Héctor, Baron de Carondelet, from 1794 to 1796, when he was sent to be the intendant of Zacatecas, Mexico.[326] Although his time in New Orleans was short, a street running from Broadmoor to the Fairgrounds area is named for the Spaniard.

ROBERTSON: It could be said that Thomas Bolling Robertson invented the excuse "the dog ate my homework." Robertson was the third governor of Louisiana after its admission as a state, serving from 1820 to 1824. During his time, Creoles and Americans battled over political control of Louisiana, verging on actual civil war. Many viewed Robertson as ineffectual for failing to settle the clash. His 1823 veto of a "Usury Bill," which Robertson alleged gave government too much control over businesses, enraged citizens. This anger was amplified when it was discovered that he stored uncounted state election returns in his dog's bed. Robertson resigned and became the U.S. judge for the District of Louisiana. He died four years later at the age of forty-nine. The street in his name follows the curves of the river from Loyola University in Uptown down to the Lower Ninth Ward.

ROFFIGNAC: Mayor Louis Philippe Joseph de Roffignac may have not been the most proficient speller (see Tchoupitoulas, Chapter 1), but he was accomplished in his contributions to New Orleans. Born in France in 1766, Roffignac fled in 1800 to escape the guillotine. Although French royalty, he "cast his lot" with the people of Louisiana and was awarded the rank of brigadier general for his service in the Battle of New Orleans.[327]

Roffignac was mayor of New Orleans from 1820 to 1828 and was immensely popular. In 1821, Roffignac introduced street lighting,[328] a progressive move at the time, as until then, citizens carried their own lanterns after dark. He also had prominent streets paved with cobblestones to prove that they would work despite the unstable ground, and as a result of their success, all streets paved from 1822 until 1852 used this material.[329]

A lover of theater, Roffignac passed an ordinance that forbade audience members from making noise during a theatrical production, running across the stage or reading notes. Theater owners could not allow delays of more than fifteen minutes between acts, and intermission could not exceed twenty minutes except in the productions with "grand scenery," and then intermission could

only last for thirty minutes—each incurring a possible twenty-five-dollar fine.[330] Despite his concern for the everyday citizen, Roffignac was still royalty, which was never displayed more vividly than in 1825, when his old friend and French aristocrat turned American Revolutionary War general and national hero the Marquis de Lafayette visited New Orleans as part of a triumphal tour of the United States. Historian Patricia Brady stated that during Lafayette's time in New Orleans, the "notoriously savage American press" reported on his every move with "never a snarl or bite of censure."[331] Unfortunately, Roffignac's passion for paving and his love of theater came to a head during Lafayette's visit. En route to the French Opera House, Lafayette's carriage was embarrassingly stuck in the mud, and New Orleanians had to wade in and carry Lafayette out on their shoulders.[332]

After Roffignac retired, he returned to France, dying in 1846 under peculiar circumstances: he was in a chair, examining a loaded pistol, when he had an apoplectic stroke, and the pistol fell to the floor, shooting him fatally in the head. It was alleged that Roffignac hoped to return to his beloved New Orleans.

Roffignac's greatest legacy, perhaps, is the drink named after him. Some reports state that Roffignac liked to have his cognac with soda water, ice and raspberry syrup, while others argue that the cocktail was only named in tribute, not based on any unique creation of his, and that there is no record of him even being fond of liquor.[333] However it came about, the Roffignac is made with two ounces of cognac or rye whiskey and one ounce of raspberry syrup mixed with club soda.[334] New Orleans also honored the beloved former mayor with the five-block ROFFIGNAC STREET in the Lower Ninth Ward. His noble friend Lafayette was also honored, with LAFAYETTE STREET and Lafayette Square in Faubourg St. Mary and the town of Lafayette upriver (which was annexed by New Orleans in 1853). The city of Lafayette in south-central Louisiana is also named after him.

ROMAN: Andre Bienvenu Roman served as governor of Louisiana from 1831 to 1835 and from 1839 to 1843. A Louisiana native, Roman was raised on a sugar plantation in St. James Parish. During his term as governor, he established a penitentiary system in Baton Rouge, increased funding for elementary and secondary education and created stricter banking regulations. He hit a tough spot in January 1843 when he stated that he was at a loss on how to pay all of the state bills from the treasury: "The greatness of our resources has from some years past tended to lead us astray. We thought them without limit, and abandoned ourselves to undertakings and speculations very far beyond our real strengths."[335] Roman was a prosperous sugar planter, but the Civil War destroyed him financially. Shortly after, in 1866, while walking down Dumaine Street a few yards from his

home, he collapsed and died suddenly at age seventy.[336] A street was named in his honor in 1873, running from Uptown to the Lower Ninth Ward.

ROSIERE: Gilbert Rosiere, known affectionately as "Titi" to his students, was one of the most celebrated fencing masters in New Orleans, who "put to sleep several adversaries."[337] Rosiere was born in France in 1812 and came to New Orleans as a young man to make his fortune. Famous for fighting seven duels in one week, Rosiere was still known for his gentle yet passionate personality. He was once moved to tears by the poignancy of an opera; when a man next to him snorted over his effeminate display, Rosiere slapped him across the face and challenged him to a duel the next day. Rosiere quickly slashed his snorting opponent, who learned that just because a man cried at the opera, it did not mean he wasn't cutthroat enough to be head of the Orleans Fencing Club.[338] Rosiere died in 1879 at the age of seventy, and New Orleans commemorated the popular duelist and teacher with a street shortly thereafter.

SOCRATES: Socrates Street in Algiers was named after the Greek philosopher, but if he were alive today, even with his vast wisdom, he would probably be baffled by locals pronouncing it "so-crates."

STORY: At first Sidney Story was mortified by the infamy attached to his name. The councilman had introduced an ordinance to allow a certain section of New Orleans to permit houses of prostitution without actually making them legal. Story, who had studied vice in European cities, recalled that "[f]rom Basin St. to Bourbon was an almost unbroken line of bawdy houses, and the girls who worked in the large stores on Canal St. could look out the rear windows of these stores upon scenes which would make a man blush for shame." He also contended that shop girls and ladies were forced to walk through "this reeking mass of sin and corruption" when commuting to and from work or on shopping expeditions. Vice, he argued, should not be permitted to "flaunt its scarlet drapery in the face of virtue."[339] Beginning in 1897, prostitution was allowed in twenty-five "Scarlet Squares," which became known as "the district," or "Storyville" after the councilman. Later, Story said that for any annoyance he suffered by having the red-light district named after him, he was rewarded for creating a "purer and better New Orleans."[340] That is debatable, but regardless, Storyville was closed in 1917 by the U.S. Navy. Story died twenty years later. The city named a street after him and his family in a far less controversial location, uptown near Tulane University.

VIGNAUD: Henry Vignaud was born in New Orleans in 1830. As a young man, he was a teacher, a journalist and an editor. During the Civil War, he was captured and imprisoned when General Benjamin Butler took New Orleans. Vignaud purchased a pass from a Federal officer and escaped to Paris.[341] Vignaud joined the American legation, later becoming the First Secretary of the United States Embassy (a position he held for more than thirty years) and vice-president of the Americanists Society of Paris. Vignaud never returned to Louisiana.

In his early seventies, Vignaud was the foremost scholar on Christopher Columbus, although some of his theories were quite controversial. He argued, among other things, that the astronomer Paolo del Pozzo Toscanelli's letter and chart were forgeries, that Columbus was a Spaniard and a Jew and that he was actually born in 1451. Some questioned Vignaud's sanity, but the French still honored him with the Grand Cross of the Legion of Honor.[342]

It appeared that New Orleans citizens never held any contempt for Vignaud's expatriate status; instead, they delighted in his fame. Local newspapers frequently boasted of his accomplishments, even claiming in 1909 that he would have been an ambassador had "gray matter counted as much as gold."[343] In 1911, the city council changed Florida Walk to VIGNAUD STREET to honor the distinguished New Orleanian, who ultimately found his place thousands of miles away.

VILLERE: Jacques Philippe Villere was Louisiana's first native-born governor. He served from 1816 to 1820 and worked to resolve disputes between the Creoles and Americans. He also sought to end unnecessary bloodshed by imposing the death penalty on the winner of any duel if it could be proven that this man initiated it. After his term, Villere retired to his sugar plantation (which was famously known as the place where the British set up for the Battle of New Orleans in 1815) and died in 1830.[344] Despite Villere's efforts to prevent unnecessary deaths, his own death directly caused another. At his burial, one of the musket shots fired in his honor struck and killed an eleven-year-old boy who was sitting on the churchyard fence. VILLERE STREET runs from CBD to the Lower Ninth Ward.

WALMSLEY: T. Semmes Walmsley might have been mayor of New Orleans, but that did not stop his pugilist ambitions. Walmsley was born to a prominent New Orleans family in 1889 and graduated from Tulane University Law School in 1912. Walmsley served as acting mayor in 1929, when Mayor O'Keefe retired due to illness, and was elected mayor in 1930 and 1934. During his second term, he crossed frequently with Huey Long (governor of Louisiana from 1928 to 1932 and senator from 1932 until his assassination in 1935). In 1934, the two men were

staying at the same hotel in Washington, D.C., and Walmsley threatened to beat up Long if he ran into him. The two did not meet, but their political rivalry was an ongoing presence in Walmsley's career.[345] Long erected obstacles to prevent New Orleans from properly functioning and stripped Walmsley of many of his powers.

The city soon tumbled into financial difficulties, with its revenues gashed by the legislature.[346] Long was assassinated in 1935, and when Richard W. Leche was elected governor in 1936, Walmsley resigned as mayor soon after to end what the *Times-Picayune* called the "despotic maltreatment of New Orleans" by the state's "dictatorship" and to restore home rule in the city (by appeasing the Long machine).[347] Walmsley died six years later of a heart attack at the age of fifty-three, and seven years later, he was honored with his own thoroughfare.

WEBSTER: See Burthe.

WHITE: Edward Douglass White Sr. served as a governor of Louisiana from 1835 to 1839. White was known as warm and affable but also as a bit of an "eccentric," demonstrated when he killed a political foe with his dagger for taunting him during an 1828 campaign. White, a Whig, was a steadfast supporter of Kentucky senator Henry Clay, even backing the Compromise Tariff, which decreased the security of the Louisiana sugar industry.[348] Despite this, he was elected governor and to multiple terms in Congress. When he died in 1847, the *New Orleans Bee* reported that his "popularity was immense, and what was rarer, it was well deserved."[349] Five years after his death, the city recognized him with a street running from Broadmoor to the Fair Grounds.

WILKINSON: Historian John S.D. Eisenhower described the Louisiana Territory's first governor, James Wilkinson, as "unique" in his "villainy," saying that "some officers were treacherous, some were avaricious, and some were simply incompetent. Wilkinson managed to combine all three."[350] Wilkinson navigated the political sphere with a beguiling deftness that led to the heights of respectability as the eighth commanding general of the United States Army and to the depths of treachery as a secret agent for Spain.

In 1787, Wilkinson took an oath of allegiance to Spain and worked toward breaking Kentucky from the Union and bringing it under Spanish authority. Known as "Agent 13," Wilkinson's rewards included thousands of Spanish silver dollars and concessions that allowed him a trade monopoly on the Mississippi River. After the Louisiana Purchase, Wilkinson was named governor of the Louisiana Territory, while William C.C. Claiborne was governor of the Territory of Orleans.[351] At the same time, Wilkinson plotted with former United States vice

president Aaron Burr to establish an independent nation in the West and attack Mexico, using New Orleans as their base.[352] When the plan looked doomed, Wilkinson turned on Burr and helped facilitate his capture, briefly putting New Orleans under martial law to thwart the plot that he had helped plan.[353] Wilkinson testified against Burr, which prompted public accusations against him. President James Madison court-martialed Wilkinson for treason; he was found not guilty by the court though public opinion was divided. Despite his polarizing history and reputation, Wilkinson was awarded the rank of major general in the War of 1812.

In the late nineteenth century, papers found in Baton Rouge confirmed Wilkinson's ties to the Spanish government. His accomplishments in traitorous activities were indeed extraordinary. Nevertheless, in 1924, New Orleans renamed Jefferson Street to WILKINSON. But as in life, Madison keeps an eye on him from nearby, with a twin, parallel street just a few blocks away named after the president who brought Wilkinson to trial.

WILTZ: Democrat Louis A. Wiltz had many entries on his political résumé: he served as mayor of New Orleans, as lieutenant governor of Louisiana, as a member of the state legislature and, finally, as governor of Louisiana beginning in 1880, which was the office he held when he died of tuberculosis the following year, a few weeks before his thirty-eighth birthday. His governorship was brief but fraught with controversy, particularly involving State Treasurer Edward A. Burke, who helped the Louisiana Lottery Company win a twenty-five-year charter and later fled to Honduras after it was discovered that he embezzled state bonds.[354]

After Wiltz's funeral the *Weekly Louisianian* noted that there were only three African American men in line to see his body but said that it was not unusual since he was "not considered the governor of that class."[355] The newspaper further stated, "Charity forbids us criticizing his public acts, we shall therefore throw a mantel of charity over his most glaring faults. Suffice it to say that his administration was an administration of blood and disorder in this city."[356] Still, the *Times-Picayune* noted that Wiltz entered the office at a time of public corruption and temptation but died a poor man.[357] After his death, friends started the Wiltz Fund to provide for his widow and five children. Time can be forgiving; almost forty years after his death, WILTZ LANE in Algiers was named after the prodigious politician.

ZACHARY TAYLOR and GENERAL TAYLOR: Twelfth U.S. president Zachary Taylor was born in 1784. Upon entering the army as a commissioned officer, he quickly moved up the ranks to a recruiting officer. In the spring of 1809, he landed in New

Orleans, where he met and married Margaret Mackall Smith and inherited 324 acres of land in Baton Rouge from his new father-in-law.[358]

Taylor earned the nickname "Old Rough and Ready" during the Seminole War for his willingness to endure the hardships of field battle. He frequently appeared disheveled and scruffy but was nevertheless exalted as a national hero. Consequently, multiple political parties wooed him for public office. His background had national appeal: northerners admired Taylor's military background, and southerners appreciated that he was a slave owner. Ultimately, he aligned himself with the Whig Party. Political clubs called "Rough and Ready Clubs" sprang up across the country. Taylor was immensely popular

City Bark, on Zachary Taylor Drive in City Park, is a 4.6-acre dog park for dogs of all sizes to play off leash. The *Mardi Gras Bead Dog* sculpture by Kathy Miller Stone is part of "Paws on Parade," a citywide project that raised money for the Louisiana SPCA.

in New Orleans, and on January 22, 1848, his supporters met at the Commercial Exchange to promote Taylor's potential candidacy. There were so many that the building could not hold them all.[359] In September 1848, New Orleans held a torchlight procession in honor of Taylor on the anniversary of the Battle of Monterrey; more than thirty Rough and Ready Clubs participated.[360]

During his presidency, Taylor vowed to follow his nationalist views, and despite owning about one hundred slaves, he took a hands-off stance on slavery, preferring to limit federal involvement and maintain sectional peace.[361] Still, as talk of southern secession grew, Taylor announced in 1850 that he would personally lead the army against southerners who threatened secession, promising to hang anyone involved (including son-in-law Jefferson Davis).[362]

Taylor served only sixteen months of his presidency before dying of cholera morbus. He was the nation's first (and so far only) Louisiana resident elected president. Years later, New Orleans named two streets after him. In 1924, parts of McDonogh, Elk and Urania in Uptown were renamed GENERAL TAYLOR, and in 1937, the city dedicated ZACHARY TAYLOR DRIVE in City Park during the annual City Park Festival. In life, he may have been disheveled and unkempt, but in New Orleans, Taylor fits well in the manicured confines of City Park.

CHAPTER 5
GLORIOUS FIGHTERS

Military Heroes and Civic Leaders

New Orleans loves Napoleon. Nearly two hundred years after his death, it's still difficult to find any part of town that is not either obviously or subtly influenced by the French leader. Many other military leaders have been honored, too, particularly in 1924, when the city renamed numerous streets after men who served in World War I. But New Orleans also honors some who took a more personal oath, fighting battles closer to home and facing challenges that many denied even existed. Often they were not afforded the same esteem and glory as those who fought on foreign fields or seas; they fought their battles in New Orleans's communities and courts, working to create a more equal place for all of its citizens. But even as the city honored these courageous individuals, in some cases the naming of streets proved to be battles in and of themselves.

A P TUREAUD: Alexander Pierre Tureaud Sr. broke many boundaries during his lifetime. Born in New Orleans in 1899, Tureaud got his law degree from Howard University in 1925, became one of the few African American attorneys in Louisiana and worked with the National Association for the Advancement of Colored People (NAACP) on several groundbreaking cases. Tureaud made strides politically and socially during a time when barriers for African Americans were only starting to fracture. He helped achieve equalization of teacher salaries (regardless of race) and desegregation of most state colleges and public schools in New Orleans before the Civil Rights Act of 1964.[363]

Tureaud died in 1972. The *Times-Picayune* called him a "citizen of a high order," and longtime resident Albert Dent stated that because of Tureaud, the present

generation would "live fuller and more dignified lives."[364] Less than ten years later, however, when the A.P. Tureaud Memorial Committee suggested renaming part of London Avenue to A P Tureaud Avenue, the response was quite different. Even though Tureaud lived in that neighborhood, the London Avenue Area Improvement Association was livid. President of the association Elaine Ratleff stated that residents were infuriated because they were left out of the decision-making process and that Tureaud sounded too much like Touro, six streets over, and would "cause confusion in mail delivery and directions of emergency vehicles."[365] Ratleff suggested that if Mayor Ernest Morial (New Orleans's first black mayor) wanted to name a street after Tureaud, then he should change his own street.[366]

Eventually, the city council voted five to one in favor of A P Tureaud Avenue, with Joseph Giarrusso casting the dissenting vote.[367] Even though a petition from half of the property owners supporting the change was presented to the council, the meeting dissolved into a name-calling match between citizens and city officials. In the end, Morial said that he had not envisioned the controversy the name change would create, saying that there were "deeper reasons for the opposition."[368] Even in death, Tureaud continued to push through obstacles, and thankfully, one of the symbols of his fight is A P TUREAUD AVENUE, which stretches from St. Bernard Avenue to Broad Street.

ARGONNE: The Meuse-Argonne Offensive (also known as the Hundred Days Offensive) was a succession of confrontations from September 26 to November 11, 1918, on the Western Front in World War I. The Americans advanced west of the Meuse River and the French west of the Argonne Forest to force the retreat of the German armies. The armistice was declared on November 11, 1918, before Germany could begin a counterattack.[369] The 114th Engineers and Signal Corps were two southern units made up primarily of New Orleans and Louisiana men and commanded by New Orleans officers who took part in the drive toward Sedan. Their last act before returning home was to connect France and Germany by telephone and telegraph.[370] In 1924, the city named ARGONNE BOULEVARD in Lakeview in honor of the battle and its participants.

AUSTERLITZ: See Napoleon.

BERNADOTTE: See Napoleon.

BOLIVAR and SIMON BOLIVAR: Known as "the Liberator," Simón Bolívar, the Venezuelan aristocrat, president of Gran Colombia and dictator of Peru, has two streets named in his honor in New Orleans. In November 1957, the city also

dedicated a $350,000, fifteen-foot-high granite statue by Avel Valimitjana that was a gift from Venezuela.[371] At the time, New Orleans's trade with Venezuela exceeded $82 million yearly.[372] Mayor Chep Morrison said during the ceremony that the city was "proud to accept such a beautiful and inspiring monument to the liberator of six great Latin American countries."[373] The celebration also included a military parade and a presentation of the keys to the city and certificates of honorary citizenship to visiting Venezuelan dignitaries. The statue is on Basin Street at Canal, BOLIVAR STREET is in the Tulane-Gravier area and SIMON BOLIVAR AVENUE runs through Central City.

BORDEAUX: See Napoleon.

CADIZ: See Napoleon.

CAMBRONNE: See Napoleon.

CARROLLTON: General William Carroll came from Nashville by flatboat with volunteers to aid Andrew Jackson in the Battle of New Orleans in 1815. He and his men camped on the Macarty plantation and were such a "thrilling interest" to the planters and their slaves that when a town emerged decades later, the town was named Carrollton in his honor for his "splendid part in the battle."[374] The town was connected to New Orleans by the New Orleans and Carrollton Railroad, and Carrollton Avenue was originally called Canal Street. The streets running from the river were named for U.S. presidents, while cross streets were numbered.[375] Carrollton had its own courthouse, post office, newspaper, public market and fire company.

In the beginning, Carrollton was separated from New Orleans by miles of plantations, gardens and swamps but was annexed by New Orleans in 1874.[376] A few years later, City Surveyor William H. Williams wrote, "[W]e cannot but feel some regret for the loss of our independence; yet we accept without dissatisfaction the change that has identified our future career with that of the great metropolis."[377] Today, Carrollton is known as an Uptown neighborhood and a street that cuts across the city from the river to City Park. It is an iconic New Orleans avenue, with homes, businesses, schools and magnificent oaks shading citizens and streetcars as they hum along.

CLARENCE HENRY: Clarence "Chink" Henry served for two decades as president of Local 1419, International Longshoremen's Association, the largest black union in the South with more than 3,600 members.[378] He started working on the

waterfront when he was just a teenager, demonstrating an innate ability to lead. Henry was elected in 1954 during a time of financial turbulence in the union, but he balanced the books and smoothed tensions with white unions. Known for his shrewd negotiating skills and tender heart, Henry was also strongly devoted to the church and civil rights.[379]

Henry died on May Day in 1974. Ten days later, a committee was established to determine a fitting public entity to be named in his honor.[380] In 1993, the dock board voted to name a four-mile port access road along the Mississippi River running from Felicity up nearly to Audubon Park after Henry.[381] Henry's greatest legacy is said to be the pension and welfare system that he created for the longshoremen's union. In the Clarence Henry Truckway, he is still looking out for the success and safety of his men.

Constantinople: See Napoleon.

Decatur: Stephen Decatur was a commodore who helped establish the U.S. Navy as a rising global power. Decatur served in the First and Second Barbary Wars in North Africa, the Quasi-War with France and the War of 1812. In 1807, fellow commodore James Barron was acting commander of the frigate USS *Chesapeake* when it was pursued and captured by the British ship HMS *Leopard*. Barron surrendered after firing only one shot and was later court-martialed and suspended; he went abroad to enter the merchant service. Decatur was a former subordinate of Barron's and one of the judges at the trial. After the War of 1812, Barron sought reinstatement, but Decatur was one of his most outspoken opponents. The two men exchanged a series of letters, with Barron accusing Decatur of insulting him with impunity. Decatur denied making any specific insult but refused to hide his contemptuous feelings toward Barron in his often sarcastic letters.

Instead of coming to an understanding, they agreed to a risky duel. The terms of the duel were pistols at eight paces, directed at each other and fired not before the word *one* and not after the word *three*. Typically, duelists' arms remained cocked or at their sides, but since they were already aimed, some argue that the odds were tilted in Barron's favor because he was notoriously nearsighted.[382] Both men were shot; Barron was crippled for life, while Decatur died in agony that night. Having survived multiple wars, he perished violently during a time of peace.

Newspapers across the country mourned Decatur's death, noting that he was the one who gave that "additional lustre to the star-spangled banner."[383] He was buried with the highest military honors. Still, rumors swirled about what had occurred between the two commodores. So, shortly after Decatur's death,

Decatur Street, named for naval hero Stephen Decatur, is home to another famous military leader, Joan of Arc, who gallantly guards the lower French Quarter.

his friends released their correspondence, and the letters were a sensation. Fifty years later, a newspaper stated that Decatur's death provoked the same outcry and attention as President Lincoln's assassination.[384]

In 1852, New Orleans named DECATUR STREET in his honor. The French Quarter stretch of the street was originally called *Rue du Quai* and then Old Levee Street, while in Faubourg Marigny, it was Victory Street. Decatur is one of the four streets that make up the "square" of the French Quarter. In its early years, the upper portion of Decatur closest to Canal catered mostly to visiting sailors, but over time, the street came to be home of landmark establishments—the French Market, Café du Monde and the gold-leaf *Joan of Arc* statue—loved by locals and visitors alike.

ELBA: See Napoleon.

FARRAGUT: David Glasgow Farragut was born in Tennessee, raised in New Orleans in the early 1800s and left for a navy career, but he returned in his sixties—not to reminisce but rather to capture the city. During the Civil War, he and his men took New Orleans in April 1862 and gave the "nascent Republic of the South a blow from which recovery was impossible, although its effects were long and valiantly resisted.[385] Farragut died in 1870 a full admiral, and the *Times-Picayune* diplomatically noted of the Southern-born warrior who helped capture the city of his youth that millions of his Southern compatriots saw him as a traitor, but they all had to agree on his courage. Still, they noted that "all Americans may not mourn at his loss in the same spirit nor with equal feeling of sorrow."[386] New Orleans overcame any past feelings of ill will and honored the naval hero with a street in Algiers.

GENERAL COLLINS: General Joseph "Lightning Joe" Collins was born in Algiers in 1896 and raised with ten other siblings while his parents ran a corner grocery store. A graduate of West Point, he earned his nickname in 1943 during World War II in the jungles of Guadalcanal for the speed with which his 25th Infantry Division attacked the Japanese.[387] On D-Day, Collins and his troops landed on Utah Beach, and he demonstrated his resolve and bravery throughout the remainder of the war. In 1970, the four-star general was honored with a street in Algiers as a part of the 100th anniversary celebration of Algiers's annexation by New Orleans. Collins attended the ceremony, proudly posing on his namesake street.

GENERAL DE GAULLE: French president Charles de Gaulle received a warm welcome from New Orleanians when he visited in the city in 1960. De Gaulle was given the city's International Order of Merit, made an honorary citizen and saw Victory Drive in Algiers renamed GENERAL DE GAULLE DRIVE in his honor. At the time, France was engaged in the Algerian War, and Mayor Chep Morrison dedicated the street by saying, "De Gaulle will forever be permanent in Algiers, the 15th Ward of New Orleans, not yours. But now, having a De Gaulle drive in our Algiers, representing a gesture of friendship and good will here, we hope may have the same echo in far-away Algiers."[388]

GENERAL DIAZ: Armando Diaz was an Italian general of Spanish descent and a hero of World War I. In December 1921, he visited New Orleans for a little over sixteen hours.[389] Diaz arrived at Union Station to thousands of people shouting, "Viva Diaz!" He was escorted from the station to a parade to city hall in a car so covered with flowers and wreaths that its front and back were

indistinguishable save for the steering wheel. The following day, he laid a wreath at a memorial flagstaff in Audubon Park; received honorary degrees from Loyola University and Tulane University; placed another wreath on the American Legion monument in City Park; had a gala luncheon of Louisiana food at the Grunewald Hotel, where he received a gold loving cup; visited the Quartier Club and was given a medal while thirty-six of New Orleans's most "beautiful girls" surrounded him with a laurel garland; visited the Italian Society, which gave him a cigarette case with his monogram inset with diamonds and where small girls from St. Mary's Italian Parochial School threw red roses at his feet and sang Italy's national anthem; and toured the American Sugar Refinery, where he viewed the battlefields of Chalmette from the roof. All throughout his short visit, crowds screamed well wishes and cried tears of gratitude.[390] But it was not just Diaz's arrival that served as a poignant symbol of the war. A few minutes before his appearance, the casket of an American solider, covered by a flag, was carried through the crowded station. The casket of the unknown solider and the war hero both embodied the realities of war: the losses, the gains, the quiet and often final sacrifices and the euphoric celebrations of victory.[391] Three years later, New Orleans honored General Diaz with a street in Lakeview.

GENERAL HAIG: Douglas Haig was the commander in chief of British forces in France and Belgium during the majority of World War I and was considered one of its best military leaders. Following the war, Haig worked with the British Legion, traveling through Britain and raising funds for former servicemen in need. He received the title of earl in 1919. Haig died of heart disease in London in 1928, but four years earlier, New Orleans commemorated him with a street in Lakeview.

GENERAL MEYER: Adolph Meyer was born in Natchez, Mississippi, in 1842 but eventually made Algiers his home. A Confederate war veteran, he later became brigadier general of the Louisiana State National Guard, but his real contribution to Louisiana was his time in Congress. In 1890, he was elected to the Fifty-second Congress and served for eight terms. While in office, Meyers secured a large appropriation for the New Orleans Naval Station in Algiers. This city was so appreciative that four years before his death in 1908, at the request of Algiers citizens, the city renamed Patterson Street, the "important avenue of Algiers," to GENERAL MEYER AVENUE.[392]

GENERAL OGDEN: Frederick Nash Ogden was a solider and statesman involved in one of New Orleans's most controversial events, which some scholars believe

helped lay the foundation for Jim Crow. Ogden was born in 1837 and fought for the Confederacy, later becoming the commander of the White League movement, an organization mainly made up of Confederate veterans who opposed "negro domination." In 1872, Democrat John McEnery ran for governor against Republican William Pitt Kellogg. After a rancorous campaign, both sides declared victory. Two inaugurations were celebrated, and two legislatures were assembled, prompting President Ulysses S. Grant to issue an executive order identifying Kellogg as the victor.[393] Many citizens, feeling resentful over the effects of Reconstruction, refused to recognize Kellogg as governor.

Tensions surged, and in the summer of 1874, the *Times-Picayune* published an editorial expressing the fears of "Africanization" and how whites needed to vindicate their race.[394] On September 14, 1874, the White League marched in the streets to battle the Metropolitan Police, an integrated force composed of 15 percent African American men. Thousands of onlookers watched as the White League forced the Metropolitans into retreat and claimed victory for McEnery. Ogden led and was injured in the skirmish, which became known as the Battle of Liberty Place. The federal government ordered the rebels to disband, but historians credit this moment as the start of a power shift in the government as the League's clout continued to grow.[395]

In 1891, the Liberty monument was installed at the foot of Canal Street to pay homage to the White League members killed in the battle. For the next eight decades, celebrations were held annually honoring the "heroes" and touting the incident as the end of the "Carpetbag Reign."[396] Sentiment shifted following the civil rights movement, and many saw the monument as a racist emblem celebrating African American oppression. New Orleans was divided: some citizens fought for its removal, and others fought to keep it. Ultimately, the monument was removed in 1989 and placed in storage during a street improvement project and then reerected on Iberville Street following a federal lawsuit filed and won by its supporters.[397] The monument's perception as a symbol of white supremacy was only reinforced when Ku Klux Klan grand wizard David Duke was involved in its rededication. Today, the Liberty monument stands in a much less prominent place than before (at the foot of Iberville, behind the Audubon Aquarium) and includes a plaque honoring the Metropolitan Police who perished in the battle. Still, graffiti representing both sides of the argument continues to appear on the controversial obelisk.

Ogden died in 1886 and had a low-key funeral, without the "booming of artillery, or pomp, or ceremony that often mock true sentiment" to honor the "brave, proud, patriotic citizen who served Louisiana in her day of need."[398] A street in Hollygrove was named after him eight years later.

GENERAL PERSHING: General John Joseph Pershing was an impressive figure. Standing a straight six feet tall, with broad shoulders and a trim waist, his square jaw and piercing eyes made many women claim that he was the most handsome man they had ever seen. Born in 1860, Pershing became the only living officer in the country's history with the rank of six stars ("General of the Armies of the United States").[399] Pershing commanded the all-black "Buffalo Soldiers" cavalry regiment in the final days of the Indian Wars, served in the Spanish-American War (so impressing the indigenous Moros that one of the tribes named him a minor noble) and chased Pancho Villa with five thousand American troops during the Mexican Revolutionary War.[400] But Pershing's actions as commander of the American Expeditionary Forces during World War I are credited with helping end the war. In 1918, embracing anti-German sentiment, New Orleans renamed Berlin Street to GENERAL PERSHING. But while a thoroughfare in Uptown was flattering, Pershing received what some New Orleanians considered an even greater honor when he came to the city in 1920.

Pershing arrived on February 16, 1920, to a hero's welcome. At a speech in Lafayette Square, policemen were powerless to hold back the twenty thousand people. Women "wild" with desire cast their ladylike pretensions aside as "kisses were thrown promiscuously to him." Tree branches bent under the weight of little boys anxious to catch a glimpse of their hero. Roofs and galleries blocks away from Lafayette Square teemed with crowds, content to view the general from a distance even though he looked like a "pigmy in khaki."[401] One newspaper declared that the general received an even greater welcome than the "savior of New Orleans," General Andrew Jackson, after the Battle of New Orleans.[402] All this was heightened by the fact that he arrived on Lundi Gras, the day before Mardi Gras. Since 1857, there had only been seven years when Mardi Gras was canceled: 1862–65, during the Civil War; 1875, due to "political unrest"; and 1918–19, due to World War I. With the Great War over, a celebration was long overdue.

On Mardi Gras morning, Pershing stood on the steps of city hall, was conferred the title "Duke of Victory" and given a medal with a diamond-encrusted crown. People were dressed for Mardi Gras, and some revelers in military uniforms pinned papier-mâché goats to their outfits (symbolizing how they "got the Kaiser's goat") and cheered their approval. But even a hero of Pershing's enormous magnitude could not make the majority of New Orleanians forget what mattered to them most. Their first Mardi Gras celebration in three years followed on the heels of the enactment of Prohibition only weeks earlier. The *Times-Picayune* wrote a long editorial bemoaning that despite brave efforts, never had a Carnival been met "with less enthusiasm" now that alcohol, which "warmed many past cold Carnivals, [was] absent."[403] Despite Pershing's visit helping the city shake off the "dead embers" of war, no matter how great of a man he was, he still could not turn water into wine.

GENERAL TAYLOR: See Zachary Taylor (Chapter 4).

HENNESSEY: Walking home from work, Police Chief David C. Hennessy was gunned down on October 15, 1890, outside his home. As he lay dying, he allegedly whispered that "dagos" did it; he had been scheduled to testify in a trial involving two rival Italian families. Anti-Italian sentiment was rampant in the United States at the time. Italians were often thought to be the "lowest" of the European immigrants, and newspaper headlines across the country claimed that Hennessy was killed by the "mafia."[404] Everyone of Italian descent in New Orleans was a suspect. Although many citizens owned firearms, any Italian carrying a gun was arrested immediately following Hennessy's assassination, a dozen in just a few hours.[405] City officials, anxious to bring the guilty party to justice and restore peace to the streets, first needed to bury their former police chief.

Hennessy's casket lay on a black bearskin rug in city council chambers, where thousands of New Orleanians from all walks of life paid their last respects. Businesses commiserated in various ways: the French Opera House exhibited two "superb" crayon portraits of Hennessy, and others displayed large photographs of the slain police chief swathed with streamers. The harbor station was draped in dark fabric, and all the ships' and steamboats' flags were at half-mast. Even Hennessy's pet horse was dressed in mourning garb.[406] The city's public lament was underscored by an intense need for retribution.

Eventually, nineteen Italians and Italian Americans were indicted for murder, but on March 13, 1891, a jury acquitted six and set three free on mistrial. At midnight, notes were delivered to the local newspapers that a meeting for all "good citizens" was taking place at ten o'clock the following morning on the steps of the Henry Clay statue to "remedy the failure of justice."[407] Various accounts numbered the participants from hundreds to more than eight thousand, but what is known is that an angry mob stormed the jail, dragged eleven of the defendants from hiding places under stairwells, behind brick pillars and huddled in corners of women's cells to deliver "justice" through gunfire, fists and knives. It was a paradoxical tragedy for a city so riven with racial inequality that blacks and whites could unite in their hatred of Italians. This bond in enmity was demonstrated when three black men and six whites joined in dragging an injured Antonio Bagnetto down Orleans Street by a rope around his neck through a crowd of men kicking, striking and beating him with clubs and sticks until they hanged him from a tree on the neutral ground.[408]

In the end, eleven Italians were shot or hanged.[409] Eight managed to hide, escaping the mob's fury.[410] It was the largest lynching in U.S. history. The newspapers, in general, approved; even the *New York Times* announced that Chief Hennessy had been "avenged."[411]

The grave of Chief Hennessy in Metairie Cemetery stands prominently above the surrounding tombs.

A move to build a monument honoring Hennessy was almost immediate. The city held fundraisers, including one unsuccessful one that featured a Shetland pony chariot race with ponies that didn't budge, a monkey race and an African American strongman from Indiana who lifted a barrel full of forty-three gallons of water with his teeth.[412] The Hallowell Granite Company in Maine made Hennessy's tombstone, even though seven of the nine workmen were Italians. The foreman reassured the public that they were "different" from those who murdered Hennessy and were in "perfect sympathy with the Americans who shot our evil-minded countrymen."[413]

The Hennessy monument was unveiled in Metairie Cemetery on May 30, 1892, to a crowd of respectful mourners, thankfully long before Freud published

his ideas on phallic symbolism. The twenty-six-foot monument looks less like a police baton and more like a case study of subliminal eroticism. Some of the tomb's inscriptions exhibit unintentional (or intentional) innuendo: "his fidelity to duty was sealed with his death," and "erected by his countrymen."

New Orleanians often remark that this monument is fair play and that, in the end, the Italians had the last laugh. In 1894, the city named a street after Hennessy and, in its charming casualness with language (or its habitual incompetence), incorrectly spelled Hennessy's name on the street sign (though correctly in the sidewalk tiles), adding an additional *e*: *Hennessey*. As Freud would say, there are no accidents.

JENA: See Napoleon.

LEE CIRCLE: Lee Circle was originally named Tivoli Circle (*tivoli* meant merry-go-round) because traveling circuses and shows would set up there, in the "wilderness" of New Orleans.[414] In 1877, an ordinance was passed to rename Tivoli Circle to Lee Place in General Robert E. Lee's honor. But the name change did not immediately dignify Lee, as supporters wished. The circle was a place of less-than-honorable activity. In 1880, the *Daily City Item* reported that employees (for a fee) left the gates open and permitted cows, horses and goats to "graze at their own sweet will." Furthermore, "vagabonds and tramps, of both sexes" made it their "trysting place."[415] Finally, on February 22, 1884, after years of the Lee Monument Association's struggle to raise the $40,000 needed, a ceremony was held to dedicate a statue to honor Lee, who had died fourteen years earlier. More than fifteen thousand people squeezed into the circle, with six hundred notables on the speakers' platform, including Jefferson Davis. At the start of the afternoon ceremony, dark clouds approached and gale winds blew. The sky opened up, and torrents of rain fell. The crowd scrambled for shelter in neighboring houses and sheds. For twenty minutes, it poured, transforming the military's "gay uniforms" into "bedraggled" outfits.[416]

When the rain abated, the sixteen-and-a-half-foot bronze statue was unveiled, and officials gathered at Washington Artillery Hall to determine how to continue with the ceremony, deciding to publish the orations instead. Just as the ceremony did not go off as planned, neither did the actual name. A few months later, W.I. Hodgson, secretary of the Lee Monument Association, wrote a letter to the *Times-Picayune* reminding it, its readers and especially the "city fathers" that the ordinance passed clearly stated that the enclosed ground was to be called Lee Place, not Lee Circle, as many were saying, and the outer section was to remain Tivoli Circle. Its correct designation should be Lee Place–Tivoli Circle.[417] However, New Orleanians continued to call it LEE CIRCLE and still do today. In 1924, they gave the general another honor, ROBERT E. LEE BOULEVARD, running from Lakeview to Gentilly; this name has stuck.

LEONIDAS: Known as the "Fighting Bishop" or the "Warrior Bishop," Leonidas Polk was certainly both. Born in North Carolina in 1806, he came under the influence of a reverend at West Point and resigned from the army to join the Episcopal Church ministry. In October 1838, Polk was elected missionary bishop of the southwest and, a few years later, moved his family to Louisiana, buying a sugar plantation near Thibodeaux. He had lost the plantation by 1853 and moved to New Orleans, taking charge of Trinity Church. Eager for Southern secession, he hoped it would be a peaceful split. When war was a certainty, he moved his family to Sewanee, Tennessee, viewing the war as an act of spoliation and incendiarism by the North.[418] Polk became a lieutenant general in the Confederate army (under some scrutiny—some believe it was because of his friendship with Jefferson Davis), and in 1864, he was killed by a three-inch round from a steel rifle cannon while standing on the crest of a hill at Pine Mountain, Georgia.[419] He was buried in Augusta, but in 1945, his remains (as well as his wife's) were reinterred at Christ Church Cathedral on St. Charles Avenue. Trinity Episcopal Church has a stained-glass memorial dedicated to Polk, and it is believed that LEONIDAS STREET, running through Carrollton and Hollygrove, is named after the man who once, when asked by a parishioner how he was going to throw off his bishop's robe for the sword, said, "I buckle on the sword over the gown."[420]

LYONS: See Napoleon.

MARENGO: See Napoleon.

MARSHALL FOCH: Ferdinand Foch, marshal of France and commander of the Allied forces toward the end of World War I, only spent nine hours in New Orleans in 1921, but he made an impression. New Orleans waited on "tiptoe" to welcome the "commander of all commanders," whom the *Times-Picayune* once called "the embodiment of genius" and the *New Orleans States* called "greater than Caesar, Frederick or Napoleon."[421] Anticipating his arrival, Boy Scouts were called to assist in keeping the crowds back, bringing their own staves and ropes and reporting to various areas all over the city. As with other war heroes who visited New Orleans, Foch's day was a whirlwind: military parade, honorary degrees from Loyola and Tulane and a memorial flagstaff dedication at Audubon Park. The Cabildo hoisted French and American flags, and during his visit there, the document authorizing the Louisiana Purchase was read in English and French, he was made an honorary member of the Louisiana Historical Society and he autographed a life-size portrait of himself.[422] Foch's visit was short, and New Orleans worked to make it memorable; however, it

is difficult to say if it stood out—by the end of his American tour, Foch had traveled more than sixteen thousand miles in forty-two states, visited at least two hundred towns and cities and had twenty college degrees conferred on him, the largest collection of degrees ever received by an individual up to that time.[423] In 1924, New Orleans gave Foch another honor by renaming a section of Toulouse Street in Lakeview after the distinguished French commander.

Martin Luther King Jr: In November 1976, the city council voted five to one to change the name of a thirty-five-block stretch of Melpomene Street running through a predominately black neighborhood in Central City to Martin Luther King Jr Boulevard. On January 14, 1977, the day before what would have been Martin Luther King Jr.'s forty-eighth birthday, Mayor Moon Landrieu gathered with about two hundred people for the dedication. Some believed that Canal Street was a more appropriate tribute considering the magnitude of King's contributions.[424] Other organizations criticized the selection of Melpomene as being racial and political. Landrieu defended the decision, claiming that Melpomene was picked for its "significance" of being "similar" to where King was from. The year 1977 was called "The Year of Upheaval via the Ballot Box" by the *Times-Picayune* since it saw (among other things) the election of Ernest N. Morial as the city's first black mayor and Sidney Barthelemy as the city's first black councilman-at-large, but while blacks had more representation in public office, difficulties over memorialization continued.[425]

In 1989, MLK Jr. Boulevard was once again thrust into local debate as Councilman James Singleton proposed to change the remaining part of Melpomene because of complaints that it ended at a white neighborhood and because King was a civil rights leader who represented "an image in this community."[426]

The proposal drew criticism from the Coliseum Square Association (CSA), the New Orleans Historic District Landmarks Commission, the Preservation Resource Center (PRC) and residents on Melpomene and nearby streets in the Lower Garden District. Elizabeth Dowling, president of the CSA, said that her group did not object to having a street named after King, just not that particular street. "We object to breaking up the sequences," Dowling asserted. "Why pick one of nine streets in a group? It's part of the charm of this area. What other city has nine streets named after Greek Muses—and then mispronounces them all?"[427] Dowling said that they had no problem with King except that he wasn't a Greek Muse.[428] Patricia Gay, director of the PRC, said that she believed that King deserved a street named after him, but they were "opposed to changing historic street names. It's more appropriate to name new streets after recent leaders…[the city] should be extremely protective of our neighborhoods and our heritage."[429]

A quintessential Carnival scene as a float turns onto Napoleon from Magazine, and the revelers plead, "Throw me somethin' mister!"

Eventually, a compromise was reached, and only two blocks of Melpomene were renamed. This left Dr. King halted at St. Charles Avenue, now practically a metaphorical as well as physical dividing line between black and white neighborhoods.[430]

New Orleans is still working through yet also perpetuating some of its own myths it has developed to both honor and veil its complex history with race and status. And while MLK Jr. Boulevard stands at the edge of one of the most celebrated streets in the city, it is doubtful it will ever cross. Despite all the barriers the man broke during his life and after, some New Orleans streets—and attitudes—may be tenaciously unbreakable.

MILAN: See Napoleon.

MURAT: See Napoleon.

NAPOLEON: Of course, NAPOLEON AVENUE was named after French military leader and emperor Napoleon Bonaparte. The city was full of his admirers, known as "Napoleonites," and former mayor and millionaire Nicholas Girod was one of his most ardent supporters. Girod built a mansion on the corner of Chartres and St. Louis Streets in 1814 that he later offered to Napoleon after he escaped from Elba. The mansion was one of the finest in the French Quarter, standing three and a half stories and crowned with a gallery with a view of the city and the Mississippi River. The walls and ceilings were ornately frescoed in the Empire style, with hand-milled cypress woodwork, Italian marble mantels, plaster cornices and corner medallions bearing the arms of France of that period.[431] In 1821, Girod took a more proactive approach to have Napoleon as his guest and plotted to rescue him from his imprisonment on St. Helena.

Girod's plan was as daring as it was rash: equip a fast ship, sail past the patrols, scale the cliffs with "pistol in hand and cutlass in mouth," overpower the guards, lower the emperor by block and tackle and sail away before the English rubbed the sleep out of their eyes and launched their ships that "couldn't make any better

time than so many bathtubs."[432] Girod's ship, the *Seraphine*, was a two-hundred-ton yacht with a long and low hull, with its decks painted black and its sails dyed brown to make it invisible at one hundred yards on a dark night. Girod hired Dominique You, former pirate and smuggler, to lead the voyage.[433] But Napoleon died before the *Seraphine* set sail. Some say that the news reached Girod three days before their rescue mission, while others claim that it was on the eve of their departure as Girod hosted a banquet at his home—a "dramatic moment, worthy of a master's canvas." Girod's dreams of their triumphant arrival home "amid boom of cannon and snort of horns and perpetual revelry" were dashed.

Girod's home later became a tenement house and an African American bar, and then in 1914, Joe Impastato bought it and turned it into a grocery store.

A bar was later added, and it became known as Napoleon House. It is now a National Historic Landmark.

Napoleon's namesake street is a broad, tree-lined avenue that runs through the heart of Uptown, but Napoleon's influence extends well beyond his street. Many historians credit Pierre Benjamin Buisson—Napoleon's brigadier general of artillery and recipient of the Legion of Honor medal—for other streets that honor the French general. Buisson worked as a civil engineer in New Orleans, and for many years, he was the official surveyor for Jefferson Parish and the city of Lafayette. Buisson felt that having only one street named after Napoleon was insufficient and named several surrounding streets to glorify the Frenchman, as John Chase has noted. Buisson was not alone, however, as over the years Napoleon was honored with a number of other streets around the city:

AUSTERLITZ: This Uptown street commentates the Battle of Austerlitz in 1805, when Napoleon led French troops and overpowered the Third Coalition. This opened the opportunity for Napoleon to rule central Europe.

BERNADOTTE: Jean-Baptiste Bernadotte was known by many names, his most important being Charles XIV and III John, king of Sweden and Norway. He was one of Napoleon's field marshals but eventually shifted allegiances and defeated Napoleon at the Battle of Leipzig. Regardless, in 1894, New Orleans named a Mid-City street after Napoleon's fair-weather friend. Furthermore, historian John Chase claimed that BURDETTE STREET is a corruption of Bernadotte Street.[434]

BORDEAUX: Under Napoleon, the French amassed a large army at Bordeaux, which was credited with helping bring Spain into the war against England. The English later defeated the French at Bordeaux, but it still found a place near Napoleon in Uptown.

CADIZ: Historians agree that this street is curiously out of place with the others. At the Battle of Trafalgar in 1805, the French and Spanish navies were defeated by the British near Cádiz, Spain. French admiral Pierre-Charles Villeneuve was captured along with his eight-gun ship the *Bucentaure*. The crew recaptured the ship, but a short time later, it was destroyed in a storm. The battle is also remembered with TRAFALGAR STREET.

CAMBRONNE: General Pierre Jacques Étienne Cambronne of the French empire had something of a dirty mouth. During the Battle of Waterloo in June 1815, the British troops scattered the French troops in every direction. Napoleon, who

theatrically vowed that he would die fighting, retreated. Cambronne and his regiment stood their ground. When asked to surrender, Cambronne shouted back, "*Merde*"— which, loosely translated, means "Bullshit"—and then charged. The expletive in those days was considered not only shocking but also incredibly ungentlemanly. Most of Cambronne's men were slashed to pieces, and the general was seriously injured. Later, Cambronne was credited with shouting a more dignified and patriotic response— "The Guard dies, but never surrenders"—but he admitted that he never said that. Instead, like his defiant behavior toward the British, he remained steadfast about the profanity he uttered. Regardless, the French were determined to attribute the more virtuous response to Cambronne and used it as his epitaph.[435] New Orleans honored him by name, not by his famous expletive, with a street in Carrollton and Hollygrove.

CONSTANTINOPLE: This Uptown street is believed to be attributed to Napoleon's victory over the Ottoman army during the Battle of Abukir in 1799.

ELBA: This Broadmoor street was named after the Mediterranean island that Napoleon was first exiled to in 1814 and escaped from in 1815.

JENA: Jena parallels Napoleon's avenue and commemorates his victory at Jena, Germany, over the Prussians in 1806.

LYONS: It is believed that Napoleon was popular in the French city of Lyon; thus, it was significant in his career and merited a street.[436]

MARENGO: The Battle of Marengo was fought between French and Austrian forces in Italy in June 1800. The French drove the Austrians out of Italy and sealed Napoleon's successful Italian campaign, but the victory was bittersweet, as General Louis Desaix was killed in action. MARENGO STREET is in Uptown near Napoleon, while DESAIX has his own street near the Fair Grounds.

MILAN: In 1797, Napoleon conquered Milan, Italy. He was crowned at Duomo di Milano in May 1805 with the Iron Crown of Lombardy (a crown said to be beaten out of one of the nails used at Jesus's crucifixion) and became known as "King of Italy" and "Emperor of France." Today in New Orleans, the street is pronounced as "*my*-lin."

MURAT: Joachim Murat was not only a dynamic cavalry commander but also a man of many titles. At points in Murat's life, he was the admiral of France, the grand duke of Berg and the king of Naples. Perhaps the reason for all of

these titles was another one he carried: brother-in-law of Napoleon. Murat was married to the emperor's youngest sister, Caroline. Murat's flashy dress also earned him another title from the public, the "Dandy King."[437] This vanity was on display even in his capture and trial for treason in Pizzo Calabro in 1815. When bravely facing the firing squad, his last words were a mixture of narcissism and heroism, shouting, "Soldiers, spare my face—aim at the heart!"[438]

VALENCE: Napoleon was stationed in Valence, France, in 1791, six years after he graduated from the military college at Brienne.

All of these streets—except Berlin (see General Pershing)—still exist today. Napoleon Avenue serves as a staging area for many Mardi Gras parades before they turn onto St. Charles Avenue to make their three-mile journey to Canal. Surely Napoleon would be proud to witness the marching bands, majestically decorated floats, lights of the flambeaux carriers, costumed walking krewes and ebullient crowds all gathered in a gaudy and joyful procession on a street bearing his name. And surely, if it's true about Napoleon's legendary ego, he would also believe that the spectacle was all for him.

ORETHA CASTLE HALEY: On September 17, 1960, twenty-year-old Oretha Castle walked into McCrory Five and Ten Cent Store at 1005 Canal Street with fellow African Americans Rudolph Lombard and Cecil W. Carter Jr. and white Tulane graduate student Sydney L. Goldfinch Jr., sat at a refreshment counter at the back of the store and requested service. Restaurant manager Wendal Barret believed that blacks sitting at a counter created an "emergency" and asked them to leave. When they refused, Barret whistled, and employees removed the stools, turned off the lights, put up a closed sign and called the police. A number of officers responded to the "crisis." Every person in the group was a member of the Congress of Racial Equality (CORE), an organization of integrated activists that fought for the civil and political rights of blacks. The four refused to leave and were arrested for "criminal mischief" and sentenced to serve sixty days in the parish prison and pay a fine of $350.[439]

A week earlier, a similar demonstration had occurred at Woolworth's. Police superintendent Joseph Giarrusso issued a statement that individuals who participated in sit-ins did not represent the community's interest and that violators would be prosecuted under the law. Mayor Chep Morrison also released a statement noting that he directed Giarrusso to disallow any sit-in demonstrations because it was against "the community interest, the public safety, and the economic welfare of this city" and that henceforth they were prohibited.[440]

Professor Longhair beams out from a mural on O.C. Haley Boulevard, just a few blocks from the jazz great's former home.

Haley and her compatriots appealed their convictions all the way to the U.S. Supreme Court, and on May 20, 1963, the lower rulings were reversed. The court held that the state or local government could not "direct continuance of segregated service in restaurants, [or] prohibit any conduct directed toward its discontinuance" where there was no violence "present or imminent by reason of public demonstrations."[441] The ripple effect was far-reaching and overturned seven different cases in Alabama, North Carolina, South Carolina, Georgia, Louisiana and Maryland, proving to be monumental in the civil rights movement.[442]

Haley, born in 1939 in Oakland, Tennessee, continued her campaign for social advancement and became one of Louisiana's leading activists. She

worked with the National Association for the Advancement of Colored People's Youth Council and the Consumers' League of Greater New Orleans (fighting employment discrimination by merchants on Dryades Street) and served as CORE president from 1961 to 1964. Her 1967 marriage to CORE member Richard Haley did not slow down her long list of achievements for African Americans and women. She served as deputy administrator at Charity Hospital, assisted in organizing the New Orleans Sickle Cell Anemia Foundation and, in 1972, directed the political campaign of Dorothy Mae Taylor, who became the first black female state legislator in Louisiana.[443]

After a long battle with ovarian cancer, Haley died in October 1987. In 1989, New Orleans honored her by renaming part of Dryades Street after her, in the exact area where she fought so tirelessly for employment opportunities for local black citizens.

PATTERSON: Commodore Daniel Patterson is often considered the unsung hero of the Battle of New Orleans. Writer Meigs O'Frost summoned it up in "football language," stating that "Andrew Jackson carried the ball and made the touchdown because of the superb blocking Commodore Patterson and his pitiably small naval force gave him."[444] Patterson, who was from Long Island, New York, was already seasoned in battle at sea before the fight at Barataria, where in 1814 he raided pirate Jean Lafitte's camp on Grand Terre and returned with eighty prisoners, more than $500,000 in merchandise and nine pirate ships.[445] During the Battle of New Orleans, Patterson's defense strategies were invaluable to Jackson and gave him extra time to bring up additional troops.[446] Patterson died in 1831 and was honored with a long street in Algiers, just over the levee from the big river he defended.

ROBERT E. LEE: See Lee Circle.

SCOTT: General Winfield Scott held the rank of officer in three wars, and his reputation for discipline earned him the nickname "Old Fuss and Feathers." While he was successful in the field, this did not earn him success in the political arena, and he lost his presidential bid on the Whig ticket to Franklin Pierce in 1852, many believe because the Whigs were divided over the issue of slavery. However, Scott would soon be united with Pierce. In 1852, New Orleans named a Mid-City street after Scott, and twenty-one years later, it named a parallel street after Pierce. At least Scott can claim that he won it first.

CHAPTER 6
CRESCENT CREATORS

The Planners, the Dreamers and the Givers

Cities are defined by their structures and the people who make them. From the surveyors who plot to the architects who design, the laborers who build, the owners who buy and, quite often, the philanthropists who donate to make everything possible, New Orleans honors all of them. Some dream up new schemes, plans or inventions within our city walls, and others make their marks from a distance. But through wit, wiles or will, each person in this chapter affected New Orleans in his or her own way.

ANDREW HIGGINS: President Dwight Eisenhower called Andrew J. Higgins "the man who won the war."[447] Higgins's boat design for the Landing Craft, Vehicle, Personnel (LCVP, or simply Higgins Boat) was instrumental in not only the D-Day invasion of Normandy but also other amphibious invasions of World War II. Higgins was born in Columbus, Nebraska, in 1886 and moved to New Orleans in about 1910. He eventually started his own lumber and export company and built boats, including the Eureka, a highly maneuverable craft that could navigate shallow waters.[448] When the navy needed a landing craft for World War II, it liked the Eureka boat but wanted one with a bow ramp, leading Higgins to develop the LCVP.[449] He went on to develop a tank landing craft and torpedo boat, too.

A flotilla of Higgins Industries' boats was on display one Sunday in August 1941 at a ceremony to dedicate the firm's new City Park plant. Thousands watched from Pontchartrain Beach as a seventy-foot torpedo boat, commanded by Higgins's son, Frank, left the Municipal Yacht Basin at West End and came toward the beach. As

The city's urban landscape is reflected in the morning sun off the National World War II Museum on Andrew Higgins Drive.

it neared, three navy planes suddenly swooped in to "attack" the boat. The agile boat outmaneuvered them, to the delighted audience. Next, a group of landing craft assembled and charged the beach, depositing men and armored vehicles even as planes dove from above, with "Higgins plant guards who represented the protecting force" resisting them.[450] Assembled dignitaries lauded Higgins and touted the renown that his boats had gained on seas and shores around the world (and this was before America had entered the war), with Governor Sam Jones stating, "For months, the navy refused to permit any publicity at all on Higgins boats…It might be dangerous for Axis agents to learn how good they were. By now, the Axis powers are well aware of the efficiency of these boats. They have met them in battle."[451] At

their peak, Higgins's plants in New Orleans were producing one thousand boats per month, and by the end of the war, they had built twenty-eight thousand, helping the Allies swamp the enemy on shores around the world.[452]

After the war, his workforce (which grew from four hundred in 1940 to twenty thousand in 1944) was heavily reduced, allegedly because state politicians did not like that the plants were integrated (other sources claim that it was due to striking workers).[453] Higgins turned to the construction of pleasure and commercial boats, particularly for Latin American countries.[454] He died in 1952, and in 2000, just in time for the opening of the National World War II Museum in the Warehouse District, the street in front of the museum was renamed to ANDREW HIGGINS DRIVE to honor the man and his boats that "won the war" and altered world history.

BUNNYFRIEND: Joseph and Ida Friend were civic leaders in New Orleans in the early twentieth century. Joseph was a prominent businessman who became a partner in the cotton brokerage firm Julius Weis and Company. He and Ida had four children: Julius, Lillian, Caroline and their youngest, Henry, nicknamed "Bunny." All of the children were active in the community in theater and sports. Lillian was on the 1911 Newcomb basketball team, with a young Bunny serving as the mascot.[455] In 1924, Bunny, then a few months shy of his nineteenth birthday, swallowed a ball bearing and required surgery. As a result of the operation, he developed adhesions that strangled his liver, and he died on February 1.[456] His grieving parents decided to honor their son, who loved athletics and the outdoors, by memorializing him with a new playground.

On July 21 of that year, hundreds of children flocked to the dedication, which transformed a vacant lot into Bunny Friend Playground—one of the best-equipped parks in the city for children.[457] There was a parade with more than a dozen floats, each covered in flowers and ribbons and carrying a child "driver." Children dressed as elves, gnomes, fairies and in other costumes danced around the playground as Mayor Andrew J. McShane and other officials made speeches.[458] The playground provided a place for festivals, concerts and athletic games.

Joseph Friend died in 1936, but Ida continued her volunteer work. Her long list of civic achievements includes serving as president of the National Council of Jewish Women and the Federation of Women's Clubs. As club president, she and some of her fellow members protested at the state capitol to get trained librarians employed in state libraries. In 1920, she was appointed by President Woodrow Wilson to serve at the Democratic National Convention. She also held office in the Louisiana Tuberculosis Association, the Prison Aid Society, Le Petit Theatre du Vieux Carré and the Public School Alliance. In 1946, she was awarded one of the highest civic honors in New Orleans, the Times-Picayune Loving Cup, an annual award that

North Bunnyfriend Street and South Bunnyfriend Street border Bunny Friend Playground, a lively spot in the Upper Ninth Ward.

since 1901 has recognized local residents who work unselfishly for the community.[459] Ida once said, "I have learned that only by serving one's fellow man can one find real and enduring happiness."[460] Mrs. Friend, in her efforts to improve the lives of so many New Orleanians, never forgot her youngest son. Until her death at the age of ninety-five, Ida always kept a fresh rose by Bunny's photograph.[461] The park is still popular today and is bordered by NORTH and SOUTH BUNNYFRIEND STREETS.

BURKE: Edward Burke, the state treasurer and one of the most powerful men in New Orleans politics, was also the director-general of the 1884 World's Exposition (which proved to be successful in all areas but financial), a spokesperson (and interested party) for the Louisiana Lottery Company and owner of the *Times-Democrat*, but he achieved each of these distinctions through dubious means. Tired of the *Democrat*'s anti-lottery stance, Burke forced it into bankruptcy in 1879 by

getting a court to declare its scrips worthless (scrips were a form of credit the state paid vendors with), and then he bought the newspaper himself and convinced the court to reverse its opinion on the scrips. Hence, the *Democrat* suddenly became pro-lottery. Burke then bought the *New Orleans Times* and merged it with the *Democrat*.

While he was editor of the *Times-Democrat*, Burke fought duels against two other editors. In January 1880, he dueled Henry J. Hearsey of the *Daily States* (and former owner of the *Democrat*). Both men were uninjured, and two years later, Burke dueled C.H. Parker, editor of the *Daily Picayune*. Burke was not so lucky the second time and sustained a wound to his leg.[462] In 1889, he was traveling in England when his successor as state treasurer discovered significant discrepancies in the books; a grand jury served Burke with nineteen indictments for embezzlement of state funds. The amount missing from the treasury was between $64,000 and $2 million. Burke vowed to fight the charges but fled to Honduras, never to return to New Orleans. Regardless, BURKE AVENUE in New Orleans East is believed to be named after him, but unlike his crooked ways, the street is straight.

CLARK: Accounts of Daniel Clark's character were often in conflict. Some praised his contributions to the Louisiana Purchase, and others deemed him an "unscrupulous schemer" who craved power.[463] Clark was a wealthy Irish-born merchant, prominent landowner and politician who claimed not to be interested in the governorship, although his friend Benjamin Moore wrote a letter in 1803 stating that he did not believe Clark's assertions, writing that "his talents fit him for office but he is not popular enough to get it" and that he was "deficient in dignity of character and sterling veracity to fill the office of governor."[464] Another acquaintance described Clark by saying that "he pants for power and is mortified by disappointment."[465]

That disappointment was never more evident than when Thomas Jefferson appointed William Claiborne to be the first territorial governor of Louisiana over Clark. Clark did serve as the first Territory of Orleans representative in the U.S. Congress, but this did not alleviate his bruised pride, which eventually led to a duel, with Clark shooting Claiborne in the thigh. Although prosperous, Clark never quite achieved the affluence and influence he desired, and when he died in 1813, it is certain that he never imagined that his secret daughter would attain the renown he coveted.

When Clark died, suspicions immediately arose over his will and the hasty manner in which it was handled by his partners and executors. It left the majority to his mother after large fees and "debts" were paid to his partners.[466] Seventeen years after Clark's death, Myra Clark Gaines (then Myra Davis) accidentally discovered that he was her father. Clark was briefly married to Myra's mother, a great New Orleans beauty, Marie Zulime Carriere. The only problem was that

Carriere was married to a Frenchman named De Grange at the time but claimed that since he was still secretly married to another before her, their marriage was void. Carriere and Clark wed in secret and produced Myra in 1804, her birth shrouded in secrecy. Eventually, the couple split, and Carriere married a Dr. Gardette and moved to Paris.

When Myra was twenty-five (and already a widow), she discovered the truth of her birth and was determined to claim Clark's estate (which equaled about one-third of the property in New Orleans) and her name. In Louisiana, an illegitimate child had no right to inherit property, so Myra needed to prove her legitimacy. In 1838, she married Major General Edmund Pendleton Gaines, a lawyer, on the condition that he take up her cause, and he did, but he never lived to see her victory. In the end, Myra spent fifty-seven years pursuing her case (the longest-running suit in U.S. history), outlasting "two husbands, two entire U.S. Supreme Courts, and two whole generations of judges in the lower court" before finally winning.[467] Through this she withstood character assassination and allegedly a few real assassination attempts. Her court battles made her internationally known and the *"cause célèbre* of which she was the heroine," but she died with little money, the majority consumed by the litigation.[468] But she won her name and the respect of many, who admitted that she was more "thorough" than most of her lawyers and "pleaded her own case with astonishing force and eloquence."[469]

Myra was buried in her father's tomb at St. Louis Cemetery No. 1. At her funeral, Reverend B.M. Palmer stated, "The great lesson she teaches us in death, as in life, is how much can be done when one's entire energies are concentrated on a single purpose—a purpose prosecuted in days of darkness and doubt."[470] And while Daniel Clark struggled to make his name and win power, Myra's powerful struggle to win her good name showed that she inherited his cunning and determination as well as his estate. Clark Street in Mid-City and Gert Town is named after Daniel.

CURIE: Marie Curie, the Polish-born French physicist and two-time winner of the Nobel Prize, died in 1934 after years of exposure to radiation. During a tour of the United States in 1921, President Warren G. Harding gave her a gram of radium for her studies, and on her second visit, in 1929, President Herbert Hoover gave her a contribution of $30,000 to purchase another gram. When she died, Curie left the gram of radium given to her by Harding, the only property of considerable value she owned, to her scientist-daughter, Irène Joliot-Curie.[471] Nine years after Curie's death, New Orleans named a street near the University of New Orleans after the scientist; it runs parallel to another great scientist, Louis Pasteur.

DAVE DIXON: To many, Dave Dixon does not need the Church to make it official—he is a saint. Born in New Orleans in 1923, Dixon was an art and antiques dealer

interested in civic affairs. In 1959, Mayor Chep Morrison tried to save the city's minor-league baseball team, the Pelicans, while simultaneously trying to gain a major-league franchise. Dixon persuaded Morrison to set his sights on acquiring a football team instead. With Morrison's blessing, Dixon worked tirelessly on this goal, and through his efforts, on All Saints' Day in 1966, the National Football League awarded its sixteenth franchise to New Orleans. A week later, bonds were passed for the construction of the Superdome. An amendment to the state constitution was drafted to create a governing body and secure financing for the building. After clearing the name with Archbishop Philip M. Hannan, the team was christened the New Orleans Saints. The archbishop did not consider the name sacrilegious because he said he had a "premonition that this team is going to need all the help it can get."[472]

The Superdome opened in 1975 and was (and is) the largest fixed dome structure in the world, rising to 273 feet above street level.[473] Dixon, known as the "father of the Saints," has been credited as the driving force behind the franchise as well as the Superdome. In 1989, Dixon was awarded the Times-Picayune Loving Cup, which is "presented to New Orleans citizens who have worked unselfishly for the community without expectation of public recognition or reward."[474] Dixon was commended in a report by local economist Tim Ryan that noted that the Superdome was "one of the wisest investments that the state has ever made," estimating that it has generated more than $10 billion for the economy.[475]

Dixon died in August 2010, six months after the Saints won their first Super Bowl. In 2011, a part of Girod Street in the Central Business District was renamed DAVE DIXON DRIVE, replacing the man who failed to bring Napoleon to the city with the man who succeeded in bringing the Saints. Some would say it was a reasonable exchange and a fitting one to follow a historic New Orleans booster with a more contemporary one.

DELGADO: Isaac Delgado was a wealthy sugar and molasses merchant and one of New Orleans's greatest philanthropists. Born in Kingston, Jamaica, in 1839, Delgado came to New Orleans as a teenager and worked as a clerk. Never married, Delgado eventually accumulated a large fortune and was known to be determined and decisive in business but soft-spoken in life, taking great pains to never utter an ill word toward anyone.[476] Two of Delgado's most important contributions to the city were the Delgado Memorial at Charity Hospital and the Delgado Art Museum (now the New Orleans Museum of Art). Delgado was too sick to attend the museum's opening in 1911 and died a few weeks later. The *New Orleans Item* praised Delgado, noting that "the man who brings the treasures of art to the people, giving the poorest the same privilege as the richest enjoys, is a public benefactor. Mr. Delgado…has

bestowed upon all the people a gift whose value will increase with the passage of time and remain to do public service as the city lasts."[477] Delgado died the same day as Governor Francis Nicholls, and the city paid tribute to them both. Delgado Community College, which was originally established as Delgado Central Trades School, is named in his honor, as is DELGADO DRIVE in the Parkview neighborhood not far from the museum and the school.

D'HEMECOURT: Many historians view French-born Claude Jules Allou d'Hémécourt as the best city surveyor New Orleans has ever seen.[478] D'Hémécourt came to New Orleans with his family in 1831 when he was twelve years old, and in 1836, he became a very young surveyor of the First Municipality, serving until the consolidation of the municipalities in 1852.[479] His magnum opus was his survey of the entire city in 1857 with Louis Pilié. He was given a contract of $30,000 to accomplish this feat, but it is unclear if he was ever paid.[480] The map was completed on forty-eight large sheets of paper, with every block in the city given precise dimensions. After d'Hémécourt's death in 1880, Pilié's son sold the general plan to Colonel Sidney Lewis for a few hundred dollars, and in 1937, his son, John, donated the original sheets to the people of New Orleans.[481] The *Times-Picayune* called d'Hémécourt accomplished in his profession and a possessor of "a heart which was his shield of nobility."[482] D'HEMECOURT STREET in Mid-City is named after him.

EADS: James Buchanan Eads was a civil engineer and inventor who designed and constructed the Eads bridge in St. Louis, but in New Orleans, he was best known for successfully altering the flow of sediment in the Mississippi by building a series of jetties that allowed New Orleans to "open her port, and give the Valley of the Mississippi a deep waterway to the sea."[483] Eads died in 1887 at the age of sixty-six and already held the honorary title of captain, bestowed by the Mississippi River men, but New Orleans honored him with a street in St. Roch.

EARHART: Utilities commissioner Fred A. Earhart was described by Mayor Chep Morrison as the "father" of New Orleans's Union Passenger Terminal. Earhart was born in New Orleans in 1875, studied pharmacy at night and, at age twenty-one, opened his first drugstore, at Eighth and Chippewa. At one point, he owned ten drugstores around the city. In 1930, he was elected utilities commissioner and was known to have lunch at one of his drugstores near city hall, always paying for his own meals—his favorite being potatoes and tongue. Earhart advocated a union station to consolidate rail facilities and the separation of street vehicular and rail traffic. By the time he died in 1948, both were a reality.[484] In 1954, the boulevard (only partially completed) that connected the union station area with

the western part of city was named EARHART BOULEVARD. Thirty-two years later, the fifth and final segment of the project was completed, linking New Orleans and Harahan by a 4.8-mile expressway.[485]

FLOOD: Hurricane Katrina tore through New Orleans in August 2005. The disaster produced many alarming, horrific and moving images. One of the most poignant was of Flood Street in the Lower Ninth Ward, with water almost up to the street signs, nine blocks from the floodwall break that drowned the neighborhood. Yet Flood Street was not named after any rising or destructive water but rather after one of New Orleans's earliest men dedicated to healing, Dr. William Flood, who was appointed by Governor Claiborne in 1805 as the physician to the port of New Orleans.[486] Claiborne said of Flood that he was among those "who have been more uniform in support of the Administration, of the Laws and good order" than any other American.[487] Flood, along with two others, also founded the New Orleans Library Society in June 1805, volunteered his professional services during the Battle of New Orleans and was one of the founders of the first Presbyterian Church in the territory. Flood died of dysentery in 1823 at the age of forty-eight, leaving a wife and three children. FLOOD STREET honors the good doctor, and like the city he cared for, it has shown its resilience since the deluge.

GALLIER: James Gallier Sr.'s influence on New Orleans's architecture is pervasive. Examples of his artistry can be seen throughout the city to this day. Although the Irish-born architect was faring well in New York City, he feared artistic suffocation from churning out formulaic designs and decided to start fresh in New Orleans in 1834.[488] Soon, Gallier became one of the most respected (and busiest) architects in the city. He began building a new city hall (today's Gallier Hall) in 1845, and it was inaugurated on May 10, 1853, in a ceremony that was "unexceptionable and passed off to the evident satisfaction of those present."[489] The building itself, however, was exceptional and is considered by many to be the finest Greek Revival building in the United States.[490] With two rows of fluted Ionic columns, six in the front and four in the rear, and granite steps leading to the entrance, it conveys a masterful elegance.[491] The building served as city hall for more than a century, and it is used as an event space today. On Mardi Gras Day, the mayor of New Orleans toasts Rex and Zulu from its steps.

Gallier retired due to failing eyesight in about 1849, and in 1866, he and his wife were passengers on the ill-fated *Evening Star* steamship that sank after a hurricane. His son, James Gallier Jr., received a letter from the purser stating that the couple was "striving to support themselves in their state-room, when the ship timbers

Gallier Hall, designed by and named after James Gallier Sr., was New Orleans's city hall from the 1850s to the 1950s and is still a popular site for events and Mardi Gras festivities.

started from their fastenings and the noble vessel yielded to the raging fury of the storm and descended into the depths."[492] Gallier Jr. memorialized his father and stepmother with a cenotaph of his own design at St. Louis Cemetery No. 3 on Esplanade Avenue. The city made its own memorial to the architect who lent such regality and style to the city, naming a street in the Upper Ninth Ward after him.

Charles Howard, namesake of Howard Avenue, is buried at Metairie Cemetery, which he built on the site of Metairie Race Course some years after its jockey club refused to admit him as a member. His grave includes this curious figure, who appears deep in thought.

HOWARD: The benefits that Charles T. Howard brought to New Orleans (and took from New Orleans for himself) are debatable. Born in Baltimore in 1832, Howard came to New Orleans thirty-some years later and, in 1868, started what some viewed as a savior to the city and others viewed as its ruination: the Louisiana Lottery Company. Howard had been commissioned by a Kentucky lottery firm to apply to the Louisiana legislature for a charter and was given $50,000 by his employers to carry out the "scheme." After getting the grant, Howard refused to turn the charter over to his employers and made himself president and his friends directors.[493]

The LLC was a corrupt organization that sheltered its double-dealings from the public eye by paying $40,000 per year to the Charity Hospital Fund and

other charitable institutions. Howard and his stockholders took in nearly $2 million per year, after paying bribes to various public officials.[494] Howard also imposed his will on another gambling establishment—the Metairie Jockey Club, an elite and exclusive club that owned Metairie Race Course. The club refused him membership, and furious at the snub, he vowed to turn its racetrack into a cemetery. And he did, purchasing the fashionable track in 1872 and turning it into an equally fashionable cemetery two years later—Metairie Cemetery.[495]

In 1885, while vacationing at his home in New York, Howard was thrown from a "vicious Arabian horse" and died.[496] Going against the common courtesy of not speaking ill of the deceased, the *New York Times* published a lengthy article, highlighting his blatant bribery, shady political influence and vengeful manner but also devoting the final two sentences to state that he did, nonetheless, donate liberally to charitable institutions. Howard's family gave money for the Howard Memorial Library. It was dedicated on March 5, 1889 (Howard's birthday).[497]

The library contained more than 100,000 volumes and was beneficial to the state, but three years later, *Century* magazine published an article about Howard called "The Degradation of a State," about the "man who started Louisiana's Disgrace." It called Howard the "Lord of the Lottery" and noted that "certainly no knight of old, of the bar sinister or otherwise, ever carried his authority with greater aplomb." It stated that the library was "the single unselfish benefit that lottery money has conferred upon New Orleans, whose people have been impoverished by the daily drawings; and no doubt the heirs would be glad if they could disassociate from the gift its mute influence as a bribe to public respect on behalf of a gambling corporation."[498]

Howard was buried at the cemetery he built, and in his tomb sits a statue of an elderly bearded man with his finger on his lip in solemn silence, "the marble guardian of the marble dead."[499] The city renamed part of Delord Street, home to the library, to HOWARD AVENUE after the controversial albeit colorful man.

LESSEPS: Count Ferdinand de Lesseps was a French diplomat, but he is best remembered for building the Suez Canal across the Isthmus of Suez in Egypt in the mid- to late 1800s. He attempted to build a Panama canal, but a lack of funds and yellow fever quickly ended his vision as well as his life. But his legacy continued in New Orleans. Mayor deLesseps "Chep" Morrison was a great-great-grandnephew of Lesseps.

During his tenure in the 1950s, the mayor appeared to be in an ongoing public family reunion of sorts. He met his Parisian cousin Pierre deLesseps (a great-grandson) in 1955, who was more impressed with American supermarkets than the historic French Quarter, saying that "they make us understand the American way of life better."[500] Two years later, the mayor received another

visit, from Lesseps's granddaughter, whose father was born when the count was eighty-two years old.[501] Also that year, Morrison wrote to Egyptian president Gamel Abdel Nasser to protest the "dastardly act of destruction" of a statue of Ferdinand deLesseps and how he was proud to be a direct descendant of the count. The attaché to the Egyptian embassy replied that the mayor's protest should be directed to the French and British forces that bombed and killed thousands of innocent Egyptians.[502] Although Morrison may not have gotten his way in Egypt, he could at least take comfort in the fact that LESSEPS STREET in the Upper Ninth Ward remained as a tribute to his distant kin.[503]

MARCONI: Guglielmo Marconi, the Italian physicist and inventor of wireless telegraphy, visited New Orleans in 1917, six years after he received the Nobel Prize for physics. He was greeted by crowds "almost as dense as at Carnival times." Thousands of Italians, many hailing from various Italian societies, cheered and waved American and Italian flags. Marconi, who was fluent in English, praised Americans' war efforts and said that he was thankful that America and Italy were united in common goals.[504] In 1938, the city renamed part of Orleans Avenue after the physicist.

MARGARET: Margaret Haughery was known by many names in New Orleans: "Saint Margaret," "the Mother of Orphans," "the Bread Woman of New Orleans," "the Milk Woman," "the Patron Friend of Seamen" and "Angel of the Delta." She was so well known that many local newspapers simply referred to her as Margaret. An Irish immigrant who was orphaned at a young age, Margaret came to New Orleans with her husband, Charles Haughery, in 1835 at age twenty-one and gave birth to their daughter shortly after. Within a year, her husband and daughter died.

Penniless and illiterate, Margaret was once again alone. She worked as a laundress and volunteered at the Sisters of Charity orphanage, purchasing two dairy cows to give fresh milk to the orphans and selling the surplus. From this she acquired a small herd and built a thriving dairy. Margaret gave much of her profit to the orphans and invested in a local bakery, which she turned into the largest bakery in the United States and the first in the South to operate machinery by steam. During New Orleans's occupation by Union troops, she continually crossed Federal lines to give wagonloads of bread and flour to the needy. She was brought before General Benjamin Butler and ordered not to cross lines, but she refused, stating that starving people needed her. Impressed, Butler gave his permission, and soldiers joked whenever they saw the petite woman with her Quaker-style bonnet walking by that "there goes the only person of whom General Butler is afraid."[505]

Margaret died in 1882, and the *Times-Picayune* ran two long columns about her on its front page titled simply "Margaret." She was given a state funeral with the

current and former governors and mayors of New Orleans among her pallbearers (as well as other government officials and military men in attendance). In her will, she left more than $30,000 to the city's orphans. Plans were made almost immediately to honor her, and in 1884, a statue by Alexander Doyle was erected in a small park where Camp and Prytania meet. The statue, the newspaper noted, was a realistic portrayal, and the young boy by her side was the pretty touch that added the "grace and beauty the subject would not otherwise afford."[506] This remarkable woman, who overcame dire circumstance to care for others, is remembered not only in a small street next to her statue but also in the institutions she started. The statue's inscription, for the woman who despite running a successful business still signed her name with an *X*, says simply "Margaret."

MILNE: Scotsman Alexander Milne came to New Orleans in the late eighteenth century and has gone down in history as one of the five great bachelor philanthropists of New Orleans, along with John McDonogh, Julien Poydras, Judah Touro and Paul Tulane.[507] According to historian Charles Dufour, however, while McDonogh, Touro and Poydras were bachelors with broken hearts, Milne and Tulane were "bachelors at heart, without it ever being broken."[508]

Milne made money in real estate, including his development of Milneburg, once a popular port and resort in the area of today's Pontchartrain Beach and University of New Orleans (UNO). It was connected to New Orleans by the Pontchartrain Railroad, which ran along Elysian Fields, shuttling people to and fro to enjoy the balmy lakefront weather. Its famous steam engine Smoky Mary is memorialized today as a float in Carnival's Orpheus parade. The Milneburg name lives on in a neighborhood nearby and MILNEBURG ROAD, running through UNO.

Milne died in 1838 in his nineties and left a large sum of his fortune to orphans and to the Poydras Female Asylum. He also left many of his relatives between $4,000 and $6,000 each, but his largest bequeaths to individuals were to his two female slaves, Nancy (twenty-four years old) and Jane (twenty-two years old), for "compensation for their services, and the great care they have taken of me during my old age and infirmities."[509] He gave them a plot of land on Esplanade Avenue and $10,000 for his executors to build each woman a brick house and receive an allowance of $3 per day until the houses were built. Until then, they were to live in his home and use all of his furniture, which they were to take with them when they moved into their houses. Most importantly, he gave them their freedom.[510]

MILNE BOULEVARD in Lakeview and MILNE ROAD in Tremé were named for this generous man, who, legend has it, came to New Orleans only because he got into a fight in his homeland over refusing to cut his hair.[511]

MORGAN: Charles Morgan was a shipping and railroad magnate born in Connecticut in 1795. He moved to New York City in 1809 and got a job in a small grocery store, but after twenty years of saving and investing, he opened the first scheduled steamship service between New Orleans and Galveston, and in due course, he expanded his shipping empire and branched into railroads. Morgan died in New York City in 1878, and the *Times-Picayune* noted that "few capitalists have accomplished more for her [Louisiana] material interests than he, though he labored in quiet and without ostentation." The *New Orleans Times* took a more practical tone, acknowledging the number of men he employed and how many grew rich from his business. Years later, the city named a street after Morgan in Algiers near the ferry landing.

PAUGER: Just as New Orleans was not the French Crown's first choice to be the colonial capital, Adrien de Pauger was not the first choice to design it. Pierre le Blond de La Tour, the main engineer, believed that Biloxi was the ideal place for the colony's headquarters. La Tour was confident that his design (as well as Biloxi) would serve as the young colony's nucleus; he did not anticipate Bienville's tenacity and devotion to New Orleans.

Bienville led the effort by John Law's Company of the Indies to found New Orleans, as chartered by the regent, Philippe, duc d'Orléans. In March 1721, La Tour sent his assistant, Pauger, a military engineer from Normandy, to survey the new city.[512] Pauger arrived to find a few scattered cabins in the woods and got to work on his plan.[513] He finished in mid-April and sent a copy to La Tour in Biloxi and, later, upon his request, one to Bienville. La Tour stashed it away, believing that Pauger's design, featuring a grid of eleven squares by six squares fronting the Mississippi River, was a waste of time.[514] What La Tour did not know was that Bienville forwarded a copy of the map to the company in Paris, whose officials likely knew that Pauger's map was not just a plan for a new and (hopefully) prosperous colonial outpost—it was a design for a grand royal city appealing to the regent's ego. The city *de la Nouvelle-Orléans* was named after him, as were multiple streets, including *Rue d'Orléans*, its main street, which bisected the city and led directly to the church. While Pauger also named streets after other royals, saints and d'Orléans' illegitimate half brothers, it was clear that Philippe was the star of the city. Historian Lawrence Powell surmised that the decision to choose New Orleans over Biloxi was most likely an act of financial desperation spurred by the years of vacillation on where to put the capital with no definite resolution. But the order to make New Orleans the new colonial capital conceivably had an element of royal egotism as well.

Upon hearing of the decision, La Tour rushed to New Orleans and took command. While La Tour was the lead engineer and refined Pauger's original

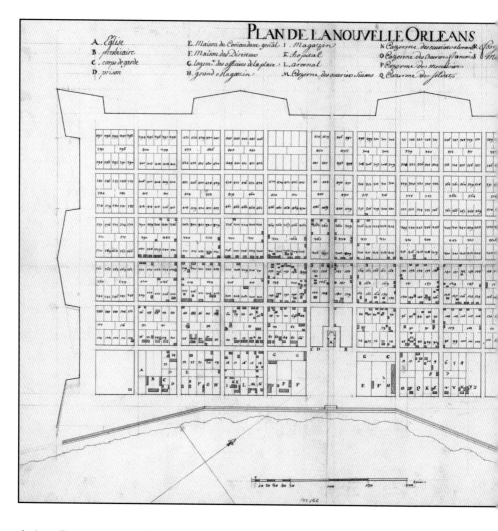

design, Pauger gets credit for the French Quarter's checkerboard grid, as well as many of the street names.[515] Upon La Tour's death in 1724, Pauger was made major general and chief engineer but did not enjoy this title long, dying just two years later, before he could see the completion of one of the new city's centerpiece elements: St. Louis Church. It is rumored that Pauger was buried under the church, which stood for almost sixty years before it was destroyed in the Great Fire of 1788.[516]

Pauger did attempt to leave his signature on the early streets. The last named street on the downriver side of his grid was named St. Adrien, after his patron saint. But the man who walked the very streets he created carried less weight than elites who never saw them. St. Adrien went through many name changes,

Adrien de Pauger's original plan laying out New Orleans, drawn in 1721. The French Quarter still has nearly the exact same layout today, nearly three hundred years later. *Library of Congress.*

first to Arsenal, then to Saint Ursula and finally to Ursulines after the nuns who arrived in the city a year after Pauger's death.[517]

Bienville spotted potential in the sliver of high ground on a crescent in the river, but Pauger brought form to that land and bestowed its earliest regal character. It would take almost two hundred years to have a street named after him, but in 1924, the city renamed Bagatelle Street in Faubourg Marginy to PAUGER STREET around the same time that La Tour Street went "out of duration." And in a typical New Orleans twist, after Pauger's long wait to have a street named after him, locals mispronounce it as "Pawger" rather than the correct "Po-jay."[518] Now he truly is a New Orleanian.

PASTEUR: French chemist and bacteriologist Louis Pasteur was world renowned for his advancements in science, industry and medicine, from inventing the process of pasteurization to curing a silkworm disease (saving the industry in France) and developing vaccines. Pasteur died in 1895, and the world mourned, including New Orleans, which named PASTEUR BOULEVARD after him in 1927.

PETERS: Samuel Jarvis Peters was a businessman and civic leader who helped develop the American Sector of New Orleans.[519] He led the movement in the early 1800s to establish the Second Municipality as a separate governing body, via the charter of 1836, despite resistance from the Creole elite. The new municipality went from "Faubourg St. Mary, extending upriver to encompass the present Lower Garden District to Felicity Street."[520] Peters died in 1855; the *Times-Picayune* heralded him as an "excellent citizen and a much esteemed friend." A street downtown honors Peters.

POYDRAS: Julien de Lallande Poydras was an affluent plantation owner, philanthropist, poet, advocate for public education and lawyer who assisted with Louisiana's first constitution. Accomplished in myriad fields, Poydras's achievements were even more remarkable given his humble background. Born in France in 1746, Poydras served in the French navy as a young man but was captured by the British in 1760 and taken to England. He eventually escaped to

Santo Domingo, and in 1768, he immigrated to Louisiana, arriving with only the pack on his back. He worked as a "pack peddler," going from house to house selling goods to blacks and whites. In 1775, he purchased land in Pointe Coupee Parish, and his fortune "grew as rapidly as malicious gossip."[521]

In a few decades, Poydras accumulated a great deal of wealth, becoming one of the largest property owners in the South. He also owned a boat in which, with his oarsmen, cook and servant, he would leisurely descend the Mississippi River, stopping along the way to visit friends.[522] In 1779, Poydras wrote a poem in French eulogizing Louisiana governor Bernardo de Gálvez. The poem is lauded not for its literary excellence but rather for its historical significance, as it is regarded as the first poem published in Louisiana.[523]

A lifelong bachelor, Poydras was considered a pious man who lived a simple life, so it was shocking when he was the target of what became known as the Pointe Coupee Conspiracy. In 1792, Governor Carondelet issued an extensive set of guidelines on slave management, from how to feed and shelter slaves to the number of lashes a slave could receive at one time. Overseers and slave owners could face legal sanctions and fines if they violated these guidelines. Poydras was considered the leader among planters who rebelled against Carondelet's regulations, viewing them as slave-friendly policies.[524]

In April 1795, the colonists in Pointe Coupee learned of a looming rebellion. Slaves and a few white overseers plotted to set fire to one of Poydras's buildings, and when the other plantation owners came to his aid, the slaves would capitalize on the chaos, seizing all of the ammunition and killing their masters and any recalcitrant Creole slaves. Poydras was in Philadelphia at the time, which arguably lent an advantage to the rebellion. Slaves from neighboring plantations coordinated to strike simultaneously, but days before, members of the Tunica tribe, fearful for their own lives, informed whites of the plan, leading to a swift roundup by the authorities. In the end, fifty-seven African Americans and three whites were found guilty. Twenty-three of those convicted were executed (including three slaves owned by Poydras). Their severed heads were nailed to poles along the Mississippi River's banks as a warning to other slaves who dreamed of rebellion. Many historians consider this incident the apex of white paranoia and the justification for further oppression and violence against African Americans.

Poydras was considered to be personally frugal but publicly generous. During his lifetime, he gave the New Orleans Female Orphan Society a house and three acres of land valued at $7,000.[525] After his death in 1824, he left Charity Hospital two of his houses and left the Poydras Female Asylum (which he helped found) all of his property on Poydras Street and on the batture. And since (it was rumored) he could not marry his love because she did not have enough money

for a dowry, he also donated more than $60,000 to pay the dowries of poor girls in Point Coupee and West Baton Rouge Parishes. Any bride who had been a parish resident for five years was eligible for the fund, with the annual amount depending on the number of applicants. One year, a bride received the whole allotment of $2,400 because she was the only applicant. It was not uncommon for brides to delay their wedding in order to increase their donated dowry.[526]

The most "highly interesting particulars" of Poydras's will regarded his slaves. Considered one of the most humane slave owners in contemporary times, Poydras was not deterred by his slaves' previous plans to destroy his plantation and murder his neighbors. He bequeathed freedom to his more than seven hundred slaves after twenty-five years and gave them ten dollars per year for life. For those who died before their twenty-five years were up, their children would be freed at the age of thirty. Interestingly, the majority of Poydras's slaves at his Pointe Coupee plantation were women, with many being elderly. Out of the seventy-two slaves, only four women were of childbearing age, and almost 30 percent were children.[527] Poydras specified that those who were more than sixty years old were to be instantly manumitted.[528] Louisiana law at that time stated that no slave could be emancipated before he or she was thirty-years old. Hence, with so many of his slaves being elderly or children, many of his slaves would be immediately freed, while most of the rest would be freed in their mid-thirties and forties. Sadly, while the charitable portions of his will were carried out, the section regarding his slaves was not. None of them was set free.

In 1898, the Baton Rouge and Bayou Sara Packet Company hosted a contest to name its new luxury steamer. *Julien Poydras* was chosen from a list of names submitted. Julia Wilkinson, who sent the winning letter, wrote of Poydras: "The peddler of 1769, the statesman of 1809, the great public benefactor of 1824, has had honors offered to his name, but a grateful and admiring people would be pleased to know that it would be borne by 'a thing of life' that will walk the waters of the stream along whose banks, in early manhood, he was wont to travel."[529]

The evolution of POYDRAS STREET almost mirrors the career of the man after whom it is named. Poydras Street also had modest beginnings. Its main draw was its market, which opened on July 4, 1838. Measuring 42 feet wide by 402 feet long, it extended from near Baronne Street to Circus Street.[530] For almost one hundred years, until the market was demolished in 1932, everything from fruits and vegetables to "everything butchering" was sold there. In the mid-1960s, the street was widened to 134 feet, transforming it into something larger and grander. Now Poydras Street is considered the heart of the Central Business District, with the core stretch lined with upscale hotels, office towers, a casino at its foot and crowned by the Mercedes-Benz Superdome. The street ends just steps from the Mississippi River, Julien Poydras's old friend that he wrote about in that very first published poem:

I shall tell my waters to moderate their course,
And to fertilize the place of his abode,
By flowery paths let him attain glory,
Let his name be written in the Temple of Memory.[531]

SOPHIE WRIGHT: Born in New Orleans one year after the Civil War ended, Sophie Bell Wright had many obstacles in her way: she was poor, she was a cripple and she was a woman. But in her "delicate body was the repository of a noble soul and a wonderful mind," and she went on to become one of the most influential and benevolent individuals in the city.[532] Her physical infirmities kept her inside, but she used her time "devouring" books until she was an "encyclopedia of knowledge." Wright began teaching girls, and her school, the Home Institute for Girls, became one of the foremost learning institutions in the city, not only educating women but also turning them into "polished corner-stones in the social edifice."[533]

One night, she received a knock on her door from a stranded acrobat; Wright later referred to it as the "knock of opportunity." The young man was from a prominent southern family who had disowned him when he joined the circus. He wanted an education but had to work in the daytime. Seeing the need, Wright opened up one room in her school on Pleasant Street and started the city's first free night school, opening up the opportunity for education to tens of thousands of individuals who otherwise might not have had it. She was a leader in the benevolent order of the King's Daughters and was essential in establishing Rest Awhile, a sanctuary in St. Tammany Parish that workingwomen and their children could visit in the summer. In 1903, she was awarded the Times-Picayune Loving Cup, a yearly award to an individual whose altruistic work benefits the community. In true form, Wright asked that the ceremony be held both in the day and at night so all of her students could attend.

When Wright died in June 1912, the outpouring in the city and around the country was immense, with social, political and religious groups paying tribute and represented at her funeral, which included those "most distinguished and those in the lowliest walks of life." Wright was laid to rest at Metairie Cemetery in her family tomb, and twelve years later, the city named a street in the Lower Garden District to honor the woman many called the "South's Most Useful Citizen" but even more knew and loved as "Saint Sophie."[534]

TOURO: Judah Touro, born in 1775, was a Jewish philanthropist and merchant who moved to New Orleans from Boston in 1801. Touro quickly established himself as a shrewd businessman and one of the most successful merchants in the city. His wealth did not cloud his sense of duty, though, and Touro served

in the Battle of New Orleans. Reports vary on his role, whether he was a common solider or a civilian volunteer, but what is known is that he was severely wounded on January 1, 1815. Left for dead, Touro was rescued by his friend Rezin Shepherd, who nursed him back to health. Always shy and meditative, the effects of his wound made Touro even more withdrawn. Touro made his presence known throughout the city with his generosity and benevolent contributions, not by his attendance at balls and operas. His style of giving matched his introverted personality, discreet and void of any pretense or self-promotion.

Touro died in January 1854 and left more than $500,000 to charity, notably to the New Orleans Public Library and to a hospital and synagogue that still bear his name. Touro made Shepherd his executor, and in March of that same year, Shepherd agreed to provide $30,000 a year beginning in 1855 to beautify Canal Street. In appreciation, on March 21, 1854, the city council voted unanimously to change Canal to Touro Street.[535] Giant oak trees were planted, and iron posts were linked with ornamental chains, but what could not be planted into the public's mind was the actual name. Citizens and city council members continued to refer to the street as Canal. Just a little over a year later, on April 19, 1855, Canal Street officially returned. It would take almost forty years for Touro to be honored with another street, but in 1894, Union was changed to TOURO STREET. Today, it runs from the Marigny, through the Seventh Ward, to Gentilly.

On Touro's tombstone is the epitaph, "The last of his name, he inscribed it in the Book of Philanthropy, to be remembered forever."[536] Through his kindness and generosity, Touro is forever inscribed in the fabric of New Orleans.

TULANE: Paul Tulane arrived in New Orleans from Princeton, New Jersey, on horseback in 1818. When he departed the world sixty-nine years later, he left millions toward the education of others and was eventually honored with an avenue running from the CBD to Mid-City.

Within ten years of Tulane's arrival in New Orleans, he had amassed a fortune of more than $150,000 from his general merchandise store. Tulane's wealth continued to grow, and in 1882, he left all of his property in New Orleans (reportedly valued from $1 million to $2 million) to the University of Louisiana, which changed its name to Tulane University in his honor. Tulane was described as a very conservative man who was overly cautious and deliberated over details for hours, generally "exhaust[ing] a subject." Although he was of a suspicious nature and had few close friends, he was considered a great talker and a lengthy letter writer, often composing thirty- to forty-page letters.[537] When Tulane died in 1887, Governor McEnery stated that he lived a "pure and blameless life."[538] The front of Tulane University was draped in mourning emblem out of respect.

Crepe myrtles abound in New Orleans, here welcoming visitors to Tulane University's Gibson Hall on St. Charles Avenue.

In 1950, historian Charles Dufour recounted a popular anecdote about Tulane. Allegedly, Tulane and his nephew were walking past an apple stand. Tulane asked him if he wanted one; the boy replied yes. Tulane started to buy two apples for ten cents but then stopped, saying, "If I buy these two apples, I'll spend 10 cents. To regain that 10 cents I must earn two dollars and put them out at interest for a year." He put the apples back and took his nephew home.[539] While Tulane may have been personally frugal, fortunately for New Orleans, his generosity helped create one of the finest universities in the country.

WHITNEY: Charles A. Whitney married well, to Marie Louise Morgan, daughter of railroad and shipping magnate Charles Morgan. They built a grand mansion on St. Charles Avenue, and Whitney started working with his father-in-law. They endeavored to run a steamboat line between New Orleans and San Francisco by way of Nicaragua, but the plan was stymied by the invasion of

For more than eighty years, this clock has been the iconic symbol of Whitney Bank. The bank was founded by Charles Whitney, who was honored with a street in Algiers.

Nicaragua by General William Walker.[540] When Morgan died in 1878, Whitney became executor of his vast estate, which was largely invested in steamship and railway properties. Whitney died four years later at the age of fifty-seven at the Fifth Avenue Hotel in New York City, just before he and his wife and young son Morgan were to board a steamship to Europe.

The following year, his wife gave money to their sons Charles and George to start Whitney National Bank, with their mother serving as one of its first directors. Oddly enough, Whitney's son (and namesake) died at a hotel in New York (the Hotel Albemarle) in 1913 of the same malady as his father at the age of fifty-nine.[541] Today, Whitney Bank is one of the largest banks in New Orleans and throughout the Gulf South, and the city honored the family with WHITNEY AVENUE in Algiers.

ZIMPLE: German immigrant Charles Zimpel was a noted surveyor, civil engineer and cartographer who contributed to the subdivision of plantations and

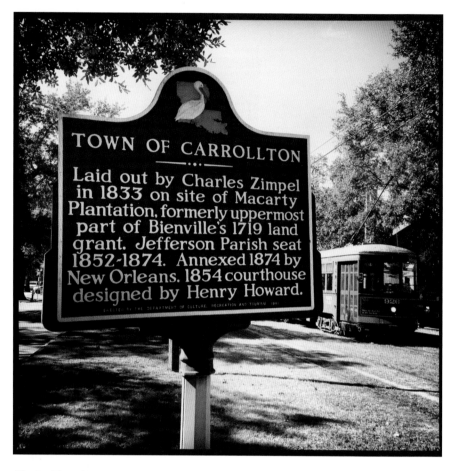

TOWN OF CARROLLTON

Laid out by Charles Zimpel in 1833 on site of Macarty Plantation, formerly uppermost part of Bienville's 1719 land grant. Jefferson Parish seat 1852-1874. Annexed 1874 by New Orleans. 1854 courthouse designed by Henry Howard.

Charles Zimpel laid out many of New Orleans's streets in the 1800s, and today has a street named after him. Even if some of its street signs are misspelled ("Zimple"), this historical marker nearby gets it right and commemorates his work in Carrollton.

development of neighborhoods all over the city. He is best known for his 1832 plan for the town of Carrollton, in which he divided the land into squares and lots that were later auctioned at the Exchange Coffee House in New Orleans.[542] A street in the area is named after him, and despite Zimpel's attention to detail, his name is misspelled as "Zimple" on some street signs but spelled correctly on others. In the 1940s, a historian suggested that New Orleans set up a Department of Public Proofreading, but as of yet, it has not.[543]

WHIMSICAL REALITY

The Contrived, the Fanciful and the Practical

The original purposes behind many street names have disappeared or become faded, and some were never more than dreams. These streets represent landmarks in New Orleans's cityscape that were notable in its history, may or may not still be with us or, in some cases, were strictly the grand inspirations or imaginings of early planners.

BARRACKS: Barracks is one of the early streets of the French Quarter. When French engineer Adrien de Pauger laid out the city in 1721, he had the street drawn but not named. When the Spanish renamed some of the streets in 1792, it was called *Calle Duana*, which means Customhouse Street, but it was renamed three years later to *Calle Quartel*, which the French converted to *Rue de Quartier*, for the military quarters on the street. The Americans changed the name once again, to Garrison Street and then quickly to Barrack Street. Over time, it gained an *s* to become Barracks as we know it today.[544] While many New Orleans streets have had their names changed to something completely different, none has seen as many changes in as short a time—seven iterations in less than one hundred years—only to continue to mean nearly exactly the same thing.[545]

BASIN: Basin Street was laid out in the early 1800s, running from Common Street to the turning basin of the Carondelet Canal, just past St. Louis Cemetery No. 1. While the basin was filled with boats, the street became filled with what some might consider sin: jazz and prostitution. After the Civil War, for nearly five decades, Basin was the hub of the red-light district (when it was legal and

illegal), with the height being from 1897 to 1917, when prostitution was legal within the bounds of Iberville, St. Louis, North Robertson and Basin Streets in a district nicknamed Storyville.

Some of the most luxurious "sporting houses" in town were on Basin—"Countess" Willie Piazza, Hilma Burt, Kate Townsend, Hattie Hamilton and Josie Arlington were just a few of the madams who had grand brothels there filled with marble tables, hand-carved mahogany woodwork, Oriental rugs, velvet draperies and gilded French mirrors. Anything could be imported, and the women who lived and worked in these establishments exported their valuable carnality on the finest linens while sipping the best champagne.[546]

While Basin schooled some in the art and business of sex, it also educated musicians. Basin and Storyville were a training ground for jazz legends such as Jelly Roll Morton, Louis Armstrong and Sydney Bechet. The tolerant mores of the area also made for easy mixing and consorting of races.[547] But the torrid libertinism could not last forever, as in 1917 Storyville was shut down amid wartime concerns about the "dangers New Orleans and its vice district posed to young military men," as well as efforts by moral reformers.[548] Basin hung on for a little while, but in the 1930s, most of the area was demolished to build the Iberville housing development. Today, Basin Street is seeing resurgence, with condominiums, the renovated Saenger and Joy Theaters and the coming redevelopment of the Iberville area.[549]

Key to the city's founding, Bayou St. John was once a bustling shipping route from early New Orleans, via Bayou Road, to Lake Pontchartrain, the Gulf of Mexico and the world beyond. Today, it is quieter, with homes, Cabrini High School and a canoe offering a friendly ultimatum.

BAYOU ROAD: Bayou Road predates New Orleans. Originally, it was a Native American path along a ridge through the woods and swamp, a portage between the Mississippi River and a bayou connected to Lake Pontchartrain. Indians showed the path to early French explorers, including Iberville, and the French established a fort at the bayou's mouth in 1701 and named it Bayou St. Jean. But it was Bienville who decided in 1718 that the portage helped make a certain bend in the Mississippi the best place to site a new city to better control and exploit the river and its bounty.

Bayou Road was an instrumental part of the young city, running from the back of town to the bayou, facilitating access to the lake and gulf at a time when sailing to town from the river's mouth was still challenging in the face of shifting currents, bends and winds. In the 1790s, the Carondelet Canal was dug, lessening traffic on Bayou Road, which over time became residential as development rose up around it. Faubourg St. John was laid out at the bayou end of the road, and today it is uncertain where exactly it met the bayou.[550] An early map shows St. John Street (today's BELL) and Washington Street (Desoto) branching off from Bayou Road to the bayou, with St. John Route (Grand Route St. John) running to the bayou from just past where Bayou Road became Gentilly Road.[551] Today, Esplanade Avenue is the main thoroughfare between the French Quarter and Bayou St. John, leaving Bayou Road as a quiet and curious fragment of the old portage, angling across the street grid in Tremé and the Seventh Ward.

BROAD: The area around Broad Street and Bayou Road started evolving from plantations to streets and lots in about 1800.[552] It was originally called *Grande Rue* and separated LeBreton D'Orgenois' and Daniel Clark's properties, the latter of which became Faubourg St. John.[553] Over time, it lengthened as the backswamp was drained for development, but it was always broad (it once had a canal).[554] Today, it is a busy thoroughfare running from Broadmoor to the Seventh Ward, full of businesses old and new, with institutions such as the Zulu Social Aid and Pleasure Club, and includes the well-known intersection of Tulane and Broad, site of the Orleans Parish Criminal District Court and Orleans Parish Prison (OPP).

CAMP: Camp Street was originally called Calle del Campo, after the "Campo de Negros" just across the *Terre Commune* from the Vieux Carré, which was where slaves were brought to the city to be sold. Today, Camp runs from Canal all the way uptown to Audubon Park.[555]

CANAL: Canal Street was named for what it was supposed to become. The area was originally known as *la Promenade Publique* or the *Terre Commune*, the space between the Vieux Carré and Faubourg St. Mary. In the early 1800s, there was a plan to connect the Carondelet Canal with the Mississippi River through the area.[556] For years, maps read "Proposed Route of Canal," but it was never built.[557] Instead of serving as a connection between waterways, it became known as a dividing line between the Creoles who resided in the old quarter and the "modern" residents of the American Sector, today's Central Business District. The median became known as the "neutral ground," where uptown and downtown residents could meet peacefully. As a result, New Orleanians refer to all medians as neutral grounds.[558]

Since it was a common meeting ground, city officials planned to turn Canal into "an agreeable resort and public promenade, where all can meet for relaxation and pleasure during the sultry heat of summer."[559] Beautification efforts started in the mid-1850s with the planting of oak trees and iron posts with ornamental chains, but instead of recreation, big business came. In 1869, the *New Orleans Republican* lamented the changes, condemning "the votaries of the almighty dollar, our capitalists who smile superciliously at the almost unanimous condemnation which has met their wanton act."[560] In the 1880s, the trees were dug up and the posts removed to facilitate transportation and the freer flow of goods and shoppers, in service of what some argued was a higher charge—capitalism.

The Canal streetcar line opened in 1861; in the 1880s, the first "skyscrapers" (seven stories) dotted the skyline; and in 1884, the first soda fountain in the city was installed, which drew large crowds.[561] Canal Street was the fashionable place to shop and be seen.

In October 1929, New Orleans took part in Light's Golden Jubilee, a national celebration of the fiftieth anniversary of Thomas Edison's incandescent light bulb. New Orleans had events for five days leading up to the grand finale on October 21, when Lafayette Square, city hall and other buildings and parks were illuminated, as were dock board buildings at the foot of Canal, where blue and amber lights concealed in shrubbery flooded the buildings, harmonizing "perfectly with the Spanish architecture of the structures."[562] Pictures of Edison surrounded by lights hung at the entrances to all the buildings, as everyone touted the genius of man in overcoming nature's darkness. Eight days later, the stock market crashed on what became known as "Black Tuesday," sending the country into a new darkness—the Great Depression.

Even with the Depression, Canal continued to be the grandest shopping district in New Orleans, but some of its restrictions became an issue in the early 1960s, when it became a focal point for civil rights protests. The stores (and the city) were segregated, sit-ins were staged at various businesses on Canal and there were

marches in the street. Simultaneously, many New Orleanians were moving to the suburbs, and shopping followed. In 1964, the streetcar line was removed in favor of buses (as was done with most streetcar lines in the city). By the 1980s, Canal was no longer the glittering retail mecca it had been. Some institutions ultimately closed (Maison Blanche), and others survived (Rubensteins), while large new hotels took the places of many nineteenth-century buildings.

But Canal's location at the heart of the city ensured that it remained a key hub, and in the 2000s, a renewal started. A Ritz-Carlton hotel opened, the streetcar returned in 2004 and even though Hurricane Katrina dealt a strong blow in 2005, the street was resilient, with the Saenger and Joy Theaters undergoing renovations, new condos and stores appearing and a large new medical complex being built in Mid-City.

Today, Canal extends from the Mississippi River to City Park Avenue in Mid-City, ending near a cluster of the city's old cemeteries. There it becomes Canal Boulevard and runs through Lakeview to the lake. As the symbolic dividing line between downtown and uptown, Canal has been one of the city's "main streets" since its birth. And as such, it is ground zero every year during Carnival. Nearly every Mardi Gras parade, whether it begins uptown, in Mid-City or downtown, makes its way to Canal, bringing people from all sides together, as it always has.

CITY PARK: City Park Avenue is so named because it borders and leads to City Park, designed by Frederick Law Olmsted and one of the oldest urban parks in the country, featuring 1,300 acres of oaks, lakes, paths, recreational attractions and the New Orleans Museum of Art. The avenue runs along Metairie Ridge from Carrollton Avenue, past the park, Delgado Community College and some of the city's largest cemeteries to the Pontchartrain Expressway, where it becomes Metairie Road.

CHURCH: St. Mary Street in Faubourg St. Mary (today's Central Business District) was changed to Church Street in 1869 in honor of the First Presbyterian Church that was built there.[563] However, the church relocated uptown, and today there are none on the street.

Top: Canal Street gets festive on the holidays, decorating streetcars and light posts with festive ribbons and wreaths.

Bottom: Gondola rides are but one of the many activities offered in City Park.

COLISEUM: See Pryrania.

COMMON: In the late 1700s, the land immediately outside New Orleans's fortifications was a public commons, the *Terre Commune*, including a large wedge-shaped area of woods between the Vieux Carré and the new Faubourg St. Marie.[564] The city planned to extend the Carondelet Canal to the Mississippi River through this area along what became Canal Street, and City Surveyor Jacques Tanesse's maps show it. The path of the canal is depicted on his 1816 map with the words, "réserve faite par acte du Congrés pour un Canal de Navigation," and his 1817 map even shows the canal as if it existed, bordered by handsome trees from Rampart to *Rue de la Levee* (today Decatur).[565] Alas, the canal was never built, and today the neutral ground and streetcar line lay in its place. Tanesse's maps also show the old commons laid out in blocks and streets, with its upper boundary as *Rue de la Commune*, or Common Street.

DRYADES: In Greek mythology, a dryad is tree nymph. The myth holds that as long as a tree flourishes, so does its dryad, but when the tree dies, the dryad dies as well. This street on the "woods side of town" was laid out in the early 1800s as *Cours de Driades* by Barthelemy Lafon when he planned the four faubourgs upriver from Faubourg St. Mary.[566] A section of the street was renamed in 1989 to honor activist Oretha Castle Haley, who now serves as a celestial nymph looking over the neighborhood she called home.

EDEN: See Muses Streets.

ESPLANADE: Esplanade Avenue, on the lower side of the French Quarter, runs through many historic neighborhoods on its way from the Mississippi River levee to Bayou St. John and the entrance to City Park: the Vieux Carré, Marigny, Tremé, Esplanade Ridge and Faubourgs St. John and Pontchartrain.[567] As New Orleans developed beyond its original footprint in the nineteenth century, a fine new avenue was laid out through the former commons and military parade ground on the lower edge of the Vieux Carré and then roughly along the old route to the bayou (cutting across Bayou Road). Previously, its route had been home to more than thirty-six plantations, but soon wealthy Creoles built mansions along it. It became almost their counterpart to St. Charles Avenue, replete with majestic oaks, a wide neutral ground and a streetcar.[568] Esplanade also became home to such landmarks as the U.S. Mint at one end and City Park at the other.

French impressionist painter Edgar Degas found inspiration on Esplanade for several months beginning in October 1872, when he lived in his uncle Michel

Musson's house. One of the most famous paintings from his stay is *Cotton Merchants in New Orleans*; upon Degas' death in 1917, the *Times-Picayune* noted that the "strongly illumined cotton office in New Orleans, with its snowy bundles of cotton samples, proved a tempting theme for his brush."[569] Degas was the only major French impressionist painter to travel to and paint scenes of life in the United States, and the Degas House, a museum and bed-and-breakfast on Esplanade, is the only home of Degas' in the world that is open to the public.[570] From its head at the big river that unlocks the continent to its foot at the little bayou that unlocked the river, Esplanade's two and a half miles have seen every era of New Orleans's history.

EUPHROSINE: Euphrosyne is one of Greek mythology's "Three Graces," who are Zeus's daughters and are known for their beauty and charm. Euphrosyne is the goddess of joy, mirth and merriment. As New Orleans grew toward the backswamp in the mid-1800s, it gave her a street—altering the spelling slightly—next to the Muse Calliope.[571] It extended outward with development but perhaps lost some joy when the city later lopped part of it off to build the railyards leading to Union Passenger Terminal.[572] Still, without a doubt, she feels mirth at locals' attempts to pronounce her name.

EVE: See Muses Streets.

EXCHANGE PLACE: Although its official name is Exchange Place, most New Orleanians call this small (three-block) street in the upper French Quarter Exchange Alley. In 1831, a group of businessmen wanted an alley cutting from Canal to Conti that was free from horses or carriages and was allocated for commerce and pedestrian traffic. The city council approved its plan, and J.N.B. Depouilly was commissioned to design a cast-iron rail for each end of the alley to guarantee that it would remain exclusively pedestrian.[573] Its biggest early business, though, was not trade or finance but fencing.

The 300 block of Exchange Place was lined with fencing academies where, as a matter of pride and often necessity, young Creole men flocked to become proficient in the art of the sword. Duels were commonplace at the time, and the newspapers later estimated that from the early 1800s to the 1870s, three to four duels were fought daily. And while many chose the picturesque oaks of Louis Allard's plantation (modern-day City Park) or the Fortin property (now the Fair Grounds), numerous men learned and executed their skills in Exchange Alley from such masters as Marcel Dauphin (who was eventually killed in a shotgun duel), Pepe Llulla (who was proficient in pistols, swords and knives and owned his own cemetery, which he quickly filled), Gilbert "Titi" Rosiere (a lawyer

who realized he could make more money teaching army officers how to fence) and Bastile Croquere (a mulatto gentleman with whom many dared not cross swords—not out of prejudice but out of fear).[574] Exchange Place was the hub of Creole culture in the nineteenth century, but in the early to mid-twentieth century, it became known as the city's "Skid Row."[575] Today, the first block is a back alley given over to vehicles, but the other two blocks are still pedestrian-only and lined with restaurants and shops (but usually no swordplay).

GRAND ROUTE ST. JOHN: Capitalist Daniel Clark bought land near Bayou St. John in 1804–5 and had surveyor Barthelemy Lafon lay out Faubourg St. John in 1809.[576] Settlement had begun on the bayou one hundred years earlier, but this was the first formal residential plan. Three streets—St. John (today Bell), Washington (Desoto) and Lepage—fanned out toward the bayou from Bayou Road, while St. John Route ran toward the bayou from Gentilly Road alongside the property soon to become Faubourg Pontchartrain.[577] In time, St. John Route became Grand Route St. John. Some say that it follows the path of the old portage from the Vieux Carré to Bayou St. John, but this seems less likely than today's Bell or Desoto Street having that distinction.[578] It is still a grand route, though, anchored at the bayou end by the elegant Old Spanish Custom House, as well as being home to some of the other more beautiful homes and greenery in the city.

LOWERLINE: It's often confusing that Lowerline is above Upperline in Uptown, but the streets' origins stem from two different plantations. LOWERLINE was named for the lower line of the Macarty Plantation, which became the city of Carrollton. UPPERLINE was the upper limit of Faubourg Bouligny, developed out of Louis Bouligny's plantation. In 1834, it was subdivided into two parts, East and West Bouligny. They were both a part of the city of Jefferson but were annexed by New Orleans in 1870.[579]

MAGAZINE: There are conflicting beliefs on what exactly Magazine Street is named for. Some historians believe it was named for the *magasin a poudre* (ammunition warehouse), while others believe it was named for a tobacco warehouse and others still argue that it was so named because it was where the "magazines," or public stores, were located.[580] Regardless of the exact origin, the common thread among these possibilities is that they were all places where goods were on hand, and that much has not changed. Magazine Street today is more than five miles of bustling commerce, running from Canal to the river levee just past Audubon Park. Antique stores and vintage shops mingle with high-end specialty shops and hardware stores. People can unwind or replenish at spas, neighborhood

Perhaps named for a warehouse that once existed near its beginning—be it for ammunition or tobacco, depending on the source—today's Magazine Street has traded bullets for bucks, sporting hundreds of unique local stores and restaurants interspersed among nineteenth-century homes. Magazine also has many of the old-style street name tiles.

pubs and all manner of eateries. The street is also dotted with shotguns, double galleries, raised center-halls and other styles of homes. Magazine Street is truly one street in New Orleans where you can find everything.

MANDOLIN: Livingston Street in Gentilly was changed to Mandolin in 1894. The name appears to be completely random, as there were no music stores, schools or instructors listed in the 1894–95 city directory entry for Mandolin. Possibly it was the whim of a council member out of love or respect for the musical instrument.

It may by the French word for "swamp," and at one time it was one, but today alligators like this are more at home in the bayous surrounding the city than on Marais Street.

MARAIS: In French, *marais* means swamp or marsh. This street received its name in the early 1800s because at nine blocks from the river, it was at the edge of the backswamp.[581] However, some claim that it was named after the Des Marais family.[582]

MARKET: In the early 1800s, when Barthelemy Lafon laid out the suburbs of the "second phase of Americanization," the first faubourgs upriver from Faubourg St. Mary (and today's Lower Garden District), his plan included a *Place du Marche*, or market place, to serve as a new market area for the city.[583] It was right by the river, and Market Street extended back from it. The market was never built, but the Orange–Market Street Wharf was. The street eventually became industrial, populated by warehouses that remain today.[584]

MOSS: This street follows the curves of Bayou St. John from Lafitte Street to Florida Avenue in Gentilly, passing some of the oldest homes in the city. It was

named Moss in 1894, but its original name was Port Street, presumably because it ran along the bayou when it was the city's port for vessels arriving from Lake Pontchartrain in the 1700s.[585]

MUSES STREETS: Barthelemy Lafon had as many careers as the nine Muses after whom he named some of New Orleans's streets. Lafon arrived in New Orleans in about 1789 and enjoyed employment as architect, engineer, surveyor, town planner, publisher, cartographer, planter, land speculator and, in later years, pirate. A brilliant man who spoke four languages, he had never studied architecture in his native country before arriving in New Orleans but still appeared to be influenced by the town plans of eighteenth-century France.[586]

As a city surveyor in 1806–7, Lafon was hired by Madame Marguerite Delord-Sarpy to subdivide her plantation into a faubourg. Lafon worked on this commission until Delord-Sarpy sold her holdings to Armand Duplantier, a man with a more inventive and expensive ambition. He instructed Lafon to submit a new, more elaborate plan, and he did not disappoint. Lafon responded with "by far the greatest urban scheme yet devised in New Orleans, or, indeed, in the entire Mississippi Valley," a design incorporating circles with fanned-out, tree-lined streets, fountains, parks, canals, basins, a coliseum and a place for amusements called Tivoli Circle. Lafon's complete vision was never realized, but his imprint is apparent in what is now the Lower Garden District, one of the first suburbs in North America.[587]

Scholars argue that after the French Revolution, the classics came into vogue as the inspiration for modern European planning. Perhaps they influenced Lafon in his creation of Nayades Street (later part of St. Charles Avenue), which he named after naiads, the Greek water nymphs, and its cross streets, which he christened with names of the Muses.[588]

In Greek mythology, the Muses embodied art, science and knowledge. They also came with an impressive lineage. Their father, Zeus, was the ruler of sky and thunder, and their mother, Mnemosyne, was the personification of memory. And though rooted in the ages, these inspiring Greek goddesses naturally gained unique new pronunciations once they began rolling off the tongues of New Orleanians:

- CALLIOPE (pronounced cal-lee-ope) is the Muse of epic poetry.
- CLIO (pronounced cleye-oh) is the Muse of history.
- ERATO is the Muse of love poetry and mimicry.
- EUTERPE (pronounced you-terp) is the Muse of music.
- MELPOMENE (pronounced mel-pah-meen) is the Muse of tragedy.

- POLYMNIA is the Muse of sacred poetry.
- TERPSICHORE (pronounced *terp*-sah-core) is the Muse of dancing.
- THALIA is the Muse of comedy and of playful and idyllic poetry.
- URANIA is the Muse of astronomy.

Not all citizens were enamored of living on a street that paid homage to the classics. One editorial in the *Times-Picayune* in 1839 complained about having to reside in a neighborhood that had "Pagan Mythology" despite that its residents knew "as little of these Heathen Divinities as a mile-stone does of Mozart's requiem."[589]

It is uncertain why Lafon, a successful, versatile artist, chose piracy in his final years. Writer Harriet Bos contended that a logical explanation was that he alienated the city's affluent with his arrogant and outspoken manner, and they stopped giving him commissions.[590] After a few years of rumored association with the pirate Jean Lafitte, Lafon returned to New Orleans in 1820. In September of that year, he was staying on St. Louis Street during a yellow fever epidemic. He died twenty-four hours after falling ill with the disease and was buried on the same day at St. Louis Cemetery No. 1.

The Muses' presence still offers inspiration today, and these passionate and expressive goddesses perhaps received some divine protection of their own. They have survived while certain nearby streets named after men of Greek and Roman mythology were not so lucky: Apollo, Bacchus and Hercules all fell over the years to the more earthly appellations, respectively, of Carondelet, Baronne and Rampart. Some of the Muses have been altered due to changes in the street grid (for example, the Crescent City Connection and its ramps) or partial name changes (see Martin Luther King Jr Boulevard), but they are all still present in some form, and when stretches of Euterpe and Terpsichore in Broadmoor were changed in 1894, the city even stuck with the "heavenly" theme, renaming the sections EDEN and EVE, respectively.[591] The Muses also inspired the Krewe of Muses, the first all-female krewe to parade at night in Uptown and today one of the most beloved krewes.

MYSTERY: It is a mystery why exactly Mystery is named that, but what is not a mystery is that it was one of the original streets of Faubourg Pontchartrain, laid out in 1809.[592] It had a big year in 1856, when the city's Committee on Streets and Landings authorized the Streets Commission to place one lamp at the corner of Mystery and Grand Route St. John and to have a ditch dug on Mystery by a chain gang.[593] Today, it is considered part of Faubourg St. John, and each spring, it leads countless music lovers to uncover the many aural, visual and gustatory mysteries to be revealed at the New Orleans Jazz and Heritage Festival.

ORANGE: Orange Street in the Lower Garden District is named for a large orange grove on the former Jesuit plantation through which the street was laid.[594] It was laid out as *Rue des Orangers* by Barthelemy Lafon in the early 1800s.

PERDIDO: When New Orleans was young and still surrounded by swamp, areas at the "back of town" were often inundated by rain or flooding. Early streets that extended beyond the Vieux Carré were sometimes said to be "lost"—or "perdido," in the language of the colonial rulers of much of the era—when covered by floodwaters, including Bayou Road, along the old portage to Bayou St. John, which the Spanish referred to as "Portage of the Lost."[595] According to historian John Chase, an early "Perdido Road" ran through what is now Tremé, but by 1817, the first blocks of today's Perdido had appeared on the map in Faubourg St. Mary.[596] By 1900, far from being lost, the street was found, by saloons, "rough characters" and music—the area around Perdido and Rampart is where Buddy Bolden built his legend. Bolden and his band played in dance halls such as Odd Fellows and the Masonic Hall, quickening the pulse of the area known as "Black Storyville."[597] Eventually, hot spots of the area were lost to the wrecking ball, and today Perdido is not exactly lost but is rather quieter, running past offices, city hall, hospitals and the Orleans Parish Prison.

PORT: The area around Port Street, the lower Marigny today, was a plantation that changed hands many times until Nicholas Daunois bought it in 1795.[598] Several years later, he developed it into Faubourg Daunois, naming three of the streets after forts that used to surround New Orleans—*Rue St. Louis*, *Rue St. Charles* and *Rue St. Ferdinand*.[599] In the 1830s, most of Daunois' street names were changed, with the cross streets gaining Faubourg Marigny's colorful names and *Rue St. Charles* becoming Port Street because it abutted the port on the river.[600] Only *Rue St. Ferdinand* kept its name, although it lost "St." for some years before getting it back (and as in other neighborhoods, the cross streets were changed again to match their Vieux Carré counterparts).[601]

PRESS: Press was originally an unnamed street on the lower boundary of Faubourg Daunois. Nicholas Daunois had sold the lower fourth of his plantation in 1796, and the area was divided and changed hands again before a sliver was bought by Madame Lalaurie, who named the street *Rue Delphine* (see Bartholomew, Chapter 3).[602] In 1832, the adjacent plot became home to the Levee Steam Cotton Press, and by the next year, the street was called Cotton Press Street.[603] Over time, it was shortened to Press, and a railroad was laid down to serve the area. A passenger depot was built at Press and Royal,

and it was there that Homer Plessy stepped onto a train, and into American history, on June 7, 1892.

When Plessy boarded the East Louisiana Railroad train to Covington, he sat down in a whites-only car. Although he was a "Creole of color," he could pass for white, but he readily admitted to the conductor that he was not.[604] When he refused to leave the car, he was arrested for violating Louisiana's Separate Car Act. His actions and subsequent case were part of an effort by the Comité des Citoyens (Committee of Citizens) to challenge the law and, more broadly, to challenge the tide of Jim Crow laws that had risen since Reconstruction.[605] *Plessy v. Ferguson* went all the way to the U.S. Supreme Court, but Plessy and the committee's goals were crushed with the court's landmark 1896 decision, which affirmed the legality of the "separate but equal" doctrine and allowed racial segregation to flourish for another fifty-eight years until the court reversed it in *Brown v. Board of Education*.

Today, the depot is gone, but the tracks remain, still leading to one of the old cotton press buildings, which is now part the campus of New Orleans Center for Creative Arts (NOCCA).[606] PRESS STREET marks the line between the Marigny and the Bywater, one of the many lines in New Orleans where past meets present.

PRYTANIA: As New Orleans expanded upriver in the early 1800s, the men developing the new faubourgs, spurred by their rivalry with the Creoles in the "old city" and inspired by classical Greece, envisioned grandeur. Above Faubourg St. Mary, surveyor Barthelemy Lafon laid out four adjoining plantations into streets and lots.[607] Pierre Robin Delogny named his Faubourg de la Course after his love of horse races. He also named *Rue de la Course*, or Racetrack Street, which was a wide street extending from the river to Coliseum Street.[608] He planned for it to lead to a racecourse, but it was never built.[609] Today, the street is called RACE.

Delogny and his neighboring developers had bigger plans though—they were going to have a *Prytaneum*, a "Palace of the People," likened after those of ancient Greece. It would be a grand municipal auditorium of sorts where foreign dignitaries were received, youths were schooled and the most eminent citizens gathered.[610] On Lafon's plan, it took up an entire block, divided between Faubourgs de la Course and de L'Annunciation.[611] Delogny's 1807 prospectus for his faubourg, in addition to reserving land for the Prytaneum, also reserved "in perpetuity to himself and to his heirs or assigns, the gratuitous disposition of two places in the said college."[612] Alas, the Prytaneum was never built. It is unknown whether Delogny's heirs ever got into other colleges so cheaply or easily.

The street that led to the proposed Prytaneum was named, a tad prematurely, *Rue du Pritanee*, and was eventually corrupted via "New Orleans English" to Prytania.[613]

The word *Prytania* does not exist anywhere except in the streets of New Orleans. For a "fake" name founded in ancient inspiration, Prytania Street does have its share of venerable landmarks, including Lafayette Cemetery No. 1 and the Prytania Theater, founded in 1914 and the oldest single-screen movie house still operating in Louisiana.

Prytania and Race are not even the only streets in the Lower Garden District that represent unrealized dreams. A large coliseum, shaped like the letter *E* and seating thousands to view public games and races, was planned for the area of today's Coliseum Square.[614] It, too, was never built, but the road leading to it, *Cours du Collisee*, remains as COLISEUM STREET.[615] Although these streets may represent unfulfilled, epic visions, the reality that was built is today an archetypal charming New Orleans neighborhood.

RACE: See Prytania.

RAMPART: New Orleans lost three of its most fanciful street names when the name Rampart was extended along its current length: Hercules, Love and Circus.[616] The original Rampart was one of the first streets laid out by Adrien de Pauger, so named because it ran just inside the ramparts, or fortifications, at the rear of the city. As New Orleans grew, the street along Rampart's route got new names in new areas, but eventually all were homogenized to Rampart, although it is arguable that Hercules (or even Love) could have provided equal protection. Today, Rampart is one of the four streets that bound the French Quarter, and it also extends both upriver and downriver a good ways.

UPPERLINE: See Lowerline.

THEMES

Like the Muses streets, many other streets follow themes (although they are not necessarily united in any orderly placement).

CITIES AND STATES: Some of these streets have historical significance (see Napoleon), while others simply honor a city or state: Babylon, Belfast, Brooklyn, Bruxelles, Dublin, Edinburgh, Florida (Avenue and Boulevard), France, Frankfort, Havana (Street and Place), Louisiana, Louisville, Madrid, Mexico, Monterey (somehow the other *r* was dropped), Montpelier, Montreal, New Orleans, New York (Street

and Place), Panama, Paris (Avenue and Road), Seattle, Spain, Tacoma, Tennessee, Versailles, Vicksburg and Vienna (Street and Court).

FLORA AND FAUNA: New Orleans is lush and verdant, and it's no wonder it has streets that represent some of the foliage in Louisiana and beyond: Apricot, Birch (Street and Lane), Cherry, Chestnut, Deers, Fern, Fig, Hickory, Hollygrove, Laurel, Maple, Mistletoe, Oak, Oleander, Olive, Orchid, Palm, Palmetto, Palmyra, Peach, Pear, Pine, Plum, Rabbits and Willow.

MARDI GRAS: New Orleans has a BACCHUS DRIVE, after the Roman god of wine (and which is also a popular Mardi Gras krewe); a COMUS COURT, after the Mistick Krewe of Comus, founded in 1856; and a MARDI GRAS BOULEVARD in Algiers, after the colorful holiday.

Above: A golden sunset lights up the sky above St. Louis Cathedral, and a switch engine chugs past as another day winds down in this timeless view of the French Quarter from Algiers Point.

Opposite: Rabbits, Deers and Peoples all run together in this little pocket of the Eighth Ward, but Rabbits yields, only going three blocks.

Perhaps the real beauty of New Orleans is that it cannot be explained. The illogical, unusual and often erroneous are not viewed as flaws but rather as misty embellishments that embody the complex narrative of a city that care forgot. They are all on display in its streets' history, demonstrating that despite their conflicting nature, they still manage to coexist and complement one another in the fibers of its landscape and in the sediments of its culture. The city's history, whether fanciful or flawed, exists in every odd bend in the road, every misplaced vowel and consonant and every slight inflection on the tongue, showing that New Orleans takes everything with a grain of salt so that it can give everything else so much flavor.

VOCABULARY

arpent: A French unit of measure for land. In colonial Louisiana, plantations were measured by arpents, which were approximately 192 linear feet.

backswamp: New Orleans was first built on the natural levee alongside the Mississippi River. Moving back from the river, the land became lower and wetter until it was primarily swamp. New Orleanians referred to it as the backswamp because it was at the "back of town" (another term in its own right). After some drainage efforts and plantation usage in the city's first 150 years or so, it was mostly drained for development in the twentieth century.

banquette: A French word for sidewalk. It remained common in the New Orleans vernacular for well over one hundred years after Louisiana became a U.S. state. Today, you can still occasionally hear it from a native.

batture: The low land right alongside the Mississippi River. In the New Orleans area today, it is on the river side of the levee.

chevalier: A French noble title.

Code Noir: The "Black Code," the French colonial laws concerning slaves and free people of color.

Creole: The definition of Creole in New Orleans is not entirely clear-cut and can depend on whom you ask, but it originally referred to someone born in Louisiana of French or Spanish heritage and their descendants, including those of mixed race. Today, it also applies to the culture and cuisine rooted in the Creoles and Louisiana's colonial era.

faubourg: A French word meaning "suburb." As New Orleans expanded beyond its original boundaries, many new neighborhoods were called "Faubourg [name]." Over the decades, some areas took on different names, but recently, the term has come back into vogue in places.

French Quarter: The most common name today for the original area of New Orleans, bound by the river and Rampart and Canal and Esplanade. Although it is called the "French" Quarter, most of its historic buildings date from the Spanish colonial period, as most of the French structures were destroyed by fires in the late 1700s. See also **Vieux Carré**, which is used interchangeably with French Quarter in this book.

krewe: A festive, sometimes themed organization consisting of members who may have a ball or other organized functions year round but whose main event is parading during Carnival.

lagniappe: New Orleanian for "a little something extra."

neutral ground: Whereas in most of the United States a strip of land running down the center of a street is called a median, in New Orleans it is called a neutral ground. Around the turn of the nineteenth century, Creoles primarily lived in the French Quarter, while the American newcomers largely settled on the other side of Canal Street in the area known today as the Central Business District (CBD). Tensions and conflicts between the two groups were strong, but Canal Street was considered the neutral ground where they could meet.

parish: Louisiana's governmental subdivision within the state, equivalent to counties in other states. A parish has no relation to the church division of the same name.

Rex: Latin for "king" and the name of one of the most elite and historic Carnival krewes in New Orleans, as well as its annual king (although it is a faux pas to ever say "King Rex").

rue: French for "street."

second line: Traditionally, a brass band parade in New Orleans has a "first line," consisting of the band and official parade participants, and it is often followed by anybody else who cares to join in and dance along. They are the "second line." Increasingly, the term also refers more broadly to the parade as a whole.

uptown, **downtown**, **lakeside** and **riverside**: With New Orleans's fanning and curving streets, it is nearly impossible to maintain a true sense of north, south, east and west. So, New Orleans came up with its own cardinal directions, referring to the two main bodies of water surrounding it, as well as the direction to something from a given spot using river-derived directional indicators (uptown and downtown correlate with upriver and downriver). Not to be confused with the section of New Orleans known as Uptown.

Vieux Carré: In French, "old square." It refers to the original footprint of New Orleans, drawn by Pauger in 1721 and remaining the entire city, with only slight changes at the margins, until nearly the end of the 1700s. Today, it consists of the area between the river and Rampart and between Canal and Esplanade. Also known as the **French Quarter** (a much later term), the names are used interchangeably in this book.

NOTES

INTRODUCTION

1. *The Picayune's Guide to New Orleans*, 6th ed. (New Orleans: The Picayune, 1904).
2. *Daily Item*, June 5, 1894.

CHAPTER 1

3. *Encyclopedia Britannica*, "Cherokee," Encyclopedia Britannica Online, http://www.britannica.com/EBchecked/topic/109474/Cherokee.
4. John Chase, *Frenchmen, Desire, Good Children…And Other Streets of New Orleans!* (Gretna, LA: Pelican Publishing Company, Fourth Printing, April 2010).
5. Frederick Webb Hodge, ed., *Handbook of American Indians North of New Mexico*, A–M, vol. 1–vol. 30, part 1, Bureau of American Ethnology (Washington, D.C.: Government Printing Office, 1907).
6. Ibid.
7. Ibid.; Clare D'Artois Leeper, *Louisiana Place Names: Popular, Unusual, and Forgotten Stories of the Towns, Cities, Plantations, Bayous, and Even Some Cemeteries* (Baton Rouge: Louisiana State University Press, 2012).
8. Hodge, *Handbook of American Indians*.
9. Ibid.
10. Ibid.
11. Ibid.

12. William Read, *Louisiana Place Names of Indian Origin: A Collection of Words* (Tuscaloosa, University of Alabama Press, 2008).

13. Donald A. Gill, *Stories Behind New Orleans Street Names* (Chicago: Bonus Books, Inc., 1992).

14. Henry C. Bezou, *Metairie: A Tongue of Land to Pasture* (Gretna, LA: Pelican Press, 2003).

15. *Times-Picayune*, November 26, 1950; Catherine Campanella, *Metairie* (Charleston, SC: Arcadia Publishing, 2008).

16. Grace King, "Abstracts of French and Spanish Documents Concerning Early History of Louisiana," *Louisiana Historical Quarterly* 1, no. 1 (January 8, 1917); Carlos Trudeau, *Plano de la Ciudad de Nueva Orleans y de las Habitationes Imediatas Formado en Virtud del Dec-Reto del Yuo Cabo y Cedula Real*, December 24, 1798, map, Louisiana State Museum.

17. Campanella, *Metairie*.

18. Ibid.; Bezou, *Metairie*.

19. Henry Möllhausen, *Norman's Plan of New Orleans & Environs, 1845*, map, from Library of Congress, Map Collections, http://www.loc.gov/item/9868713.

20. *Times-Picayune*, December 13, 1915.

21. *Times Democrat*, January 9, 1910; William Head Coleman, *Historical Sketch Book and Guide to New Orleans* (New York: Will H. Coleman, 1885).

22. *Times-Picayune*, March 13, 1921.

23. *Times-Picayune*, November 26, 1950.

24. *Times-Picayune*, December 13, 1915.

25. Fred B. Kniffen, Hiram F. Gregory and George A. Stokes, *The Historic Indian Tribes of Louisiana: From 1542 to the Present* (Baton Rouge: Louisiana State University Press, 1987).

26. *Times-Picayune*, November 14, 1837.

27. *Times-Picayune*, January 26, 1845.

28. Today's Fair Grounds Race Course was called the Union Race Course.

29. *Times-Picayune*, February 8, 1975.

30. Robert Ryal Miller, "Cortés and the First Attempt to Colonize California," *California Historical Quarterly* 53, no. 1 (Spring 1974).

31 James L. Haley, *Passionate Nation: The Epic History of Texas* (New York: Simon & Schuster, Inc., 2006).

32. Some historians claim that the year was 1667.

33. Pie Dufour, "La Salle Put State on Map April 9, 1682," *Times-Picayune*, April 4 1967; *Encyclopedia Britannica*, "Rene-Robert Cavelier, sieur de La Salle (French Explorer)," Encyclopaedia Britannica Online, http://www.britannica.com/EBchecked/topic/326519/Rene-Robert-Cavelier-sieur-de-La-Salle.

34. Edwin Adams Davis, *Louisiana: A Narrative History* (Baton Rouge: Claitor's Book Store, 1961).

35. Robert S. Weddle, "Tarnished Hero: A La Salle Overview," *Southwestern Historical Quarterly* 113, no. 2 (October 2009).

36. Ned Sublette, *The World that Made New Orleans: From Spanish Silver to Congo Square* (Chicago: Lawrence Hill Books, 2008).

37. Also known as Crevel de Moranget.

38. Charles L. Dufour, *Ten Flags in the Wind: The Story of Louisiana* (New York: Harper & Row, 1967); Weddle, "Tarnished Hero."

39. *Times-Picayune*, March 14, 1882.

40. At the time, New France primarily consisted of what today is eastern Canada.

41. Dufour, *Ten Flags in the Wind*; Lawrence N. Powell, *The Accidental City: Improvising New Orleans* (Cambridge, MA: Harvard University Press, 2012); Clayton Rand, "Jean Baptiste Le Moyne de Bienville," *Times-Picayune*, November 15, 1964.

42. Stanley Clisby Arthur, *Old New Orleans* (New Orleans: Arthur Publications, 1966).

43. Clayton Rand, "Sons of the South," *Times-Picayune*, November 15, 1964.

44. Arthur, *Old New Orleans*.

45. Various sources alternately refer to Crozat as having a lease, having extensive trade rights, being the operator, being a private owner or being the financial administrator.

46. Davis, *Louisiana*.

47. Joseph G. Dawson, ed., *The Louisiana Governors: From Iberville to Edwards* (Baton Rouge: Louisiana State University Press, 1990).

48. Powell, *Accidental City*.

49. Dufour, *Ten Flags in the Wind*.

50. Powell, *Accidental City*.

51. Davis, *Louisiana*.

52. Dufour, *Ten Flags in the Wind*.

53. Michael T. Pasquier, "French Colonial Louisiana," KnowLA: Encyclopedia of Louisiana, ed. David Johnson, Louisiana Endowment for the Humanities, article published August 4, 2011, http://www.knowla.org/entry/534/&view=summary.

54. Currently Jackson Square.

55. Powell, *Accidental City*.

56. R.E. Chandler, "Ulloa's Account of the 1768 Revolt," *Louisiana History: The Journal of the Louisiana Historical Association* 27, no. 4 (Autumn 1986).

57. Ibid.

58. Pie Dufor, "First Revolt Flared Here in 1768," *Times-Picayune*, October 27, 1968.

59. Ibid.

60. R.E. Chandler, "Aubry: Villain or Hero?" *Louisiana History: The Journal of the Louisiana Historical Association* 26, no. 3 (Summer 1985).

61. Ibid.

62. Catherine Mizell-Nelson, "Alejandro O'Reilly," KnowLA: Encyclopedia of Louisiana, ed. David Johnson, Louisiana Endowment for the Humanities, article published February 25, 2013, http://www.knowla.org/entry/914/&view=summary.

63. Ibid.

64. Richard E. Chandler, "O'Reilly and the Rebels' Report to Arriaga," *Louisiana History: The Journal of the Louisiana Historical Association* 23, no. 1 (Winter 1982); David

Ker Texada, *Alejandro O'Reilly and the New Orleans Rebels* (Lafayette: University of Southwestern Louisiana, 1970).

65. Chandler, "O'Reilly and the Rebels' Report to Arriaga"; Texada, *Alejandro O'Reilly*.

66. Texada, *Alejandro O'Reilly*.

67. Grace King, *Creole Families of New Orleans* (New York: Macmillan Company, 1921).

68. Ibid.; Dufour, *Ten Flags in the Wind*; John Preston Moore, *Revolt in Louisiana: The Spanish Occupation 1766–1770* (Baton Rouge: Louisiana State University Press, 1976).

69. *Harrisburg (PA) Patriot*, "The First Republic in America," July 12, 1902.

70. Dufour, *Ten Flags in the Wind*.

71. Dufor, "First Revolt Flared Here in 1768." See also Chandler, "Aubry"; Chandler, "Ulloa's Account of the 1768 Revolt"; Texada, *Alejandro O'Reilly*.

72. Anonymous, "Antonio de Ulloa," KnowLA: Encyclopedia of Louisiana, ed. David Johnson, Louisiana Endowment for the Humanities, article published July 27, 2011, http://www.knowla.org/entry/913/&view=article.

73. King, *Creole Families of New Orleans*.

74. Catherine Mizell-Nelson, "Alejandro O'Reilly," KnowLA: Encyclopedia of Louisiana, ed. David Johnson, Louisiana Endowment for the Humanities, article published February 25, 2013, http://www.knowla.org/entry/914/&view=summary; *Times-Picayune*, September 17, 1933.

75. Albert R. Israel VI, "Louisiana Thrives Under Don's Rule," *New Orleans States*, May 15, 1921.

76. Walter Greaves Cowan and Jack B. McGuire, *Louisiana Governors: Rulers, Rascals, and Reformers* (Jackson: University Press of Mississippi, 2008); Dawson, *Louisiana Governors*; Davis, *Louisiana*.

77. Davis, *Louisiana*.

78. Israel, "Louisiana Thrives Under Don's Rule"; *Columbus Daily Enquirer*, November 13, 1887; *Patriot*, January 17, 1888; Clayton Rand, "They Built Louisiana," *Times-Picayune*, September 20, 1942.

79. Rand, "They Built Louisiana."

80. Davis, *Louisiana*.

81. *Times-Picayune*, July 30, 1961.

82. Ibid.

83. *Times-Picayune*, November 26, 1922.

84. *New Orleans Item*, November 29, 1922; November 30, 1922.

85. Cowan and McGuire, *Louisiana Governors*; Dawson, *Louisiana Governors*; Davis, *Louisiana*.

86. Davis, *Louisiana*.

87. *Times-Picayune*, December 18, 1968.

88. Dawson, *Louisiana Governors*.

89. Ibid.

90. Israel, "Louisiana Thrives Under Don's Rule."

91. *Albany Gazette*, January 16, 1804.

92. Powell, *Accidental City*.

93. Davis, *Louisiana*; Dawson, *Louisiana Governors*.

94. Sometimes spelled "Almonester."

95. Antoine also married another equally famous New Orleans woman, Marie Laveau.

96. Davis, *Louisiana*; Charles Dufour, "Her Ancestors Built 'Square,'" *Times-Picayune*, December 4, 1955; Wesley Jackson, "St. Louis Parish Churches Predecessors of Basilica," *Times-Picayune*, May 20, 1973; Powell, *Accidental City*; *Times-Picayune*, January 9, 1978.

CHAPTER 2

97. Richard Campanella, *Time and Place in New Orleans: Past Geographies in the Present Day* (Gretna, LA: Pelican Publishing Company, 2002); Jacques Tanesse, *Plan of the City and Suburbs of New Orleans from an Actual Survey Made in 1815 by J. Tanesse City Surveyor*, April 29, 1817, Historic New Orleans Collection.

98. *Times-Picayune*, December 10, 1922.

99. City Ordinance 395 CC, November 20, 1852.

100. *Encyclopedia Britannica*, Encyclopedia Britannica Online, http://www.britannica.com/EBchecked/topic/75716/House-of-Bourbon.

101. For some examples, see *Times-Picayune*, July 19, 1920; September 19, 1930; June 26, 1932; March 19, 1933.

102. J. Mark Souther, *New Orleans on Parade: Tourism and Transformation of the Crescent City* (Baton Rouge: Louisiana State University Press, 2006).

103. *Times-Picayune*, September 20, 1962.

104. *Times-Picayune*, July 18, 1958.

105. Frank Thistle, "Stripdom's Sexiest Strippers," *Adam* 1, no. 11 (1957).

106. *Times-Picayune*, May 3, 1963.

107. *Times-Picayune*, June 13, 1974.

108. Julie Melrose, "100 March through Bourbon St Porn," *Off Our Backs* 15, no. 8 (August–September 1985).

109. Antonia Fraser, *Love and Louis XIV: The Women in the Life of the Sun King* (New York: Anchor Books, 2007).

110. Chase, *Frenchmen, Desire, Good Children*.

111. Fraser, *Love and Louis XIV*.

112. Arthur, *Old New Orleans*. Some early maps show the section named Chartres and others Condé—for example Tanesse, *Plan of the City and Suburbs of New Orleans*; Meigs O. Frost, "State Historical Society Receives Bourbon Letters," *Times-Picayune*, September 27, 1940.

113. Fraser, *Love and Louis XIV*.

114. Ibid.

115. Chase, *Frenchmen, Desire, Good Children*.

116. Fraser, *Love and Louis XIV*.

117. James S. Zacharie, "New Orleans, Its Old Streets and Places," address delivered before the Louisiana Historical Society, New Orleans, February 1900.

118. W.H. Lewis, *The Sunset of the Splendid Century: The Life and Times of Louis Auguste de Bourbon, Duc du Maine, 1670–1736* (New York: Doubleday & Company Inc., 1963).

119. Chase, *Frenchmen, Desire, Good Children*.

120. Bruce Nolan, *Times-Picayune*, December 13, 2010.

121. Powell, *Accidental City*.

122. Chase, *Frenchmen, Desire, Good Children*.

123. King, *Creole Families of New Orleans*.

124. *Daily Item*, March 22, 1893; Chase, *Frenchmen, Desire, Good Children*; Meigs O. Frost, "Strange Stories Behind New Orleans Street Names," *Times-Picayune*, August 30, 1936; King, *Creole Families of New Orleans*.

125. Stanley Clisby Arthur, *Old Families of Louisiana* (New Orleans: Harmanson, Publisher, 1931). Estimates vary on the exact amount of his fortune, but it is agreed that Marigny was one of the wealthiest, if not the wealthiest, men in Louisiana.

126. *Daily Item*, March 22, 1893.

127. City Ordinance 395; Chase, *Frenchmen, Desire, Good Children*.

128. *Daily Item*, March 22, 1893; Chase, *Frenchmen, Desire, Good Children*; Frost, "Strange Stories"; King, *Creole Families of New Orleans*.

129. The original street names were in French: *Rue des Bons Enfants* (Good Children), *Rue de Craps* (Craps), *Rue D'Amour* (Love), *Rue de Poetes* (Poets), *Rue Musique* (Music), *Rue des Grand Hommes* (Great Men) and so on.

130. *Dallas Morning News*, October 8, 1902; Chase, *Frenchmen, Desire, Good Children*; Frost, "Strange Stories."

131. Chase, *Frenchmen, Desire, Good Children*; *Times-Picayune*, March 7, 1853.

132. *Times-Picayune*, March 7, 1853.

133. *New Orleans Times*, February 22, 1868.

134. *Daily Constitutionalist*, June 6, 1868.

135. Some sources say seven nuns remained.

136. Campanella, *Time and Place in New Orleans*; Chase, *Frenchmen, Desire, Good Children*; Barthelemy Lafon, *Plan of the City and Environs of New Orleans, Taken from Actual Survey* (Baltimore, MD, 1816). Map courtesy of the Historic New Orleans Collection; Francis B. Ogden, *Plan of the City of New-Orleans...*, New York, 1829. Map courtesy of the Historic New Orleans Collection; Samuel Wilson Jr. and Bernard Lemann, *New Orleans Architecture*, vol. 1, *The Lower Garden District* (Gretna, LA: Friends of the Cabildo Inc. and Pelican Publishing Company, 1998).

137. Powell, *Accidental City*.

138. Chase, *Frenchmen, Desire, Good Children*.

139. *Times-Picayune*, December 30, 2011.

140. Pie Dufour, "Story of Baroness, Her Buildings Told," *Times-Picayune*, February 16, 1964; Christina Vella, *Intimate Enemies: The Two Worlds of the Baroness de Pontalba* (Baton Rouge: Louisiana State University Press, 1997).

141. Frost, "Strange Stories."

142. Powell, *Accidental City*.

143. Gill, *Stories Behind New Orleans Street Names*; Powell, *Accidental City*; Chase, *Frenchmen, Desire, Good Children*.

144. Arthur, *Old New Orleans*.

145. Mark Souther, "The Disneyfication of New Orleans: The French Quarter as Façade in a Divided City," *Journal of American History* 94, no. 3 (December 2007).

146. Gill, *Stories Behind New Orleans Street Names*.

147. Matthew Bunson, Margaret Bunson and Stephen Bunson, *Our Sunday's Visitor's Encyclopedia of Saints* (Huntington, IN: Our Sunday Visitor Publishing Division, 2003).

148. Andrew Vanacore, *Times-Picayune*, March 29, 2011.

149. Chase, *Frenchmen, Desire, Good Children*.

150. Bunson, Bunson and Bunson, *Our Sunday's Visitor's Encyclopedia of Saints*.

151. *Times-Picayune*, February 8, 1997.

152. Rick Bragg, "Where a Vampire Walked, Tastes Clash," *New York Times*, March 19, 1997; James Gill, "The Rice Versus Copeland Fracas," *Times-Picayune*, February 12, 1997; Lynne Jensen, "Copeland Fries Rice, Plans to Sue," *Times-Picayune*, February 8, 1997; Jesse Katz, "Clash of Vampire Author, Popeyes Founder Shows New Orleans' Two Sides Public Battle Over Restaurant Becomes 'Gothic vs. Gauche' in Fight for City's Soul," *Los Angeles Times*, December 26, 1997; Craig LaBan, "Dinner Is Over at Delmonico—Plus; Graham Leaves Creole Café, and Copeland's Straya Has Star Power," *Times-Picayune*, February 11, 1997.

153. Petula Dvorak, "Judge Throws Out Suit Against Rice—Copeland Loses Free-Speech Row," *Times-Picayune*, September 27, 1997.

154. Gill, *Stories Behind New Orleans Street Names*; Roulhac Toledano, Mary Louise Christovich, Sally Evans and Samuel Wilson Jr., *New Orleans Architecture*, vol. 4, *The Creole Faubourgs* (Gretna, LA: Pelican Publishing, 1996).

155. Mary Louise Christovich, Roulhac Toledano, Betsy Swanson and Pat Holden, *New Orleans Architecture*, vol. 2, *The American Sector (Faubourg St. Mary)* (Gretna, LA: Pelican Publishing, 1998).

156. Chase, *Frenchmen, Desire, Good Children*.

157. Bunson, Bunson and Bunson, *Our Sunday's Visitor's Encyclopedia of Saints*.

158. Chase, *Frenchmen, Desire, Good Children*.

159. See Jacques Nicolas Bellin's 1732, 1742 and 1750 maps.

160. Mary Louise Christovich, ed., *New Orleans Architecture*, vol. 3, *The Cemeteries* (Gretna, LA: Pelican Publishing Company, 2004).

161. Chase, *Frenchmen, Desire, Good Children*.

162. Bunson, Bunson and Bunson, *Our Sunday's Visitor's Encyclopedia of Saints*; Chase, *Frenchmen, Desire, Good Children*.

163. Bunson, Bunson and Bunson, *Our Sunday's Visitor's Encyclopedia of Saints*; Leonard V. Huber, Peggy McDowell and Mary Louise Christovich, *New Orleans Architecture*, vol. 3, *The Cemeteries* (Gretna, LA: Pelican Publishing, 2004).

164. Huber, McDowell and Christovich, *New Orleans Architecture*, vol. 3, *The Cemeteries*.

165. Richard Campanella, *Bienville's Dilemma: A Historical Geography of New Orleans* (Lafayette: Center for Louisiana Studies, University of Louisiana–Lafayette, 2008).

166. The exact number of the nuns varies according to different reports. In a letter from Mother Superior Marie Tranchepain to the director of the company on December 24, 1726, it appears that it was herself in addition to seven nuns, one novice and two secular nuns. Many modern scholars, however, set the number at twelve. Heloise Hulse Cruzat, "The Ursulines of Louisiana," *Louisiana Historical Quarterly* 2, no. 1 (January 1919); Mother Mary Theresa Austin Carroll, *The Ursulines in Louisiana, 1727–1824* (New Orleans: Hyman Smith, Book and Job Printers, 109 Poydras Street, 1886).

167. Mario Ware, "An Adventurous Voyage to French Colonial Louisiana: The Narrative of Mother Tranchepain, 1727," *Louisiana History: The Journal of the Louisianan Historical Association* 1, no. 3 (Summer 1960).

168. Carroll, *Ursulines in Louisiana*; Clark Robenstine, "French Colonial Policy and the Education of Women and Minorities: Louisiana in the Early Eighteenth Century," *History of Education Quarterly* 32, no. 2 (Summer 1992).

169. Powell, *Accidental City*.

170. Carroll, *Ursulines in Louisiana*. "Even girls from the House of Correction became excellent wives and mothers, although their offspring were not fond of ascending the ancestral tree, while those of the 'casket girls' were as proud of the virtue of their mothers as of the nobility of their fathers."

171. *Times-Picayune*, December 15, 1948.

CHAPTER 3

172. Marjorie Roehl, "Tales that Twine about the Oaks," *Times-Picayune*, October 4, 1987.

173. Merritt M. Robinson, *André Latour Allard v. Louis Allard and Another* (S.C. LA 1844), *Reports of Cases Argued and Determined in the Supreme Court of Louisiana*, vol. 25 (New Orleans, LA, 1845); Mary Louise Christovich, Sally Kittredge Evans and Roulhac Toledano, *New Orleans Architecture*, vol. 5, *The Esplanade Ridge* (Gretna, LA: Pelican Publishing Company, 1995).

174. Allard served as a state representative for Orleans Parish during this period.

175. Christovich, Evans and Toledano, *New Orleans Architecture*, vol. 5, *The Esplanade Ridge*; *Times-Picayune*, February 11, 1926.

176. The last suicide is believed to have occurred in 1908.

177. One of the two Dueling Oaks was destroyed in a hurricane in 1949. *Times-Democrat*, March 3, 1892; *Times-Picayune*, July 26, 1908; *Times-Picayune*, Febrary 11, 1926; Janet Wallfisch, "Preserve a Piece of Local History: Adopt an Oak," *Times-Picayune*, July 6, 1980; Rochl, "Tales that Twine about the Oaks."

178. *Daily Item*, January 5, 1902.

179. Roehl, "Tales that Twine about the Oaks."

180. Russell B. Guerin, "Removal of City Park Tomb Is a Shame," *Times-Picayune*, March 1, 2012.

181. Chase, *Frenchmen, Desire, Good Children*; Toledano et al., *New Orleans Architecture*, vol. 4, *The Creole Faubourgs*. It has been posited that Macarty also named PAULINE STREET after the enchanting "belle" Pauline Forstall, although it seems unlikely that he named a street after a friend's daughter who was still a mere child.

182. Meigs Frost, "Was Madame Lalaurie of Haunted House Victim of Foul Plot?" *Times-Picayune*, February 4, 1934.

183. They purchased the home from Soniat Duffosat.

184. Frost, "Was Madame Lalaurie of Haunted House Victim."

185. *Times-Picayune*, March 13, 1892.

186. This number varies by source.

187. *New Orleans Bee*, April 11, 1834.

188. *National Gazette*, July 26, 1834.

189. Victoria Cosner Love and Lorelei Shannon, *Mad Madame Lalaurie: New Orleans' Most Famous Murderess Revealed* (Charleston, SC: The History Press, 2011); *New Orleans Bee*, April 11, 1834; *Times-Picayune*, November 18, 1873; *Times-Picayune*, March 13, 1892.

190. Merritt M. Robinson, *Saul, Commissioner, v. Lalaurie* (S.C. LA 1846), *Reports of Cases Argued and Determined in the Supreme Court of Louisiana*, vol. 32 (New Orleans, LA, 1845).

191. *Times-Picayune*, October 23, 2013.

192. Roulhac Toledano and Mary Louise Christovich, *New Orleans Architecture*, vol. 6, *Faubourg Tremé and the Bayou Road* (Gretna, LA: Pelican Publishing Company, 2003).

193. Bill Hyland, "Frenchman Championed Spanish Rule," *Times-Picayune*, October 6, 1988; Toledano et al., *New Orleans Architecture*, vol. 4, *The Creole Faubourgs*.

194. Bill Hyland, "Spaniard Started Settlement," *Times-Picayune*, October 13, 1988.

195. Campanella, *Time and Place in New Orleans*.

196. Dorothy G. Schlesinger, Robert J. Cangelosi Jr. and Sally Kittredge Reeves, *New Orleans Architecture*, vol. 7, *Jefferson City* (New Orleans: Friends of the Cabildo Inc., 1989).

197. *New Orleans Item*, April 23, 1922.

198. Arthur, *Old Families of Louisiana*; Gary B. Mills, "The Chauvin Brothers: Early Colonists of Louisiana," *Louisiana History: The Journal of the Louisiana Historical Association* 15, no 2 (Spring 1974).

199. Arthur, *Old Families of Louisiana*.

200. Chase, *Frenchmen, Desire, Good Children*.

201. Martin Fontaine, *A History of the Bouligny Family and Allied Families* (Lafayette: University of Southwestern Louisiana, 1990); Ned Hémard, "Genteel Beginnings," *New Orleans Nostalgia: Remembering New Orleans History, Culture, and Traditions* (New Orleans: New Orleans Bar Association, 2012), http://www.neworleansbar.org/new-orleans-nostalgia.html; King, *Creole Families of New Orleans*; *Times-Picayune*, April 21, 1931.

202. King, *Creole Families of New Orleans*.

203. J.E. Boulgoyne, "Gentilly: Where Suburban Dreams Grow Old," *Times-Picayune*, April 25, 1975.

204. Hémard, "Turning on Dufossat," *New Orleans Nostalgia*.

205. Ibid.; Meloncy C. Soniat, "The Faubourgs Forming the Upper Section of the City of New Orleans," *Louisiana Historical Quarterly* 20 (January–October 1937).

206. The plantations were the Rienzi plantation, the Barataria plantation and the Fanny plantation, respectively.

207. *Times-Picayune*, January 27, 1864.

208. Ibid.

209. J. Hawkins, *No. 1019. Canal and Banking Co. v. M.J. de Lizardi* (S.C. LA 1868), *Reports of Cases Argued and Determined in the Supreme Court of Louisiana*, vol. 20 (New Orleans, LA, 1868).

210. King, *Creole Families of New Orleans*.

211. Charles Zimpel, *Topographical Map of New Orleans and Its Vicinity, Embracing a Distance of Twelve Miles Up and Eight and Three Quarters Miles Down the Mississippi*, September 1833, Historic New Orleans Collection.

212. Campanella, *Time and Place in New Orleans*; Betsy Swanson and Henry Bezou, *Historic Jefferson Parish: From Shore to Shore* (Gretna, LA: Pelican Publishing Company, 2003).

213. *Times-Picayune*, December 9, 1981.

214. Chase, *Frenchmen, Desire, Good Children*.

215. Robert J. Cangelosi and Dorothy G. Schlesinger, *New Orleans Architecture*, vol. 8, *The University Section* (Gretna, LA: Pelican Publishing Company, 2000).

216. Chase, *Frenchmen, Desire, Good Children*.

217. Robert C. Reinders, *End of an Era: New Orleans, 1850–1860* (Gretna, LA: Pelican Publishing Company, 1964); Chase, *Frenchmen, Desire, Good Children*; Campanella, *Time and Place in New Orleans*.

218. Merritt M. Robinson, *Alexander Grant, Syndic of the Creditors of Cornelius Hurst, an Insolvent, v. John S. Hurst, Reports of Cases Argued and Determined in the Supreme Court of Louisiana*, vol. 10, no. 49 (New Orleans, LA, 1845).

219. *Times-Picayune*, November 16, 1844; *Times-Picayune*, May 2, 1851.

220. *New Orleans States*, February 13, 1921; Cangelosi and Schlesinger, *New Orleans Architecture*, vol. 8, *The University Section*. The details of Husrt's house were featured at the Smithsonian.

221. At the time of Louisa's death, the newspapers reported that her husband had died forty years prior; however, his death is listed as August 30, 1893.

222. *Times-Picayune*, November 12, 1913.

223. *Times-Picayune*, December 5, 1913.

224. *Times-Picayune*, February 13, 1921.

225. Ibid.

226. John Smith Kendall, *History of New Orleans*, vol. 2 (Chicago: Lewis Publishing Company, 1922); *Times-Picayune*, July 18, 1926.

227. Her name is sometimes also spelled as "Marguerite."

228. Chase, *Frenchmen, Desire, Good Children*.

229. Rousseau is also known as Don Pedro Rousseau. In some sources, Catherine is referred to as Catiche.

230. Raymond Martinez, *Rousseau: The Last Days of Spanish New Orleans* (New Orleans: Hope Publications, 1975).

231. *Orleans Gazette and Commercial Advertiser*, November 16, 1807; *Times-Picayune*, November 5, 1970.

232. *Orleans Gazette and Commercial Advertiser*, November 16, 1807; Campanella, *Time and Place in New Orleans*; Martinez, *Rousseau*.

233. Campanella, *Time and Place in New Orleans*; *Times-Picayune*, April 2, 1950; Wilson and Lemann, *New Orleans Architecture*, vol. 1, *The Lower Garden District*.

234. Martinez, *Rousseau*. There is also some belief that Philip Street might be named after Bernard de Marigny's sister, Celeste Philippe Marigny Livaudais, who owned the adjacent Livaudais plantation.

235. *Times-Democrat*, January 9, 1910.

236. Chase, *Frenchmen, Desire, Good Children*.

237. Campanella, *Time and Place in New Orleans*.

238. Schlesinger, Cangelosi and Reeves, *New Orleans Architecture*, vol. 7, *Jefferson City*.

239. Ibid.

240. Campanella, *Time and Place in New Orleans*.

241. Ned Hémard, "A Scandal in Bohemia," *New Orleans Nostalgia*.

242. Chase, *Frenchmen, Desire, Good Children*.

243. Hémard, "Scandal in Bohemia"; New Orleans Bar Association, 2006 and 2013.

244. *Times-Picayune*, April 21, 1868.

245. Chase, *Frenchmen, Desire, Good Children*; Schlesinger, Cangelosi and Reeves, *New Orleans Architecture*, vol. 7, *Jefferson City*.

246. Wilson and Lemann, *New Orleans Architecture*, vol. 1, *The Lower Garden District*.

247. Cora R. Jones, "Carrollton Boasts of Own Centennial," *Times-Picayune*, July 18, 1926; *Times-Picayune*, March 19, 1939; Kendall, *History of New Orleans*, vol. 2.

248. *Times-Picayune*, January 26, 1975; Mary Louise Christovich, *New Orleans Interiors* (New Orleans: Friends of the Cabildo Inc., 1980).

249. Louise McKinney, *New Orleans: A Cultural History* (New York: Oxford University, 2006).

250. Toledano and Christovich, *New Orleans Architecture*, vol. 6, *Faubourg Tremé and the Bayou Road*; *Times-Picayune*, February 25, 1980.

251. Campanella, *Time and Place in New Orleans*.

252. *Times-Picayune*, "Treme's History Culturally Rich," February 25, 1980; *States Item*, September 20, 1985.

CHAPTER 4

253. Danny Heitman, "John James Audubon," KnowLA: Encyclopedia of Louisiana, ed. David Johnson, Louisiana Endowment for the Humanities, article published January 3, 2011, http://www.knowla.org/entry/531/&view=summary.

254. *Times-Picayune*, February 10, 1851.

255. Marjorie Roehl, "Audubon Park Puts Years of Strife Behind," *Times-Picayune*, March 31, 1985.

256. Ibid.

257. *Times-Picayune*, March 31, 1978; June 8, 1978; May 4, 2002.

258. Donald M. Marquis, *In Search of Buddy Bolden: First Man of Jazz* (Baton Rouge: Louisiana State University Press, 2007).

259. *Times-Picayune*, May 20, 2002.

260. Cangelosi and Schlesinger, *New Orleans Architecture*, vol. 8, *The University Section*.

261. *Times-Picayune*, December 3, 1852.

262. *Times-Picayune*, December 10, 1852.

263. Glen Jeansonne and David Luhrssen, "William C.C. Claiborne," KnowLA: Encyclopedia of Louisiana, ed. David Johnson, Louisiana Endowment for the Humanities, article published May 7, 2013, http://www.knowla.org/entry/921/&view=summary.

264. Walter Cowan, John C. Chase, Charles L. Dufour, O.K. Leblanc and John Wilds, *New Orleans Yesterday and Today: A Guide to the City* (Baton Rouge: Louisiana State University Press, 1983).

265. Charles Dufour, "Mr. D. Clark Our 1st in Congress," *Times-Picayune*, July 23, 1950.

266. Jack B. McGuire, "William Charles Cole Claiborne," *Louisiana Governors*.

267. *Times-Picayune*, April 21, 1940.

268. Dawson, *Louisiana Governors*; *Times-Picayune*, April 21, 1940.

269. Pie Dufour, "Where'd Rex Get Colors?" *Times-Picayune*, February 12, 1950.

270. *Times-Picayune*, September, 25, 1872.

271. Lazardi, "Mayors of New Orleans," *Times-Picayune*, March 29, 1925.

272. Ibid. One frigid night, he went to the prison to make sure the prisoners were properly clothed, as years before many had frozen to death due to an unscrupulous jailer.

273. *Times-Picayune*, August 16, 1978.

274. *Times-Picayune*, September 1, 1843.

275. Some sources say that Freret Street also honors both William and James Freret.

276. *Times-Picayune,* January 9, 1840.

277. Gasper Stall, *Buddy Stall's French Quarter Montage* (Gretna, LA: Pelican Publishing Company, 2006).

278. Some accounts note this amount as $1.5 million.

279. An olographic will in other states is called a holographic will—that is, a will that is entirely handwritten, signed and dated by the person who made it. It does not need to be notarized or witnessed.

280. *Times-Picayune,* February 2, 1841; January 20, 1841.

281. Tulane University at the time was called the University of Louisiana.

282. *Times-Picayune,* January 5, 1912; Clayton Rand, *Sons of the South* (New York: Holt, Rinehart, and Winston, 1961).

283. *Times-Picayune,* January 5, 1912.

284. Dawson, "Francis R.T. Nicholls," *Louisiana Governors.*

285. Rand, *Sons of the South.*

286. *Times-Picayune,* January 6, 1912.

287. *Times-Picayune,* December 1, 1909; Chase, *Frenchmen, Desire, Good Children.*

288. The high school was renamed the Frederick Douglass High School in the mid-1990s as part of the drive to drop names linked to slave owners or Confederate leaders. *Times-Picayune,* September 20, 2008.

289. *Times-Picayune,* March 19, 1939.

290. *Journal of the Franklin Institute of the State of Pennsylvania, for the Promotion of the Mechanic Arts* (Philadelphia: Franklin Institute, 1849).

291. *Boston Recorder,* July 17, 1845; *New York Herald,* July 1, 1845; *Portland Weekly Advertiser,* July 15, 1845; *Times-Picayune,* June 19, 1845.

292. *Times-Picayune,* February 10, 1856.

293. *Louisiana Gazette,* July 25, 1826.

294. *Times-Picayune,* December 10, 1889.

295. *Times-Picayune,* February 23, 1911.

296. Louisiana Works Progress Administration, *Jefferson Davis Monument* (LA, 1938).

297. *States Item,* September 3, 1983; *States Item,* April 17, 1986; *States Item,* April 22, 1986.

298. *Times-Picayune,* January 12, 1988.

299. *Times-Picayune,* August 16, 1988.

300. Mayoralty of New Orleans, City Hall, February 6, 1891, no. 5987.

301. See the foreword by Stanley Clisby Arthur in M. Le Page du Pratz, *The History of Louisiana or of the Western Parts of Virginia and Carolina* (New Orleans: Harmanson Publisher, 1952); Charles Dufour, "Du Pratz's History Should Be Reprinted," *Times-Picayune,* December 3, 1967; Pat Phillips, *Times-Picayune,* December 6, 1964.

302. Arthur foreword in Du Pratz, *History of Louisiana.*

303. Arthur, *Old New Orleans.*

304. *Times-Picayune*, September 7, 1930.

305. *Times-Picayune*, October 25, 1987.

306. James H. Gillis, "Maestri Remembered," *Times-Picayune*, May 8, 1974; Marjorie Roehl, "Looking Back," *Times-Picayune*, October 25, 1987; *Times-Picayune*, May 8, 1974.

307. Clancy DuBois, "Waiters Remember Antoine's Famous Diners," *Times-Picayune*, May 2, 1976.

308. *Times-Picayune*, August 25, 1937.

309. Chase, *Frenchmen, Desire, Good Children*.

310. Clinton Street is one block at 240 feet long, Dorsiere Street is 354 feet and Madison and Wilkinson Streets are 380 feet long. The shortest streets in New Orleans are Pirates Alley and Pere Antoine Alley, both only 330 feet, but they are strictly pedestrian thoroughfares.

311. Cowan and McGuire, *Louisiana Governors*; Judith Gentry, "Alexandre Mouton," in Dawson, *Louisiana Governors*.

312. *Times-Picayune*, February 14, 1885.

313. Lazardi, "Mayors of New Orleans"; *Times-Picayune*, February 11, 1890.

314. Scholar Michael L. Kurtz stated that at the time, New Orleans had no reputation for chess. Michael L. Kurtz, "Paul Morphy: Louisiana's Chess Champion," *Louisiana History: The Journal of the Louisiana Historical Association* 34, no. 2 (Spring 1993).

315. Ibid.

316. Kurtz, "Paul Morphy."

317. *Times-Picayune*, May 16, 1879.

318. Kurtz, "Paul Morphy"; *New York Times*, July 11, 1884.

319. See *Times-Picayune*, October 20, 1921; October 17, 1922; *New Orleans States*, October 23, 1921; October 30, 1921; August 6, 1922.

320. *Times-Picayune*, July 6, 1869.

321. Various sources list the name change as occurring in the 1960s, particularly 1964, but city ordinance CCS 18620 lists the date as October 9, 1953.

322. *Times-Picayune*, February 27, 1933; *Times-Picayune*, February 10, 1934.

323. *Times-Picayune*, November 7, 2009.

324. *Times-Picayune*, March 11, 1843.

325. *Centinel of Freedom*, April 11, 1843.

326. Gayarré Charles, *History of Louisiana*, vol. 3 (republished, Gretna, LA: Pelican Publishing, 1965).

327. *Times-Picayune*, December 9, 1928.

328. Louisiana Division, New Orleans Public Library, "Administrations of the Mayors of New Orleans": Louis Phillippe Joseph de Roffignac (1766–1846); *Times-Picayune*, January 17, 1910; *Times-Picayune*, March 22, 1925.

329. *Times-Picayune*, December 9, 1928.

330. *New Orleans Argus*, January 22, 1828.

331. Patricia Brady, "Carnival of Liberty: Lafayette in Louisiana." *Louisiana History: The Journal of the Louisiana Historical Association* 41, no. 1 (Winter 2000).

332. Meigs Frost, *Times-Picayune*, August 16, 1936.

333. *Times-Picayune*, January 17, 1910.

334. Denise Gee, *Southern Cocktails: Dixie Drinks, Party Potions, and Classic Libations* (San Francisco, CA: Chronicle Books, 2007).

335. *Times-Picayune*, January 4, 1843.

336. Anonymous, "André Bienvenu Roman," KnowLA: Encyclopedia of Louisiana, ed. David Johnson, Louisiana Endowment for the Humanities, article published August 24, 2011, http://www.knowla.org/entry/930/&view=summary; Mrs. S.B. Elder, "Sidelights on the History of Louisiana: Andrew Bienvenu Roman," *Times-Picayune*, March 29, 1909; *Times-Picayune*, January 30, 1866.

337. *Times-Picayune*, July 26, 1908.

338. G. William Nott, "The Fencing Masters of Exchange Alley," *Times-Picayune*, April 29, 1928; *Times-Picayune*, October 5, 1952.

339. John Wilds, *Times-Picayune*, May 22, 1977.

340. Ibid.

341. Alvan F. Sanborn, "Henry Vignaud, American," *Times-Picayune*, May 23, 1909.

342. *Times-Picayune*, October 27, 1912; *Times-Picayune*, September 19, 1922.

343. *Times-Picayune*, December 26, 1909.

344. Anonymous, "Jacques Philippe Villere," KnowLA: Encyclopedia of Louisiana, ed. David Johnson, Louisiana Endowment for the Humanities, article published July 28, 2011, http://www.knowla.org/entry/923/&view=summary.

345. *Times-Picayune*, June 22, 1986.

346. *Times-Picayune*, June 18, 1942.

347. *Times-Picayune*, June 19, 1942; *Times-Picayune*, June 30, 1961.

348. Joseph G. Tregle Jr., "Edward Douglass White," in Dawson, *Louisiana Governors*.

349. *Newport Mercury*, May 1, 1847.

350. John S.D. Eisenhower, *Zachary Taylor* (New York: Henry Holt and Company, 2008).

351. Cowan and McGuire, *Louisiana Governors*. The Territory of Orleans consisted of modern Louisiana without the Florida parishes.

352. Andro Linklater, *An Artist in Treason: The Extraordinary Double Life of General James Wilkinson* (New York: Walker and Company, 2009).

353. Cowan and McGuire, *Louisiana Governors*.

354. Anonymous, "Louis A. Wiltz," KnowLA: Encyclopedia of Louisiana, ed. David Johnson, Louisiana Endowment for the Humanities, article published September 20, 2011, http://www.knowla.org/entry/946/&view=summary.

355. *Weekly Louisianian*, October 22, 1881.

356. Ibid.

357. *Times-Picayune*, October 16, 1881.

358. Eisenhower, *Zachary Taylor*.

359. Some of the clubs' names included Algiers Rough and Ready Club, Carrollton Rough and Ready Club, Freeport Rough and Ready Club, Boatmen's Rough and Ready Club, Steamboat Rough and Ready Club, Union Rough and Ready Club, Independent Rough and Ready Club, German Rough and Ready Club, Italian Rough and Ready Club, Spanish Rough and Ready Club and so on.

360. *Times-Picayune*, September 23, 1848.

361. Taylor was the last president to own slaves while in office.

362. *Times-Picayune*, September 23, 1848.

CHAPTER 5

363. *Times-Picayune*, January 23, 1972; *Times-Picayune*, January 25, 1972.

364. *Times-Picayune*, January 27, 1972.

365. *Times-Picayune*, March 30, 1981.

366. *Times-Picayune*, January 17, 1981.

367. He was also the lone dissenting vote against naming Martin Luther King Boulevard.

368. *Times-Picayune*, May 8, 1981.

369. *Encyclopedia Britannica*, "Battles of the Meuse-Argonne (World War I)," Encyclopaedia Britannica Online, http://www.britannica.com/EBchecked/topic/378992/battles-of-the-Meuse-Argonne.

370. *Times-Picayune*, May 17, 1919.

371. *Times-Picayune*, October 6, 1957.

372. *Times-Picayune*, November 24, 1957.

373. *Times-Picayune*, November 26, 1957.

374. Mrs. S.B. Elder, "The History of Carrollton, Public and Personal," *Times-Picayune*, March 14, 1910.

375. Zimpel, *Topographical Map of New Orleans*.

376. Elder, "History of Carrollton"; Jones, "Carrollton Boast of Own Centennial"; *Times-Picayune*, March 19, 1939; *New Orleans City Guide*, Federal Writer' Project of the Works Progress Administration for the City of New Orleans (Boston: Houghton Mifflin Company, 1938).

377. Jones, "Carrollton Boast of Own Centennial."

378. *Jet* magazine claims that Henry was a high school dropout. A *Times-Picayune* article from September 14, 1994, claims that he had little "formal education," and a *Times-Picayune* article from 1974 states that he graduated from an elementary school.

379. *Times-Picayune*, May 2, 1974. Henry was an executive board member of the Southern Christian Leadership Conference, a lifetime member of the NAACP, president of the Crescent City Independent Voters League and a member of the Young Men's Christian Association advisory committee.

380. *Times-Picayune*, May 11, 1974.

381. *Times-Picayune*, September 14, 1994.

382. David E. Long, "William Bainbridge and the Barron-Decatur Duel: Mere Participant or Active Plotter?" *Pennsylvania Magazine of History and Biography* 103, no. 1 (January 1979).

383. *New-York Spectator*, March 28, 1820.

384. *Augusta Chronicle*, July 4, 1875.

385. *Times-Picayune*, August 16, 1870.

386. Ibid.

387. Marjorie Roehl, "Vivid Memories of D-Day Remain in the Mind of 'Lightning Joe,'" *Times-Picayune*, June 3, 1984.

388. James H. Gillis, "Warm Greeting Is Given General at City Hall," *Times-Picayune*, April 30, 1960.

389. *Times-Picayune*, December 2, 1921.

390. Ibid.; *New Orleans States*, December 2, 1921; *Times-Picayune*, December 3, 1921. The Grunewald Hotel is now the Roosevelt Hotel.

391. *New Orleans Item*, December 2, 1921.

392. *Times-Picayune*, September 17, 1904; *Times-Picayune*, March 9, 1908.

393. C. Howard Nichols, "William Pitt Kellogg," *Louisiana Governors*.

394. *Times-Picayune*, June 9, 1874.

395. Justin A. Nystrom, "The Battle of Liberty Place," KnowLA: Encyclopedia of Louisiana, ed. David Johnson, Louisiana Endowment for the Humanities, article published January 3, 2011, http://www.knowla.org/entry/757/&view=summary; *Times-Picayune*, November 11, 1902.

396. *Times-Picayune*, September 15, 1899; September 11, 1932; September 14, 1951.

397. Littice Bacon-Blood, *Times-Picayune*, January 29, 2012.

398. *Times-Picayune*, May 27, 1886.

399. President George Washington was awarded one posthumously in 1976.

400. Historian John Perry stated that before Pershing went to West Point, he taught African American children, also earning him the name "Nigger Jack," but the press later softened it to "Black Jack." John Perry, *Pershing: Commander of the Great War (The Generals)* (Nashville: Thomas Nelson, 2011).

401. *New Orleans States*, February 16, 1920; *Times-Picayune*, February 17, 1920.

402. *New Orleans States*, February 16, 1920.

403. *Times-Picayune*, February 18, 1920.

404. John Higham, *Strangers in the Land: Patterns of American Nativism, 1860–1925* (New Brunswick, NJ: Rutgers University Press, 2011).

405. John V. Baiamonte Jr., "'Who Killa de Chief' Revisited: The Hennessey Assassination and Its Aftermath, 1890–1891," *Louisiana History: The Journal of the Louisiana Historical Association* 33, no. 2 (Spring 1992).

406. *Times-Picayune*, October 18, 1890.

407. Tom Smith, *The Crescent City Lynchings: The Murder of Chief Hennessy, the New Orleans "Mafia" Trials, and the Parish Prison Mob* (Guilford, CT: Lyons Press, 2007). The Henry Clay statue was located blocks from the city jail.

408. Ibid.

409. Of the eleven killed, three had had a mistrial, three had been acquitted and five had yet to go to trial.

410. Baiamonte, "'Who Killa de Chief' Revisited."

411. *New York Times*, March 15, 1891.

412. *Times-Picayune*, November 29, 1891.

413. *Times-Picayune*, March 9, 1892.

414. Joy Jackson, "Erected Lee's Statute the First Time," *Times-Picayune*, January 18, 1953. It has also been said that it was named after the town in Rome.

415. *Daily City Item*, February 16, 1880.

416. *Times-Picayune*, February 23, 1884.

417. *Times-Picayune*, August 31, 1884.

418. *Times-Picayune*, January 7, 1894.

419. *Times-Picayune*, April 11, 1907.

420. Cowan et al., *New Orleans Yesterday and Today*; Gill, *Stories Behind New Orleans Street Names*; *New Orleans City Guide*.

421. *Times-Picayune*, April 29, 1918; *New Orleans States*, October 20, 1918.

422. *Times-Picayune*, December 9, 1921.

423. Ibid.

424. *Times-Picayune*, January 15, 1977.

425. *Times-Picayune*, January 1, 1978.

426. *Times-Picayune*, April 19, 1989; *Times-Picayune*, April 21, 1989.

427. *Times-Picayune*, April 19, 1989.

428. *Times-Picayune*, April 21, 1989.

429. *Times-Picayune*, April 19, 1989.

430. According to 2010 census data, the neighborhood that Martin Luther King Jr. Boulevard primarily runs through in Central City is 93 percent African American and 4 percent white. The area where King and Melpomene meet at St. Charles Avenue is 57 percent white and 32 percent black, while the area around Melpomene in the Lower Garden District on the river side of Saint Charles is 72 percent white and 18 percent black, 2010 US Census Tract demographic data from http://www2.census.gov/geo/maps/dc10map/tract/st22_la/c22071_orleans and http://www.census.gov/2010census/popmap/ipmtext.php?fl=22.

431. *Kansas City Star*, July 1, 1907; *Times-Picayune*, January 10, 1909; Jim Fraiser, *The French Quarter of New Orleans* (Jackson: University Press of Mississippi, 2003).

432. *Kansas City Star*, July 1, 1907; *Times-Picayune*, January 10, 1909.

433. You was the half brother of Jean and Pierre Lafitte.

434. Chase, *Frenchmen, Desire, Good Children.*

435. *Daily States,* May 14, 1917.

436. Gill, *Stories Behind New Orleans Street Names.*

437. Edward Latham, *A Dictionary of Names Nicknames and Surnames of Persons Places and Things* (New York: E.P. Dutton & Company, 1904).

438. R.W. Phipps, ed., *Memoirs of Napoleon Bonaparte* (London: Richard Bentley and Son, 1885).

439. *Lombard v. Louisiana,* 373 U.S. 267 (1963).

440. Ibid.

441. Ibid.

442. *Times-Picayune,* May 21, 1963.

443. Shannon Frystak, "Oretha Castle Haley," KnowLA: Encyclopedia of Louisiana, ed. David Johnson, Louisiana Endowment for the Humanities, article published July 22, 2011, http://www.knowla.org/entry/850/&view=summary.

444. Meigs Frost, *Times-Picayune, New Orleans States Magazine* Section, January 6, 1946.

445. Bates M. Stovall, "Seadog Who Burned Out the Pirates," *Times-Picayune,* July 19, 1953.

446. Ibid.

Chapter 6

447. *Times-Picayune,* March 26, 1987.

448. *Times-Picayune,* March 13, 1942.

449. *Encyclopaedia Britannica,* "Landing Craft," Encyclopaedia Britannica Online, http://www.britannica.com/EBchecked/topic/1058973/landing-craft.

450. *Times-Picayune,* August 25, 1941.

451. Ibid.

452. *Times-Picayune,* August 2, 1952.

453. *Times-Picayune,* March 26, 1987; *Times-Picayune,* August 2, 1952.

454. *Times-Picayune,* August 2, 1952.

455. *Times-Picayune,* March 26, 1911.

456. An article from the *Times-Picayune* on February 2, 1924, reported that Bunny died from pneumonia, but Joseph Friend, grandson of Ida and Joseph Friend, in a personal interview, claimed that it was from the surgery.

457. *Times-Picayune,* July 21, 1924.

458. Ibid.

459. *Times-Picayune,* March 1, 2013.

460. *Times-Picayune,* September 23, 1963.

461. Personal interview with Joseph Friend, February 25, 2013.

462. Stuart O. Landry, *Duelling in Old New Orleans* (New Orleans: Harmanson, 1950).

463. Charles Dufour, "The Puzzling Daniel Clark," *Times-Picayune*, September 13, 1953.

464. Ibid.

465. Ibid.

466. Decades later, it would come out in court that one of Clark's aged servants had seen Clark's partner remove his sealed will—which included the daughter—and burn it.

467. Chase, *Frenchmen, Desire, Good Children*; Dufour, "Puzzling Daniel Clark"; *Times-Picayune*, January 10, 1885; *Cleveland Plain Dealer*, January 10, 1885; *New Haven Register*, January 11, 1885.

468. *Times-Picayune*, January 10, 1885.

469. *Times-Picayune*, January 11, 1885.

470. Ibid.

471. *Times-Picayune*, July 5, 1934; *Times-Picayune*, July 21, 1934.

472. *New Orleans* magazine, January 2010.

473. Ibid.; *Times-Picayune*, August 9, 2010; *New York Times*, August 9, 2010. In 2011, the Superdome was renamed the Mercedes-Benz Superdome.

474. *Times-Picayune*, August 9, 2010.

475. *Times-Picayune*, December 12, 2012.

476. *New Orleans Item*, January 5, 1912.

477. Ibid.

478. Schlesinger, Cangelosi and Reeves, *New Orleans Architecture*, vol. 7, *Jefferson City*.

479. *Times-Picayune*, May 10, 1880.

480. Chase, *Frenchmen, Desire, Good Children*; Schlesinger, Cangelosi and Reeves, *New Orleans Architecture*, vol. 7, *Jefferson City*.

481. Schlesinger, Cangelosi and Reeves, *New Orleans Architecture*, vol. 7, *Jefferson City*.

482. *Times-Picayune*, May 10, 1880.

483. *Times-Picayune*, March 18, 1887.

484. *Times-Picayune*, May 1, 1954.

485. *Times-Picayune*, November 3, 1948; May 1, 1954; June 14, 1986.

486. *Orleans Gazette and Commercial Advertiser*, July 31, 1805; Campanella, *Bienville's Dilemma*.

487. Jared William Bradley, ed., *Interim Appointment: W.C.C. Claiborne Letter Book, 1804–1805* (Baton Rouge: Louisiana State University Press, 2002).

488. Gary Van Zante, "James Gallier Sr," KnowLA: Encyclopedia of Louisiana, ed. David Johnson, Louisiana Endowment for the Humanities, article published October 1, 2012, http://www.knowla.org/entry/815/&view=summary.

489. *Times-Picayune*, May 11, 1853.

490. Leonard V. Huber, *New Orleans: A Pictorial History* (Gretna, LA: Pelican Publishing, 1991).

491. Ibid.

492. *New Orleans Weekly Times*, October 27, 1886.

493. *New York Times*, June 1, 1885.

494. Ibid.

495. Ibid.; *Times-Picayune*, April 14, 1985; Mark T. Carleton, *Politics and Punishment: The History of the Louisiana State Penal System* (Baton Rouge: Louisiana State University Press, 1971).

496. *New Haven Register*, June 2, 1885.

497. Samuel Wilson Jr., "The Howard Memorial Library and Memorial Hall," *Louisiana History: The Journal of the Louisiana Historical Association* 28, no. 3 (Summer 1987).

498. *Philadelphia Inquirer*, April 20, 1892.

499. *Times-Picayune*, June 11, 1885.

500. *Times-Picayune*, November 28, 1955.

501. *Times-Picayune*, October 21, 1957.

502. *Times-Picayune*, January 16, 1957; January 30, 1957.

503. Meigs O. Frost, *Times-Picayune*, August 30, 1936. Other sources believe that Lesseps was after the deLesseps family.

504. *New Orleans Item*, June 14, 1917; *Times-Picayune*, June 15, 1917; July 21, 1937.

505. *Times-Picayune*, February 10, 1882; February 15, 1882; Laura D. Kelley, "Margaret Haughery," KnowLA: Encyclopedia of Louisiana, ed. David Johnson, Louisiana Endowment for the Humanities, article published January 19, 2011, http://www.knowla.org/entry/790/&view=summary; Stella Pitts, "Margaret Haughery Statue Honors Beloved Personality," *Times-Picayune*, March 10, 1974; Stella Pitts, "'Margaret' Spent Her Life Helping Orphans and the Poor," *Times-Picayune*, April 25, 1976.

506. *Times-Picayune*, May 22, 1883.

507. Some years reported for Milne's arrival are 1776, 1778 and 1790.

508. Charles Dufour, "Bachelors Top Benefactors?" *Times-Picayune*, March 5, 1950.

509. *Times-Picayune*, October 28, 1845.

510. Ibid.

511. *Times-Picayune*, February 6, 1839.

512. Roulhac B. Toledano, *A Pattern Book of New Orleans Architecture* (Gretna, LA: Pelican Publishing Company, 2010); Powell, *Accidental City*.

513. Pie Dufour, *Times-Picayune*, September 26, 1954.

514. Fraiser, *French Quarter*; Powell, *Accidental City*; Toledano, *Pattern Book of New Orleans Architecture*. The Mississippi River was then called the *Fleuve Saint-Louis*, or St. Louis River.

515. There is some conflict among sources over whether the original street names were directed by John Law, Company of the Indies officials, Bienville, Pauger or some combination of namers. See Arthur, *Old New Orleans*; Chase, *Frenchmen, Desire, Good Children*; Davis, *Louisiana*; Fraiser, *French Quarter*; Huber, McDowell and Christovich, *New Orleans Architecture*, vol. 3, *The Cemeteries*; Zacharie, "New Orleans, Its Old Streets and Places."

516. Huber, *New Orleans*.

517. Arthur, *Old New Orleans*.

518. Pie Dufour, *Times-Picayune*, September 26, 1954.

519. Christovich, Toledano, Swanson and Holden, *New Orleans Architecture*, vol. 2, *The American Sector (Faubourg St. Mary)*.

520. Ibid.

521. Erica Robin Johnson, "Louisiana Identity on Trial: The Superior Court Case of Pierre Benonime Dormenon, 1790–1812" (PhD dissertation, University of Texas at Arlington, 2007).

522. Alcee Fortier, *A History of Louisiana*, vol. 2 (New York: Goupil & Co. of Paris, Manzi, Joyant & Co., Successor, 1904).

523. Fortier, *History of Louisiana*.

524. Powell, *Accidental City*.

525. *New-England Palladium*, November 11, 1818.

526. Workers of the Written Program (WPA), *Louisiana: A Guide to the States* (Baton Rouge: Louisiana Library Commission at Baton Rouge, 1941).

527. Recensement de la Pointe Coupee et Fausse Riviere, March 29, 1790, in Leg. 227A, Carpete 21, Do. 2, PC, AGI, sale of Trenonay estate, January 17, 1794, Doc 1799, in OAPC.

528. *Evening Post*, August 20, 1824; *Connecticut Gazette*, November 11, 1824; Fortier, *History of Louisiana*, vol. 2.

529. *Times-Picayune*, September 13, 1898.

530. *Times-Picayune*, June 28, 1838; *Times-Picayune*, July 4, 1838; Benjamin Moore Norman, *Norman's New Orleans and Environs: Containing a Brief Historical Sketch of the Territory and State of Louisiana and the City of New Orleans, From the Earliest Period to the Present Time* (New Orleans: B.M. Norman, 1845). Circus Street is now South Rampart Street.

531. Fortier, *History of Louisiana*, vol. 2. The title of Poydras' poem was "La Prise de Morne du Baton Rouge par Monseigneur de Galvez, Chevalier pensionne de l'Ordre Royal distingue de Charles Trois, Brigadier des Armees de Sa Majeste, Intendant, Inspecteur et Gouverneur General de la Province de la Louisiane, etc. A la Nouvelle Orleans, chez Antoine Boudousquie, Imprimeur du Roi et du Cabildo. M.DCC. LXXIX."

532. *Times-Picayune*, June 11, 1912.

533. Ibid.

534. *Times-Picayune*, January 12, 1912; June 11–12, 1912; *New Orleans Item*, June 11, 1912.

535. *Times-Picayune*, March 22, 1854.

536. Marilyn Yalom, *The American Resting Place: 400 Years of History Through Our Cemeteries and Burial Grounds* (Boston: Houghton Mifflin Harcourt, 2008).

537. *Times-Picayune*, November 11, 1884; *New York Tribune*, March 29, 1887; *Philadelphia Inquirer*, March 29, 1887; *Times-Picayune*, June 10, 1887.

538. *Times-Picayune*, March 30, 1887.

539. Dufour, "Bachelors Top Benefactors?"

540. *Times-Picayune*, October 30, 1882.

541. *New York Times*, November 16, 1913.

542. *Times-Picayune*, March 19, 1939; *City of New Orleans v. Carrollton Land Co.*, 60 So. 695 (La. 1912).

543. *Times-Picayune*, October 22, 1950.

CHAPTER 7

544. Arthur, *Old New Orleans*.

545. Maps from 1829, 1834, 1841 and 1845 all show the street as "Barrack."

546. Alecia P. Long, *The Great Southern Babylon: Sex, Race, and Respectability in New Orleans 1865–1920* (Baton Rouge: Louisiana State University Press, 2004); Al Rose, *Storyville, New Orleans: Being an Authentic, Illustrated Account of the Notorious Red-Light District* (Tuscaloosa: University of Alabama Press, 1979); Troy Taylor, *Wicked New Orleans* (Charleston, SC: The History Press, 2010).

547. Long, *Great Southern Babylon*.

548. Ibid.

549. *Times-Picayune*, September 10, 2013.

550. Campanella, *Time and Place in New Orleans*.

551. Zimpel, *Topographical Map of New Orleans*.

552. Toledano and Christovich, *New Orleans Architecture*, vol. 6, *Faubourg Tremé and the Bayou Road*.

553. Chase, *Frenchmen, Desire, Good Children*.

554. Christovich, Evans and Toledano, *New Orleans Architecture*, vol. 5, *The Esplanade Ridge*.

555. Lois K. Pelton, "Many Old Romances Are Buried Under Names of the City's Streets," *Times-Picayune*, February 12, 1922; Powell, *Accidental City*. An alternative view holds that Campo de Negros was a camp for free blacks who came after the San Domingo revolution. *Picayune's Guide to New Orleans*. Also, an article in *Times-Picayune* notes that it was named Camp Street because it led to the camp of the slaves belonging to the Gravier brothers. *Times-Picyaune*, May 15, 1870.

556. *Times-Picayune*, October 12, 1941.

557. John Pope, "Canal Street: A Sojourn Down the City's Lifeblood," *Times-Picayune*, April 11, 1981.

558. See the appendix section "Vocabulary" in this book.

559. *Times-Picayune*, November 3, 1929.

560. Ira B. Harkey, "From Potters Field to Superstreet," *Times-Picayune*, October 12, 1941.

561. Ibid.; Peggy Scott Laborde and John Magil, *Canal Street: New Orleans' Great Wide Way* (Gretna, LA: Pelican Publishing Company, 2006).

562. *Times-Picayune*, October 6, 1929; October 22, 1929; February 25, 1930.

563. Chase wrote that St. Mary Street was changed to Church shortly after 1834, but city ordinance 1211 N.S. lists the change on January 4, 1869. Chase, *Frenchmen, Desire, Good Children*.

564. Ibid.

565. Jacques Tanesse, *Plan de la Nouvelle-Orléans*, December 16, 1816, Historic New Orleans Collection; Tanesse, *Plan of the City and Suburbs of New Orleans*.

566. Tanesse, *Plan of the City and Suburbs of New Orleans*; Chase, *Frenchmen, Desire, Good Children*. Chase stated that it was named in 1852, but its presence on early maps indicates otherwise.

567. Christovich, Evans and Toledano, *New Orleans Architecture*, vol. 5, *The Esplanade Ridge*.

568. Toledano, *Pattern Book of New Orleans Architecture*.

569. *Times-Picayune*, November 2, 1917.

570. Christopher Benfey, *Degas in New Orleans: Encounters in the Creole World of Kate Chopin and George Washington Cable* (New York: Alfred A. Knopf, 1998).

571. S. Pinistri, *New Orleans General Guide & Land Intelligence*, 1841 map, in *Charting Louisiana* (New Orleans: Historic New Orleans Collection, 2003).

572. George F. Cram, *New Orleans*, 1886 map, in Gaskell's *Atlas of the World*, University of Alabama Historical Maps of New Orleans, http://alabamamaps.ua.edu/historicalmaps/us_states/louisiana/NewOrleans.htm.

573. Sandi Donnelly, "Sense of Unique Past Is Held in Exchange Place," *Times-Picayune*, March 12, 1972.

574. Louis J. Meader, "Dueling in the Old Creole Days," *Century*, June 1907; G. William Nott, *Times-Picayune*, April 29, 1928; Donnelly, "Sense of Unique Past."

575. Donnelly, "Sense of Unique Past."

576. Christovich, Evans and Toledano, *New Orleans Architecture*, vol. 5, *The Esplanade Ridge*.

577. Ibid.; Zimpel, *Topographical Map of New Orleans*.

578. Campanella, *Time and Place in New Orleans*.

579. Richard Campanella and Marina Campanella, *New Orleans Then and Now* (Gretna, LA: Pelican Publishing Company, 1999); Campanella, *Time and Place in New Orleans*; Soniat, "Faubourgs Forming the Upper Section."

580. Frost, "Strange Stories"; *Times-Picayune*, December 1, 1946; Pelton, "Many Old Romances Are Buried"; Zacharie, "New Orleans, Its Old Streets and Places."

581. Chase, *Frenchmen, Desire, Good Children*; Zimpel, *Topographical Map of New Orleans*.

582. Zacharie, "New Orleans, Its Old Streets and Places."

583. Campanella, *Time and Place in New Orleans*; Wilson and Lemann, *New Orleans Architecture*, vol. 1, *The Lower Garden District*.

584. *Fifth Annual Report of the Board of Commissioners of the Port of New Orleans*, Board of Commissioners of the Port of New Orleans, 1901; Wilson and Lemann, *New Orleans Architecture*, vol. 1, *The Lower Garden District*.

585. *New Orleans Item*, July 16, 1894; Zimpel, *Topographical Map of New Orleans*.

586. Frederick S. Starr, *Southern Comfort: The Garden District of New Orleans* (New York: Princeton Architectural Press, 2005).

587. Ibid.

588. *Nayades* is the French spelling of naiads.

589. *Times-Picayune*, March 6, 1839.

590. Harriet P. Bos, "Barthelemy Lafon" (master's thesis, Tulane University, October 1977).

591. City Ordinance 9411 C.S., July 9, 1894.

592. Christovich, Evans and Toledano, *New Orleans Architecture*, vol. 5, *The Esplanade Ridge*.

593. *New Orleans Daily Creole*, August 1, 1856.

594. Frost, "Strange Stories."

595. Chase, *Frenchmen, Desire, Good Children*.

596. Tanesse, *Plan of the City and Suburbs of New Orleans*.

597. Marquis, *In Search of Buddy Bolden*.

598. Toledano et al., *New Orleans Architecture*, vol. 4, *The Creole Faubourgs*.

599. Chase, *Frenchmen, Desire, Good Children*; Tanesse, *Plan of the City and Suburbs of New Orleans*.

600. Zimpel, *Topographical Map of New Orleans*; Gill, *Stories Behind New Orleans Street Names*.

601. Möllhausen, *Norman's Plan of New Orleans & Environs*.

602. Toledano et al., *New Orleans Architecture*, vol. 4, *The Creole Faubourgs*.

603. Ibid.; Zimpel, *Topographical Map of New Orleans*.

604. Thomas J. Davis, *Plessy v. Ferguson* (Santa Barbara, CA: Greenwood/ABC-CLIO, 2012); Keith Weldon Medley, *We as Freemen: Plessy v. Ferguson* (Gretna, LA: Pelican, 2003).

605. Medley, *We as Freemen*.

606. Brian J. McBride, "Press Street: A Concept for Preserving, Reintroducing, and Fostering Local History" (master's thesis, Louisiana State University, 2005).

607. Campanella, *Time and Place in New Orleans*.

608. Soniat, "Faubourgs Forming the Upper Section"; Tanesse, *Plan of the City and Suburbs of New Orleans*.

609. Ned Hémard, "Changing Course," *New Orleans Nostalgia*; Frost, "Strange Stories."

610. Wilson and Lemann, *New Orleans Architecture*, vol. 1, *The Lower Garden District*; Kendall, *History of New Orleans*, vol. 2; Frost, "Strange Stories"; *Times-Picayune*, December 1, 1946.

611. Tanesse, *Plan of the City and Suburbs of New Orleans*.

612. Wilson and Lemann, *New Orleans Architecture*, vol. 1, *The Lower Garden District*.

613. Tanesse, *Plan of the City and Suburbs of New Orleans*.

614. Kendall, *History of New Orleans*, vol. 2; Frost, "Strange Stories."

615. Tanesse, *Plan of the City and Suburbs of New Orleans*.

616. Ibid.

INDEX

ABOUT THE AUTHOR

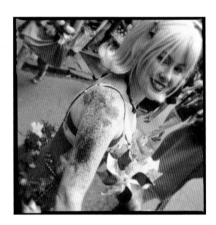

Photo by John Haffner.

S ally Asher has called New Orleans home since 1994. She has a master's degree in English from Tulane University and is currently pursuing her master's in history from Tulane. Her photography has appeared in many local, national and international media outlets, including *Newsweek*, *U.S. World News*, *The Gambit*, *Penthouse* magazine and *New Orleans* magazine. She has been the public relations photographer for Tulane since 2008. Asher's writing has been published, or is forthcoming, in many publications, including *Louisiana Cultural Vistas*, *Where Y'at*, *Antigravity*, *Bark*, *Eureka Literary* magazine and *One Square*. She frequently lectures on New Orleans's history through the Louisiana State Museum. Her work can be found at www.sallyasherarts.com and www.facebook.com/sallyasherarts. One of the original Big Easy Rollergirls (now retired), in her spare time Asher enjoys spending time with her family, friends and animals and enjoying the endless *joie de vivre* that New Orleans has to offer.